BEAUTIFUL FIGHTING GIRL

BEAUTIFUL FIGHTING GIRL

SAITŌ TAMAKI

Translated by J. Keith Vincent and Dawn Lawson
Commentary by Hiroki Azuma

University of Minnesota Press
Minneapolis
London

Originally published in Japanese as *Sentō bishōjo no seishin bunseki* (Tokyo: Ōta Shuppan, 2000) and *Sentō bishōjo no seishin bunseki* (Tokyo: Chikuma Bunko, 2006). Copyright Saitō Tamaki 2000, 2006.

Published by the University of Minnesota Press
111 Third Avenue South, Suite 290
Minneapolis, MN 55401-2520
http://www.upress.umn.edu

Library of Congress Cataloging-in-Publication Data

Saitō Tamaki, 1961–
 [Sentō bishōjo no seishin bunseki. English]
 Beautiful fighting girl / Saitō Tamaki ; translated by J. Keith Vincent and Dawn Lawson ; commentary by Hiroki Azuma.
 p. cm.
 Translated from the Japanese.
 Includes bibliographical references and index.
 ISBN 978-0-8166-5451-2 (pbk. : alk. paper)
 ISBN 978-0-8166-5450-5 (hc : alk. paper)
1. Comic books, strips, etc.—Japan—History and criticism. 2. Women in popular culture—Japan. 3. Girls in popular culture—Japan. 4. Girls in literature—Japan. 5. Girls in art—Japan. 6. Popular culture—Japanese influences. 7. Animated films—Japan—History and criticism. I. Vincent, J. Keith, 1968– II. Lawson, Dawn. III. Azuma, Hiroki, 1971– IV. Title.
 PN6790.J3S2513 2011
 741.5'3524220952—dc22
 2010047576

Printed on acid-free paper

The University of Minnesota is an equal-opportunity educator and employer.

CONTENTS

A NOTE ON THE TRANSLATION

A "cotranslation" can be approached in several ways. For this project, each of us did an initial translation of three of the book's six chapters. Then we checked each other's work against the Japanese, exchanging queries about meaning and English word choices. We both take full responsibility for any errors that may have crept in during the process.

For the romanization of Japanese words, we used the modified Hepburn system (i.e., the system in the third and later editions of *Kenkyūsha's New Japanese–English Dictionary*). Japanese names are given in Japanese order, family name first; for example, Saitō Tamaki. When a manga or anime has appeared in English or has an established English equivalent for its title, that English title is given first, with the Japanese title in parentheses the first time that title appears in a chapter. References used as sources for English titles are listed in the notes. When there is no established English equivalent, the Japanese title is used, with an English translation in parentheses at first mention in a chapter. Macrons mark long vowels in Japanese, except on common words such as Tokyo and Osaka. Unless otherwise noted, all Japanese references were published in Tokyo.

The translators thank Jason Weidemann at the University of Minnesota Press for his guidance throughout the publication process and Jonathan Abel for his helpful comments on the manuscript. Finally, we thank our partners, Anthony and Alan, for their understanding and patience while this "baggy monster" dominated our waking hours.

TRANSLATOR'S INTRODUCTION

Making It Real: Fiction, Desire, and the Queerness of the

Beautiful Fighting Girl

J. KEITH VINCENT

As anyone with even a passing familiarity with Japanese popular culture can attest, the fictional worlds of anime and manga are teeming with pre-pubescent girls fighting to save the world. Sometimes overtly sexualized, always intensely cute, and often a mixture of both, the "beautiful fighting girl" in all her many guises has acquired superstar status in the Japanese cultural imagination. Sailor Moon, Nausicaä, Kiki, Princess Knight: the list goes on and on. Saitō Tamaki's book *Beautiful Fighting Girl* asks what the emergence and proliferation of this iconic figure can tell us about the genres of anime and manga in which she appears, about the sexuality of those who produce and consume her, and about the shifting borders between reality and fiction in an image-soaked world.

Most analyses of the beautiful fighting girl tend to conform to one of two perspectives. For some critics, her emergence is a welcome sign of female empowerment, or at least a Japanese version of "girl power."[1] As Susan Napier writes in her exhaustive account of Japanese anime, series such as *Cutey Honey* and *Sailor Moon*, both of which fall under Saitō's definition of the beautiful fighting girl genre,

> show images of powerful women (albeit highly sexualized in the case of *Cutey Honey*) that anticipate genuine, although small, changes in women's empowerment over the last two decades and certainly suggest alternatives to the notion of Japanese women as passive and domesticated.[2]

Spunky girl superheroes are surely preferable to damsels in distress. But as the creeping qualifiers in Napier's prose ("albeit highly sexualized," "anticipate," "genuine, although small") suggest, the beautiful fighting girl

is not an unambiguous icon of feminist empowerment. Napier's slight discomfort turns to outright hostility in other critics, for whom the beautiful fighting girl's hypersexualized and borderline pedophilic image is a symptom of precisely the opposite: the continuing objectification and infantilization of women in Japanese society.[3] This polarization of attitudes toward her is perhaps the beautiful fighting girl's most definitive characteristic. As Anne Allison writes in a masterful account of the phenomenon that is Sailor Moon, "This fable of fierce flesh, as I call it—girls who show off their bodies yet are fierce fighters just like male superheroes—defies easy categorization as either (or simply) a feminist or sexist script."[4]

No doubt a large part of what makes the beautiful fighting girl so difficult to categorize has to do with how she confounds certain mimetic understandings of cultural production that underpin both the feminist and the sexist interpretations. Both assume, in other words, that she is in some sense a *reflection* of the status of girls and women in Japan. Studying the beautiful fighting girl, then, is understood as a way to get at the reality of women's lives in the culture that produced her. What these analyses often miss, however, is that the beautiful fighting girl is also a fictional creature in her own right, and one capable of fulfilling functions other than straightforward representation. She is inscribed, moreover, within certain generic parameters and flourishes only in certain media, specifically those of anime and manga, and more recently computer games. If she were simply a representation of a certain social reality or ideology (be it feminist, misogynist, or otherwise), we would expect to find her in all sorts of media, including not only anime and manga but also novels, films, and theater. But just as the "final female" is inherently tied to the horror genre or the femme fatale to noir, the beautiful fighting girl is most at home in the "drawn" worlds of anime and manga. Why is that? What is the special affinity between the beautiful fighting girl and these media forms? What does she have to tell us about the psychic space of contemporary Japanese popular culture? If there is more to her than what one critic has called "a mirror of girls' dreams," is there someone else whose dreams she might reflect?[5]

As a practicing psychiatrist in the Lacanian tradition with a keen interest in media culture, Saitō Tamaki was uniquely positioned to tackle these questions when he wrote *Beautiful Fighting Girl* more than a decade ago, and his ideas are still reverberating among cultural theorists in Japan today. Saitō reads the beautiful fighting girl not as a reflection

of the status or the desires of women but as an autonomous object of desire, an imaginary "phallic girl" whose unbridled *jouissance* lends reality to the fictional spaces she inhabits. Saitō reconstructs her origins in the pleasurable but disorienting experience of being sexually aroused by a drawn image of a beautiful girl with no referent in reality. He locates this primal scene in the childhood of the pioneering anime director Miyazaki Hayao, the creator of works like *Nausicaä of the Valley of the Wind*, *Princess Mononoke*, and *Kiki's Delivery Service*, all of which feature beautiful fighting girls.[6] Miyazaki has said that he was first inspired to make anime by the film *Panda and the Magic Serpent* (*Hakuja den*, 1958), Japan's first color feature-length anime, and Saitō hypothesizes that the young Miyazaki was caught off guard by a sexual attraction to the film's heroine. The girl (actually the spirit of a white serpent named Bai-Niang) was an impossible object, a fictional creature who therefore "contained already within her the occasion for loss"—yet Miyazaki desired her. This experience of being "made to experience pleasure against his will by a fictional construct" constituted a trauma for Miyazaki. Because unresolved traumas can only be repeated, for Miyazaki this meant the creation of a whole string of beautiful fighting girls in his own works. While Miyazaki tends to insist on the wholesomeness of his works and to disavow any sexual component, in Saitō's analysis the appeal of Miyazaki's beautiful fighting girls has everything to do with sexuality. Insofar as their repetition perpetuates a libidinal attachment to a fictional construct, they also challenge us to rethink our understanding of the ontological status of fiction in the visual register.

In Saitō's reading, then, the beautiful fighting girl is not a reflection of a sociological reality or even of a desire for a certain reality but a perverse fantasy that functions to recathect and invest with a new reality, to "animate," as it were, a sexual object that threatens to dissolve into fiction. This perverse work of animation is there for all to see in Miyazaki's creative output and has been reenacted countless times among generations of otaku, that much-maligned group of anime and manga makers and fans for whom the beautiful fighting girl represents an unattainable yet irresistible sexual object. As Saitō writes, "A generation traumatized by anime creates its own works that repeat the wound. That wound is taken over and repeated by the next generation." The original title of Saitō's book is *A Psychoanalysis of the Beautiful Fighting Girl*, but it might just as well be titled *A Psychoanalysis of the Otaku*.[7] Understood as the image of the otaku's founding trauma, the conflicting interpretations of the

beautiful fighting girl as both feminist and misogynist at once become easier to explain. She is empowered by her status as a sex object, her reality vouchsafed by her sex appeal. She may be a creature of male desire having nothing to do with actual women, but, once called into existence by otaku fantasy, she takes on an existence of her own that forces us to rethink our definition of reality itself.

Some readers may be pleased to hear that Saitō's book contains much more than dense Lacanian analyses. Behind the theory, which is concentrated mostly in chapters 1 and 6 (which deal with the otaku and the beautiful fighting girl, respectively), is an enormous amount of textual, clinical, and historical research, much of which has also made it into the middle chapters, although not always in a fully digested form. It is, in other words, quite a baggy monster of a book. In addition to a theory of otaku sexuality, it includes an analysis of the characteristic temporality and "high-context" nature of anime and manga, a fascinating defense of their monoglossic nature versus novelistic polyphony, an exhaustive genealogy of the beautiful fighting girl (including thirteen subgenres), a brief biography and analysis of the American outsider artist Henry Darger (whom Saitō sees as a sort of ancestor of the otaku), and a collection of interviews with otaku both inside and outside Japan. Not all of its arguments are made with the same level of rigor, nor are they all equally convincing.[8] But together they represent a sustained and serious attempt to understand the otaku and, by understanding them, to think interesting thoughts about the relations between fiction and the real world in today's media environment. The very messiness of the book's approach, as Azuma Hiroki notes in the commentary, is "a function of the author's zeal and the labor pains from birthing a new paradigm." And indeed, the book has been hugely influential in Japan, modeling a new approach to the study of popular culture and sparking debates that are still ongoing today.

Although Saitō concerns himself in *Beautiful Fighting Girl* exclusively with heterosexual male otaku, there are of course many different kinds of otaku, many of whom are women. A sizable proportion of female otaku enjoy populating their fantasy lives with more or less idealized gay male relationships. Saitō has addressed this complicated issue of so-called *yaoi* culture elsewhere, as have many other critics. Here I simply note that while this book is limited to male heterosexual otaku, considering both male fans of the beautiful fighting girl and female fans of the "boys' love" genre as variations of otaku can be helpful in understanding both phenomena: just as the beautiful fighting girl has little to do with actual

women or girls, the beautiful gay boys favored by female otaku have very little to do with "real" gay men.[9] To insist on an identity-based understanding of representation when analyzing either phenomenon is to miss the complex play of identification and desire that brings these figures to life and makes them so much more than they seem.

Defining the Otaku

Who exactly are the otaku? The term refers on the most basic level to passionate fans of anime, manga, and computer games. They are known for their facility with computer technology and for their encyclopedic, even fetishistic, knowledge of particular strains of visual culture.[10] Most commentators agree that the otaku emerge historically as a new sociological type sometime in the 1970s in the vacuum left by a hegemonic mainstream culture and the sub- and countercultures that opposed it. Defined more by their tastes than their actions or convictions, the otaku are the precocious children of postmodern consumerist society.

A more precise definition than that would be impossible because the otaku have become such a highly contested (and therefore fascinating) category. As Melek Ortabasi suggests, the figure of the male otaku is akin to the prewar *moga*, or "modern girl," in that he is both a lived identity and a media creation that crystallizes all sorts of social anxieties.[11] In the case of the otaku, these are about gender, sexuality, national identity, and normative development, all highly charged issues that cause the discourse about them to shift wildly back and forth between shame and pride.

First the pride. Okada Toshio, the self-proclaimed "Otaku King" who emerged in the 1990s as the chief spokesman for the otaku and proponent of so-called otakuology, has put forward the most complimentary definition of the otaku. This is to be expected, since he is himself what Saitō calls an "elite otaku." As a founder of the hugely successful anime studio Gainax and the cocreator of some of the most important anime in the otaku canon, Okada has every reason to be proud of otaku culture.[12] He defines the otaku as, among other things, "a new human type born in the twentieth century... with an extremely evolved visual sensibility."[13] He traces their history back to early fans of televised anime who prided themselves on being able to distinguish the pictorial styles of individual producers of anime images. The more subtle the distinctions, the more pleasure it gave the otaku to make them, and they took pride in being something more than passive consumers of mass-produced

entertainment, capable of spotting value and difference where others saw only monotony. As connoisseurs, Okada claimed, they traced their roots to premodern arbiters of taste like tea ceremony founder Sen no Rikyū (1522–1591), who was famous for his ability to proclaim a broken teacup more valuable than a whole one.[14]

Other proponents of otaku culture, such as Ōtsuka Eiji and Morikawa Kaichirō, have written of the extraordinary power of otaku taste to create communities, to transform urban space, to upend capitalist relations of production and consumption, and to challenge American cultural hegemony.[15] These claims, which Thomas Lamarre has collectively labeled the "Gainax discourse," after Okada's company, shade very quickly into utopian thinking, evoking "the distributive visual field of anime to make claims for the end of all hierarchies—those of history, of modernity, and of the subject."[16] This is heady stuff, and there are many elements of otaku culture that are in fact quite radical. As Lamarre also argues, however, the emphasis on historical rupture and Japanese cultural uniqueness in many of these texts keeps what could have been a *theory* of what is truly new about otaku culture from developing beyond the level of a *discourse* on otaku, and Japanese, identity. Otaku pride, moreover, can take rather extreme forms. Here, for example, is Okada in 1996: "At this moment the country of Japan could disappear and world culture wouldn't suffer a bit. The only exception to this is 'otaku culture.' [Japanese] Anime, manga, and computer games are sought after by people all over the world."[17] Such hyperbolic, and often narcissistic, celebrations of otaku culture are perhaps not so surprising, however, insofar as they come in reaction to successive waves of fear and loathing from mainstream Japanese society, for whom the otaku are anything but exemplary postmodern subjects or heirs of the best of Japanese culture.

From the perspective of mainstream Japanese culture, the otaku have a reputation for being undersocialized, unhealthily obsessive, and unable to distinguish between fiction and reality. When Miyazaki Tsutomu, who later turned out to be a fan of pornographic "rorikon" anime, was found to have murdered and partially cannibalized four little girls in 1989, the idea of the otaku as pedophile and psychopath was cemented in the public imagination.[18] As a result, many find it hard to accept that the otaku's passion for the beautiful fighting girl is limited to the realm of fiction and fantasy and does not translate into actual pedophilia. Sensationalizing news accounts of otaku who prefer so-called 2-D love over the real thing, moreover, are taken at face value as evidence of a pathetic developmental

failure, and the challenge posed by otaku culture to the normative trajectory from childhood into adulthood can seem like a rejection of the future itself.[19] Even Morikawa, who writes quite sympathetically about the otaku in general, insists that they are characterized by what he calls "an inclination toward failure" (dame shikō).[20]

Beautiful Fighting Girl intervenes in this highly polarized discourse to put the otaku back on a continuum with the rest of humanity. For Saitō, the otaku have a great deal to teach us about how to survive and flourish in our media-saturated environment. They are distinguished not by their *inability* to distinguish reality from fiction but by their *ability* to take pleasure in multiple levels of fictionality and to recognize that everyday reality itself is a kind of fiction. In an essay published just after *Beautiful Fighting Girl,* he wrote:

> Otaku seek value in fictionality itself, but they are also extremely sensitive to different levels of fictionality. From within our increasingly mediatized environment, it is already difficult to draw a clear distinction between reality and fiction. It is no longer a matter of deciding whether we are seeing one or the other, but of judging which level of fiction something represents.[21]

The otaku's attitude toward fiction accords very well with Jacques Lacan's understanding of the imaginary nature of experiential reality and can be a healthy adaptive strategy as well. Unlike obsessive fans who abandon themselves wantonly to their passions, the otaku maintain a detached and ironic perspective toward the objects of their fascination. Unlike their close relatives the maniacs, who covet objects that take material form (such as stamps or coins), the otaku are drawn to entirely fictional objects (such as anime characters) that they seek to "possess" by fictionalizing them further in narratives of their own creation. But the most important characteristic of Saitō's otaku is their ability to eroticize fictional characters. It is the otaku's sexuality, then, that really distinguishes them for Saitō. He explores it using Lacanian psychoanalysis, which may not be to everyone's taste, but he does so without the slightest trace of moralizing judgment, which is refreshing and long overdue.

Saitō's focus on the otaku's sexuality has provoked quite a bit of criticism, most famously from the media critic Azuma Hiroki, as I discuss later. But it is also Saitō's most important contribution to our understanding of otaku culture. His Lacanian approach is also particularly well suited to analyzing otaku and the beautiful fighting girl for two interrelated reasons. First, it offers powerful tools with which to understand how the

proliferation of new media forms has come to trouble the distinction between fiction and reality. Second, it makes it possible to describe otaku sexuality in a language that does not pathologize and acknowledges their ability to derive pleasure from fictional images in the fundamentally perverse imaginary space of anime and manga.

Lacan as Media Theorist

How does Lacanian theory understand the difference between "reality" and "fiction"? As is well known, Lacan posits a tripartite model for understanding human subjectivity. The Symbolic is the realm of language and the law; the Imaginary is the realm of images and appearances; and the Real is the unmediated and hence unimaginable "raw material" of reality, the perception of which would be too traumatic for us to bear. In Saitō's account of Lacan, our experience of what we know as reality takes place only in the Imaginary. It is also in the Imaginary that we experience everything else—*including fiction* and other images and perceptions—all mediated and regulated by Symbolic forms such as language and law. As Saitō writes, "It is here [in the Imaginary] that 'meaning' and 'experiences' are possible." For this reason, Saitō makes it clear from the outset that his discussion of the otaku focuses exclusively on the realm of the Imaginary. This is because, in Lacanian theory—*as in the otaku's world*—reality (unlike the Real) is understood as an imaginary phenomenon. Imaginary objects exist right alongside our perception of "everyday reality," and to the extent that we are able to cathect them, or invest them with libido, they are no less "real" in terms of their psychic effect on us. The only thing that distinguishes imaginary forms and constructs from what we understand in commonsense terms as everyday reality, Saitō writes, is our consciousness of them as being mediated in some way. Everyday reality, conversely, is "nothing more than a set of experiences that emerge from a consciousness of not being mediated." From Saitō's Lacanian perspective, then, there is no ontological distinction between "reality" and "fiction." It is only a matter of the perception of the absence or presence of mediation.

Lacan's theory of the imaginary nature of reality, then, is itself a theory of media that turns out to be very useful for understanding and coping with our hypermediated world. The proliferation of modern media forms has led to an unprecedented expansion of the realm of the Imaginary. With television, newspapers, film, anime, manga, and—of course,

the Internet—we now have access to a virtually unlimited store of images and ideas, all competing with "everyday reality" for our attention. Some of us experience this as enriching and exciting, while others find it threatening or overwhelming. As the realm of the Imaginary expands because of the proliferation of media, some of us may feel that the ability of the Symbolic to structure and unify the Imaginary is threatened. Since the (always illusory) unity of the subject is maintained by what Lacan calls the *phallus*, this threat may even be experienced as a kind of castration anxiety. The panicked desire to reinstate the Symbolic in the face of an onslaught of images that threaten to undermine the distinction between the real and the fictional can thus take the form of an anxiety over sexual norms and gender conformity. This is one reason that Saitō insists that sexuality is key to understanding both otaku culture and the reactions it provokes in mainstream society.

From this perspective, another possible definition of the otaku would be: those who take the most pleasure in and are most knowledgeable about this expansion of the Imaginary. While the rest of us may feel overwhelmed and awash in a flood of images and information, the otaku revel in it. As mentioned earlier, Saitō argues that the litmus test for a real otaku is whether they can be genuinely sexually excited by a drawn image. He writes,

When a person is sexually excited by the image of a woman in an anime, they may be taken aback at first, but they are already infected by the otaku bug. This is the crucial dividing point. How is it possible for a drawing of a woman to become a sexual object?

"What is it about this impossible object, this woman that I cannot even touch, that could possibly attract me?" This sort of question reverberates in the back of the otaku's mind. A kind of analytical perspective on his or her own sexuality yields not an answer to this question but rather a determination of the fictionality and the communal nature of sex itself. "Sex" is broken down within the framework of fiction and then put back together again. In this respect one could say that the otaku undergoes hystericization: the otaku's acts of narrative take the form of eternally unanswerable questions posed toward his or her own sexuality. And the narratives of hysterics cannot help but induce from us all manner of interpretations. This is of course what has led me to the present analysis.

This explosion of "acts of narrative" instigated by the otaku's hysteria leads to the obsessive replication of the beautiful fighting girl theme

as discussed earlier in the case of Miyazaki Hayao. Her "fighting" is the perverse expression of the projected and inverted hysteria of the male otaku whose fantasy she embodies. The hysteria is "inverted" because, while the hysteric expresses the trauma of sexuality by somaticizing it, the beautiful fighting girl seems to have experienced no trauma at all; her battles are not about revenge or even about justice. They are an expression of an unrepressed and de-instrumentalized sexuality. She fights for no discernible reason. She is the embodiment of the phallus and of pure *jouissance*, as it can exist only in the space of fiction and of infantile polymorphous perversion. As an embodiment of the Lacanian phallus, she offers a way out of the oedipal circuits of desire and lack, rivalry and revenge. She is the emblem of the otaku's "perversion."

Otaku Perversion

It should be emphasized here that "perversion" in Lacanian psychoanalysis is not an insult. It is a structural characteristic of all human sexuality, related to the mechanism of disavowal. As Bruce Fink writes, "It is evidence of the functioning of this mechanism—not this or that sexual behavior in itself—that leads the analyst to diagnose someone as perverse. Thus, in psychoanalysis 'perversion' is not a derogatory term, used to stigmatize people for engaging in sexual behaviors different from the norm."[22]

What is it that the otaku disavow? For Saitō this would of course be the fictionality of the beautiful fighting girl and, by extension, the ontological distinction between fiction and reality more generally. While our normative understanding of sexuality insists that it must have an object in the real world (preferably of the opposite sex) and that anything else can only be a "transitional" object, Saitō's otaku recognize that, to the extent that the "real world" is itself part of the Imaginary, there is no intrinsic difference between desiring a drawn or animated image and desiring an actual human being.[23] The otaku's ability to eroticize fictional objects, moreover, perfectly exemplifies Lacan's understanding of *all* sexuality as a fantasy and an illusion. If the proliferation of new media and the emergence of the Internet have meant that the "virtual" world has started to become just as meaningful as the "real" one, the otaku are there to tell us that this is nothing new.[24] Sometimes we do not want to hear this. And this, Saitō suggests, is a major source of the visceral contempt and derision with which the otaku are often treated.[25]

If society tends to repress the phantasmic aspects of sexuality, the otaku celebrate it. Their ability to eroticize imaginary objects, Saitō argues, has made them better equipped to cope in a media-saturated postmodern society in which the distinction between fiction and reality is increasingly problematic. In a world in which the Imaginary threatens to overwhelm the Symbolic,[26] along with the phallus that serves as its guarantee, the fantasy of the "phallic girl" is the otaku's way of holding on to a sense of reality. His perversion is a kind of ontological anchor; it is his salvation—and it could be ours as well. "For the world to be *real*," Saitō writes, "it must be sufficiently electrified by desire. A world not given depth by desire, no matter how exactingly it is drawn, will always be flat and impersonal, like a backdrop in the theater. But once that world takes on a sexual charge, it will attain a level of reality, no matter how shoddily it is drawn."

Saitō's positive view of otaku sexuality has the enormous merit of making it intellectually interesting and heading off the stupefying forces of stigmatization. Its value is all the greater in a cultural context in which many want nothing more than to "castrate" the otaku by inserting them into a developmental narrative and insisting that the objects of their affection are merely transitional ones that they must eventually outgrow. Such was the message, for example, of *Train Man (Densha otoko)*, the hugely popular media phenomenon about an otaku who inadvertently saves a girl from a harasser on a train and ends up discovering true love, thereby "graduating" from his otaku identity.[27] Although the *Train Man* phenomenon postdates the publication of *Beautiful Fighting Girl*, Saitō has been very outspoken in his opposition to what he calls "the same old calls for otaku just to 'accept reality and grow up' and 'acknowledge the gap between the real and the ideal.'" For Saitō, the perversion of the otaku, their insistence on holding on to their transitional object forever, is precisely the lesson that they have to teach us.

It is important to understand that this is not the same as saying that the fictional object is *the only* object the otaku can love, nor does it mean that he or she cannot tell the difference between real and imaginary objects of desire. Being an otaku says nothing about one's ability to love another human being, and one's taste in *fictional* sex is not necessarily predictive of the kind of sex one actually wants to have. Saitō would no doubt agree with the queer theorist Eve Kosofsky Sedgwick, who included in a long and wonderfully nonnormative list of all the ways in which people's sexuality can be different the following item: "Many people have their richest mental/emotional involvement with sexual acts

that they don't do, or even don't *want* to do."[28] Saitō argues that their ability to inhabit "multiple orientations," a sort of nonpathological form of dissociative personality disorder, means that otaku are perfectly capable of conducting a richly perverse fantasy life while maintaining an utterly "normal" and pedestrian sex life in their day-to-day lives. Which form of sexuality represents their "true nature," however, is a matter of indifference to Saitō. As their fantasies lead them to proliferate multiple fictional worlds, the effect is to dehierarchize the relation between fantasy and reality.

It is important to remember that Saitō makes this argument about the otaku's "normality" partly to defend the otaku against those who revile them as perverts and pedophiles, which in some cases perhaps leads him to overstate his case. In his recent book *The Anime Machine,* Thomas Lamarre is extremely critical of Saitō's eagerness to assert the otaku's normality, characterizing his "agenda" as saying, "let your fantasies run wild as long as they lead you back to bed with your socially legitimate partner."[29] While Lamarre's critique is characteristically brilliant in many ways,[30] this claim strikes me as a serious mischaracterization of Saitō's position. Saitō may *describe* the real-life sexuality of the otaku he knows as tending toward the heterosexual and the vanilla, but he never *prescribes* that it be so. For Saitō, the reality-producing charge of the beautiful fighting girl sparks across the gap between the otaku's actual heterosexual "wholesomeness" and the polymorphous perversity of their fantasies, but neither pole is privileged or pathologized.

I have addressed Lamarre's critique here because I want to stress that, contrary to the impression he gives, there is much in Saitō's book that students of sexuality and queer theory will find both useful and exciting. Cast as unnatural and perverse, and devalued because unrelated to reproduction, there is something decidedly queer about otaku sexuality, and Saitō's book offers a truly loving account of it. In their ability to eroticize fiction, Saitō's otaku decouple sexual desire from social identities and naturalized bodies in ways that queer theorists will find fascinating. His understanding of fictionality as a multilayered phenomenon rather than simply "the opposite of reality," and therefore trivial or immature, is a useful way to get beyond binary thinking and normative theories of development. It is also a way to understand not just what fiction is but how it works in and on the world. In his critique of Saitō mentioned earlier, Lamarre describes Saitō's work as "a quasi-Jungian apologia for the force of creative fantasy."[31] But readers will find that there is much more

to Saitō's analysis of fiction and sexuality than the sort of mystic human-ism this implies. The wellspring of the otaku's multiple fictional worlds lies not in the depths of the human soul but in the abyss of the Lacanian Real. As Saitō writes, "What I call the 'plurality of (imaginary) reality' *(sōzōteki genjitsu no fukusūsei)* has its origin and derives its potential from the positing of the Real. Without that it is nothing more than a vari-ant of the idea that fantasy is all that exists." Far from the mindless relativ-ism of "the idea that fantasy is all that exists" or a simplistic celebration of creativity, Saitō's work takes fiction seriously. As such it helps us under-stand how, in Michael Moon's words, "play and pleasure—which in our society frequently get relegated to the domain of an ostensibly 'tempo-rary escape from reality'—can demand engagement with some of our own and other people's most disturbing feelings, memories, and desires, and can also invite and withstand rigorous analysis."[32]

In addition to Sedgwick and Moon, there is one more foundational queer theorist whose work seems relevant to Saitō's. While Lamarre may be right to take issue with Saitō's overemphasis on the otaku's "normal" heterosexuality in real life, Saitō still gets credit for battling what Judith Butler famously argued was a much more insidious form of hetero-normativity. She called it "melancholic heterosexuality" and argued that it formed the psychic basis for naturalizing the body itself. "The conflation of desire with the real—" she argued in *Gender Trouble*, "that is, the belief that it is parts of the body, the 'literal' penis, the 'literal' vagina, which cause pleasure and desire—is precisely the kind of literalizing fantasy characteristic of the syndrome of melancholic heterosexuality."[33] Melan-cholic heterosexuality, for Butler, is the result of a taboo against homo-sexuality that precedes even the heterosexual incest taboo and plays a key role in forming our sense of inhabiting sexed bodies. She argues that the oedipal injunction against incestuous desire for the opposite-sex parent is preceded by a taboo against desiring the same-sex parent. The force of this taboo is such that the loss itself cannot be acknowledged, and this unmourned loss of the same-sex parent as an object of desire causes the subject to introject and identify with that object in place of desiring it. This identification, Butler suggests, sets the same-sex parent up inside the subject as the source of the felt "reality" of our sexed bodies. In her words, "The disavowed homosexuality at the base of melancholic heterosexual-ity reemerges as the self-evident anatomical facticity of sex."[34] This sug-gests that insofar as resistance to the otaku's fictionalization of desire typ-ically manifests itself in the form of an insistence on the material facticity

of bodies (i.e., "people need a good slap in the face!"),[35] that resistance may itself be rooted in one of the psychic foundations of heteronormativity. Although Saitō does not make this argument himself, his articulate defense of the otaku against those who insist that desire must be rooted in real bodies suggests the critically queer potential of otaku sexuality.

Debate with Azuma

Hiroki Azuma's *Otaku: Japan's Database Animals* has a very different take on the otaku from Saitō's, and the differences are revealing of the relevance of Saitō's approach to queer theory.[36] As readers of Azuma's book know, he barely touches on sexuality and focuses more on social theory and historical analysis. He sees in the otaku's way of producing and consuming anime and manga an "animalizing postmodernity." "Animalization," a term Azuma borrows from the neo-Hegelian philosopher Alexandre Kojève, involves a model of subjectivity based not on desire for an other who is always just out of reach but on the optative fulfillment of discrete and satiable "needs." In the case of the otaku starting in the 1990s, these "needs" are fulfilled by affectively charged qualities, called *moe*, of anime or manga characters (such as maid's costumes or cat ears) that have little or nothing to do with the narratives in which they appear. Azuma's otaku has no use for the "person," understood in a complex intersubjective sense. Nor is he interested in the twists and turns of narrative development. All he needs to be satisfied are the superficial trappings of character. As Azuma describes his dystopic vision, " 'becoming animal' means the erasure of this kind of intersubjective structure and the arrival of a situation in which each person closes various lack-satisfaction circuits" (87). Because these circuits are so easily closed ("it is essentially a matter of nerves"), they never develop to the level of a full-blown "sexuality" such as S/M, homosexuality, or even fetishism. "In most cases the sexual awareness of the otaku does not reach that level in any way" (89). Azuma's argument, then, is not just that otaku cannot be analyzed in terms of sexuality but that the otaku *do not have* a sexuality, that they herald the end of sexuality. For Azuma, the otaku are "database animals" who have given up on sexuality as an intersubjective experience. While Saitō sees otaku sexuality as an adaptive strategy perfectly suited for life in postmodern society, Azuma sees it as a symptom of animalization, a marker not only of the end of sexuality but the end of the "human" as well.

The difference between Saitō and Azuma, then, comes down to how they understand sexuality: for Azuma it is fundamentally about a relation to the other, which means that the otaku don't have it. For Saitō, it is imaginary from start to finish, so the otaku exemplify it. In a three-person discussion among Saitō, Azuma, and the feminist critic Kotani Mari held in 2002, the contrast between Saitō and Azuma is clearly on display.[37] When Azuma insists that the satisfaction the otaku derive from imaginary sex partners is nothing more than bodily pleasure that doesn't rise to the level of sexuality, Kotani counters that many otaku have actually "come out" and thereby proclaimed a sort of sexual identity that does indeed rise to the level of sexuality. Azuma responds:

AZUMA: But in the end, masturbating to a picture doesn't add up to anything [Shikashi, somo somo, e de onanii shite mo nan de mo nai deshō] . . .

SAITŌ: But of course it does! (laughs) [nan de mo naku wa nai darō!]

AZUMA: No, it doesn't. There is a huge difference between masturbation and actual sex acts . . .

KOTANI: Is there really such a huge difference? I really don't get men (laughs).

AZUMA: Isn't masturbation an extension of oral auto-eroticism? Like thumb sucking? Of course it might depend on the specific masturbatory act you're talking about. But still, in the sexual relation you have an other, and in that sense it is completely different from auto-eroticism.

SAITŌ: No, no. Remember that there is no sexual relation.

AZUMA: This sort of thing is what makes you Lacanians crazy (laughs). In any case, I don't think there's much point in talking about this.

SAITŌ: I wonder why you are so determined to laugh this off? (laughs) I'm going to stick to my psychoanalytic guns and insist that masturbation and sex are the same thing from an analytic perspective.[38]

Here, in a nutshell, is the core debate over otaku sexuality. Kotani, a committed feminist and longtime advocate of otaku and *yaoi* fantasy as legitimate forms of sexuality, stresses the political and performative dimensions of sexuality, arguing that if you "come out" as an otaku who likes to masturbate to pictures, that is your sexuality—to which you have a right—and it is no one else's business to decide whether it's "real" sexuality or not. Her generally sex-positive attitude also puts her in the same camp as Saitō when he argues that there is no way to strictly distinguish between masturbation and "real" sex.[39]

Azuma takes a very different position. His dismissive attitude toward masturbation (it "doesn't add up to anything") and his appeal to Freud's developmental teleology of sexuality (defining masturbation as akin to oral sexuality and therefore primitive) register as attempts to counter the de-instrumentalization of sexuality being proposed by Saitō and Kotani.[40] When Saitō picks up on this and starts to psychoanalyze Azuma himself ("I wonder why you are so determined to laugh this off?"), it is clear that he is suggesting that Azuma finds the idea of imaginary sexuality some-how threatening. As if to confirm Saitō's intuition, a moment later Azuma resorts to the supposed biological ground of "actual" sex.

"I want to talk about the 'animalistic' dimension. The dimension in which men and women just have sex and multiply. The egg and the sperm come together, the womb swells, and babies get pumped out. Can you really talk about sexuality *(sei)* without including this dimension?"[41]

Saitō's initial response to this is a commonsensical, "Of course you can't." But then he immediately returns to his Lacanian position, arguing that biological reproduction is actually part of the Real, cannot be symbol-ized, and so stands outside sexuality as he understands it. One sees in this exchange something quite crucial about both Azuma and Saitō. Azuma's critique of the otaku as "animalized" causes him to resort to a knee-jerk appeal to biological essentialism as a reaffirmation of the human (i.e., the relation to the "other"), while in Saitō's Lacanian approach the otaku's perversion (his disavowal of the distinction between fiction and the real) does not threaten his status as a human being but actually confirms it. While Saitō is genuinely interested in otaku sexuality, Azuma, for all his fascination with the postmodern, seems bothered by it. Their approaches to the phenomenon of *moe* are also telling in this regard. While Azuma sees in *moe* a symptom of the decline of "grand narratives" and a derail-ment of subjectivity-producing desire, Saitō's Lacanian approach makes it possible for him to read it not just as another example of Baudrillardian postmodernity but as a strategy by which the otaku is able to experience and conceptualize his own desire in reflexive and performative terms. In distinguishing between the love the otaku have for their objects and that of the "maniac" for theirs, he writes,

The passion of the otaku is more performative than that of the maniac. Otaku are in communication with other otaku through the code of "pas-sion." They are certainly not cool or disinterested, but neither do they com-pletely lose themselves when indulging in their passion. This sort of slightly

"canted stance toward passion" is very closely related to the essence of the otaku's "affinity for fictional constructs." Later we will see how perfectly the expression "X-*moe*" describes this.

Although many accounts of the otaku, including Azuma's, tend to emphasize their compulsive and obsessive attachment to their objects, in Saitō's account they have room for community, irony, and self-reflexivity. Like a good queer theorist, Saitō chooses to find something new and positive in otaku sexuality rather than read it as a symptom of cultural decline.

Since the invention of the printing press, new media forms have caused people to fear losing touch with reality. Not long after Gutenberg, Cervantes founded the novel genre by thematizing this very issue in a highly self-reflexive fashion by creating a protagonist unable to distinguish between fact and fiction. The question being asked in these debates over the otaku and their sexuality could be said to boil down to this: Are the otaku, like Don Quixote, so fooled by new media that they believe their Dulcinea is real, despite everything? Or are they like Cervantes and his ideal reader—fully aware of her fictionality, but nonetheless entranced, able to laugh at Don Quixote but also to love him and laugh with him? No doubt they are somewhere in between the two. And Saitō's work, like Cervantes's, reminds us that there is a little otaku in all of us.

BEAUTIFUL FIGHTING GIRL

PREFACE

Do you know the "fighting girls"?

Princess Knight, Jarinko Chie, Nausicaä of the Valley of the Wind, Sailor Moon? If you happen to be Japanese, you probably know them very well. You may even have special feelings about some of them. You may feel that you grew up with them as far back as you can remember. And there would be nothing the least bit strange about it if you did.

But how was it that you came to know them and love them, these "beautiful fighting girls," who have no equal anywhere in the world? A unique form of expression exists in Japan that features a long line of fighting girls. This is no minor phenomenon; in fact, it is so widespread as to pervade every form of media. It has become so familiar that few have noticed its uniqueness. We no longer perceive anything strange about images of sweet young girls clad in armor and wearing helmets, or wielding heavy weapons. I myself was of course no exception to this.

The first experience I had that led me to realize the strangeness of this phenomenon was when I encountered the work of the American amateur artist Henry Darger. His paintings, which have recently begun to receive some attention—there have been exhibitions in New York and Tokyo—depict truly strange and utterly riveting scenes.

Darger was a painter as well as a writer, or he was neither. He produced his "works of art" to create a fictional world in which he himself could live. Can such a person be called an "artist"? Can his creations be called "works of art"? In any event, in his world, girls who are not yet ten years old wage a bloody war against an army of evil adults. The result is a bizarre mixture of cruelty and childish naïveté. Or perhaps it is better described as the cruelty of childish naïveté itself.

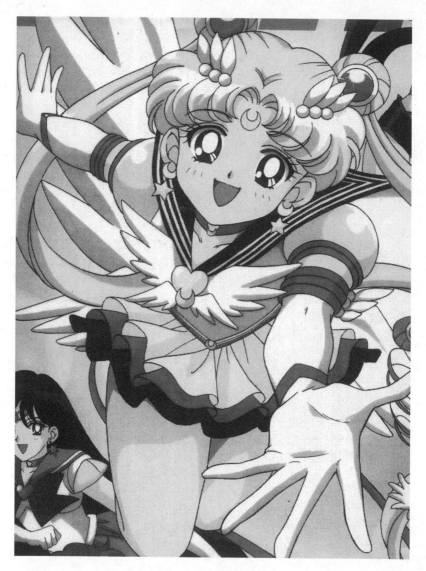

Sailor Moon

Darger is considered a so-called outsider artist, a term used to describe people who experience psychological pain or a sudden irrepressible impulse that they are compelled to express through painting, sculpture, and so forth. Motivated by a force that only he could understand, Darger secretly built a world all his own over sixty years. The brave poses of the seven

little girls, called the Vivian girls, who were saddled with responsibility for the destiny of that world, gave me a sense of déjà vu. Yes, I had seen this kind of spectacle somewhere before.

A column in a magazine introducing Darger provided one clue. It pointed out that these young girls who fight to protect a world are exactly like Sailor Moon, the Japanese manga and anime character. Looking at Darger's works again, I saw that the faces of the little girls did have something reminiscent of anime characters about them. It would, of course, strain credulity to posit some kind of connection between Japanese anime and the paintings of an American artist who died in 1972 at the age of eighty-four. The question, rather, had to do with the discontinuous relations of influence that linked these two utterly isolated phenomena.

But what I am considering in this book is something bigger than a bizarre coincidence between the work of an American outsider artist and Japanese anime. It struck me that the unique phenomenon was the girls' fighting itself. This expansion of perspective opened the way for a whole new field of inquiry.

Popular forms of expression focusing on beautiful fighting girls are, for the time being, particular to Japan. In addition to Sailor Moon, Japan has produced innumerable stories of little girls who fight. Actually, it would be more accurate to say that beautiful fighting girls appear in the majority of Japanese works of animation. It has become a virtual convention of the medium. The creators of anime seem to be conscious of this as well. As the critic and anime creator Okada Toshio put it when he made the hit OVA (original video animation) *Gunbuster* (*Toppu o nerae!* 1988), "All you need is a girl who goes to outer space and a giant robot."

What is strange, however, is that often the creators themselves don't seem to be entirely conscious of the uniqueness of this thing called the beautiful fighting girl. Why do anime heroines take up arms themselves and dedicate their adolescence to fighting battles? Why don't they let the brave heroes protect them, or be satisfied with a supporting role? Why don't they wait until they become mature women before they start acting like men? But what mystifies me the most is their ability to attain a certain reality.[1] The icon of the beautiful fighting girl, by rights a thoroughly fictional construct, nonetheless attains a paradoxical reality in the process of being desired and consumed. This is the biggest mystery that must be solved.

How is it in Europe and North America? Naturally, there are plenty of fighting heroines, in Hollywood films, for example. But there are

conspicuously few examples of fighting girls. Aside from a few recent exceptions, there is hardly a trace of such a thing in any genre. This is quite strange compared with the mass consumption of the beautiful fighting girl in Japan. What does this difference have to tell us?

France, of course, had the historical figure of Joan of Arc, the queen and ancestor of all fighting girls. Such a towering icon cannot be ignored. But she is not a fictional object of desire or mass consumption. She is, in the first place, a person who we are told actually existed. There are times when the actuality of a simple historical fact like this brings us farther from reality. But here I want to insist on the qualitative difference of fiction as an object of consumption.

We have already heard a great deal about the Japanese and their so-called Lolita complex.[2] First off, we are told that Japanese women are infantile. They love toys intended for children, and they speak in unnaturally high voices like little girls. Surrounded by these infantile women, men become infantilized as well. Japanese people in general are young in psychological terms, and their objects of sexual desire contain immature and polymorphously perverse elements. This explains the cross-dressing you find in Japanese theater. Japanese men are very repressed sexually, which is why they cower before mature women. They can safely desire only very young females, whom they can get to do what they want. . . . And so on. So what is so strange about the "fighting girls"? Aren't they precisely the very symbol of Japanese polymorphous perversion? These giggly girls with their huge vacant eyes and abnormally small mouths, dressed in lingerie-like armor and outfitted with grotesque laser guns, have no subjecthood whatever beyond their enormous breasts. This compact, convenient decoction of perverse desire is dressed in family-friendly packaging and exported all over the world as "culture." This is the real nature of Japanimation. Or so we are told.

It is entirely possible to resolve the questions posed by the beautiful fighting girl with explanations like these, but this approach amounts to little more than exhorting the Japanese to stop watching anime and grow up. This sort of sanctimonious preaching has a long history in Japan, going back to the work of "Isaiah Ben Dasan" and "Jan Denman," whose theories about "the Japanese" bear an eerie resemblance to recent theories of the otaku.[3] In the end, however, this sort of interpretation works only when we equate all Japanese with the otaku. But is that really possible?

Needless to say, bringing up the "Japanese Lolita complex" is the wrong answer. Ethical considerations aside, attributing a given perverse

tendency to an entire nation based on a mere impression is simply an unscientific fallacy. This type of arbitrary thinking has to be avoided from the outset. The same goes for the miserable business of repetitive theorizing about the uniqueness of the Japanese. The narcissistic deception involved in talking about oneself while using "the Japanese" as a pretext has been pointed out enough by now.

That being said, how should we go about examining this phenomenon of the beautiful fighting girl that is relatively and quantifiably predominant in Japanese society?

I base my analysis in chapter 3 on interactions with actual otaku, and my communications with anime fans outside Japan clarified their perspective on beautiful fighting girls for me. Some were of the opinion that beautiful fighting girls were a uniquely Japanese icon, while others maintained that there were plenty of examples of them in the West as well. One reason for this, I think, is that the exact definition of the beautiful fighting girl remains rather vague. However, at the very least I want to make clear that the icon of the beautiful fighting girl is neither originally nor uniquely Japanese. I emphasize this to reject in advance the too-easy assertion of Japanese exceptionalism.

With these conditions in mind I have been able to ascertain a few things relating to the "personality" of these fighting girls. In Europe and North America, whether they are "girls" or "women," the vast majority have butch personalities and lots of muscles—basically, they are "men in women's bodies" or female parodies of machismo. In most cases this sort of characterization is clearly a product of feminist politics.

The Japanese beautiful fighting girls are quite different in nature. As is clear in the case of Nausicaä or Sailor Moon, their pure and lovable girlishness remains intact (if not necessarily their virginity). This is the basis for the obvious differences in their reception from those of the West. Japan's beautiful fighting girls were originally icons with which their intended audience of young teenage girls could identify. Now, however, a group of consumers has emerged that far exceeds that one in scale—the otaku. The majority of male otaku, at least, see these girls as objects of sexuality.

A distinction must be made between these "Japanese-style" beautiful fighting girls and the "warrior women" of the West. Putting them in a psychoanalytic context will no doubt make this task easier.

One key concept used by psychoanalysis in the analysis of sexual perversion is that of the phallic mother. As its name indicates, it signifies "a mother with a penis." Sometimes the phrase is used more generally, to

refer to a "powerful female." In both cases the phallic mother symbolizes a feeling of omnipotence and perfection.

I use the term "phallic girls" to refer to the type of beautiful fighting girls that I provisionally called "Japanese-style" above. I have risked coining this neologism to highlight the unique nature of the lineage that stretches from Darger's little girls with penises to the beautiful fighting girls of Japanese anime. The following discussion employs this framework of the dual lineages of the phallic mother and the phallic girl.

Representations of beautiful fighting girls and phallic girls are understood here as objects (both causes and results) of sexual desire. After analyzing the otaku, the largest community of mass consumers of these images, I move on to a rough sketch of Henry Darger, whom I position as a sort of ancestor of the otaku. Next I provide a chronological catalog of concrete examples of phallic girls to confirm distinctions among them. Then the focus shifts to media theory, specifically the mode of existence and transformations of the space of fiction in the media. I introduce psychoanalytic concepts that provide evidence for my argument, particularly as it relates to sexual perversion. Media analysis depicts the establishment of the beautiful fighting girl image while also showing it to be an emergent process and suggesting a few hints about its future.

1 THE PSYCHOPATHOLOGY OF THE OTAKU

Given the topic of this book we cannot avoid a detailed inquiry into the nature of the otaku. They are, after all, the largest consumers of the beautiful fighting girls. What are the otaku thinking? What do they want and how do they get it? Are we right to speak of a "psychopathology of the otaku"? Or is that a bogus question? Or rather, don't we know the answer already?

Otaku are immature human beings who have grown up without being able to let go of infantile transitional objects such as anime and monsters. They avoid contact with reality for fear that it will harm them and instead take refuge in a world of fiction. They are afraid of adult relationships, particularly sexual relationships, and find sexual stimulation only in fictional constructs. In psychiatric terms they would be classified as "schizothymic."

These are a few of the most common stereotypical assumptions about otaku. Of course, being stereotypes does not mean they are necessarily incorrect. They may be accurate but still meaningless. These sorts of interpretations inevitably miss what is truly of interest about the otaku community.

The otaku are a strange and unique community that has come into existence as a result of the interactions between the modern media environment and the adolescent psyche in Japan. To my knowledge, however, sufficient thought has yet to be given to the otaku as a community. In this chapter I consider, sometimes from the perspective of a psychiatrist, and sometimes not, the psychopathology of the otaku.

Of course, when I say the "psychopathology of the otaku," this does not mean that being an otaku in and of itself is a pathological phenomenon. Like the "psychopathology of adolescence" or the "psychopathology of high-school girls," it is a provisional designation for the particular

psychic disposition that might be imagined to be prevalent in a given group. It is also a convenient way to avoid expressions like *psychology* or *psychic structure*. This may be difficult to understand, but to put it in the most rigorous terms possible, I would say that *psychopathology* as I am using it here refers to the intentionality of "that which mediates the subject." The problem, in other words, has to do with media.

I do not think that being an otaku in and of itself is a form of sickness, nor do I consider myself an otaku (otaku is not a self-designation in any case). It is from this standpoint that I propose to speak about the psychopathology of the otaku. This involves giving equal consideration to the degree to which the otaku community is well adapted and the degree to which it exhibits pathologies.

First, I want to say a few things about the particular challenges involved in speaking about the otaku. Otaku culture is by all accounts still in a state of immaturity (if one can expect "maturity" from it in the first place). Because it is still coming into being, one runs into fundamental difficulties in trying to view it in its entirety. For this reason, we have only a limited number of ways to discuss it. One way is to establish oneself as an otaku and speak as a complete insider, which is to say in a strategically uncritical manner (this is the stance taken by Okada Toshio). Alternatively, one can choose to take oneself out of the equation altogether and face the otaku with an attitude of revulsion and rejection. These two approaches may seem quite at odds, but in fact they are both versions of self-love and often amount to confessions of a kind of otakuphilia. When speaking of the otaku, it is crucial to begin by recognizing that these are the only two approaches currently available to us.

But I am trying for a third way. Namely, to become an "otaku of otaku," that is, an otaku whose love is directed toward otaku culture itself. This is not far from the kind of position that Okada advocates, although he calls himself an otaku of special effects and figurines. As for myself, I suppose I am a fan of special effects and monsters, although I have left my passion for Godzilla behind. (Not because I grew out of it but because Godzilla has regressed). I do not find any *moe* in most beautiful girl anime. I could not live without manga, but I hardly ever watch anime because I cannot stand the images and voice-overs. Even Miyazaki Hayao's anime come close to the limit of what I can stand in terms of anime images. Yet despite all that, I remain riveted by the activities of the otaku themselves. For better or for worse, since finishing graduate school, I have been fortunate enough to have several extremely serious otaku among my circle.

From an outsider's perspective I found their activities utterly fascinating. And while I was thrilled to be able to observe them from close-up, I cannot deny that I was also sometimes perplexed by what can only be called their immaturity as members of society. Despite this, I believe I was able to maintain friendly relations with them. They all happened to be psychiatrists, psychiatry being the profession with perhaps the highest proportion of otaku among its members. I spare the reader the details of the endless conversations among the members of a certain psychiatry department during the Evangelion boom of 1997.

So what kind of person am I? At the moment I don't have a good answer to this question. Psychoanalysis is after all premised on the impossibility of self-analysis (which is why analysts must undergo analysis themselves during their training). So allow me to refrain from useless navel-gazing and describe the contours of this unique community from a psychiatrist's perspective.

Theories of the Otaku

First we must begin with a definition of the otaku.

This definition is not all that exacting. It is a provisional description of the kind of person that this book calls an otaku. But if possible I hope it is a description that helps clarify the territory of the otaku community.

The word *otaku*, which has now spread around the globe, is remarkable for the variety of meanings it has. Let us first briefly review the all-too-famous process by which the term was coined and gained currency. As we do so, it is worth noting that the very fact that we are able to trace the word's roots with such precision is itself a reflection of the particularities of the contemporary media environment.

The writer Nakamori Akio first used the term in an article in the magazine *Manga burikko* in 1983 to refer derisively to anime fans because they used it as a second-person pronoun when speaking to each other.[1] The term was discriminatory but gradually gained a quiet foothold in the subculture industry. Incidentally, I myself first encountered the term in a 1985 article by Satō Katsuyuki in the magazine *Takarajima*.

But it was the serial murders of young girls by Miyazaki Tsutomu in 1989 that brought the word *otaku* into sudden prominence. As it spread, a number of variations also emerged, such as *otaku-zoku* (otaku "tribe") and *otakkii* (otaku-ish). In this way otaku evolved from a temporary buzzword into an everyday term.

Then came the 1990s. The word *otaku* was exported along with the growth of so-called Japanimation, eventually to take its place alongside *sushi* and *karaoke* as a borrowed term in Europe and the United States. A search on the Internet turns up nearly seventy thousand pages containing the word *otaku* in roman letters. Of course, most of these are the work of individual anime fans, but not all of them. Many universities, including elite ones like Harvard and MIT, have anime fan clubs, each with their own homepage. There are also Internet-based publications like *AM Plus* that post excellent critical articles. The term *otaku* has thus achieved a certain level of familiarity along with *anime*.

But despite its widespread diffusion, or perhaps because of it, the contours of the word *otaku* remain quite vague. Even now it is often used simply as a synonym for *maniac*. Since the Miyazaki incident it has acquired a very negative image of a gloomy (or dangerous) person who stays shut up at home and has trouble relating to other people. In this respect it seems that *otaku* has taken the place of the once popular word *nekura*.[2] You have, for example, a media phenomenon like "Taku Hachirō," apparently cooked up by the same Nakamori Akio who coined the term *otaku*.[3] Taku was also a maniac, but chose to exaggerate the negative side of the otaku for his own strategic purposes. It seems that the negatives have gradually come to dominate our image of the otaku. Image-wise one can perhaps distinguish between railroad and anime otaku who are the most positive and open, and those like the fans of a magazine like *Rajio raifu* (Radio life), who are the most closed and negative. But even among these there is a lot of overlap.

But before I can go any farther with my argument, there has to be some way to delineate the meaning of this hard-to-define word.

Nakamori, who originally came up with the term, seems to have had his own prejudicial stance toward the unique personality of the anime fan, but he never got around to providing a strict definition of otaku. Soon after the term was coined, then manga editor Ōtsuka Eiji called attention to its discriminatory nature and started a debate with Nakamori. The history of this debate and how they eventually reconciled their differences after the Miyazaki incident is a fascinating topic in itself. But I do not go into it here.

In any case, it is clear that making up the term was a stroke of genius. This single word contains everything about the phenomenon in concentrated form, from the essence to the surface. Its vagueness is merely the result of the polysemy characteristic of abstract concepts. In this sense it

is similar to "amae," the term Doi Takeo proposed as a way to understand the personality structure of Japanese people.[4] Both are ordinary household words that have been defamiliarized into neologisms. While they have a vagueness that eludes definition, they have also had a decisive impact on our language. This is why I do not believe that a perfect definition of the otaku is possible. But the abstractions and descriptions that I am going to attempt here do, I hope, go some way toward clarifying our picture of the otaku. This is all that I am aiming for.

The most active participant in the otaku field at the moment is Okada Toshio, known as the "Otaku King," who, not surprisingly, has his own explicit definition. In his book, *An Introduction to Otaku Studies*, Okada writes that the otaku are characterized by three essential traits:

An evolved visual sensibility

Advanced referencing ability

Indefatigable desire for self-improvement and self-assertion.[5]

According to Okada the term *otaku* was invented by science fiction fans who graduated from the elementary school affiliated with Keiō University. He also claims that the otaku population exploded after the release of the first videocassette recorders. In the beginning they used the term *otaku* because it was a way to avoid being rude to people one had just met. But now they hardly use it at all. In other words, the otaku themselves do not like the appellation *otaku*. Okada explains this as a result of their "excessive self-reflexivity (as opposed to self-appellation)" and their "extreme dislike of being categorized by other people."

Otaku, according to Okada, tend to cross genre boundaries, which distinguishes them from "maniacs," who concentrate on a single genre. In other words, they are not simply anime fans. Their interests straddle multiple areas, such as special effects, film, and comics.

To be a true otaku, Okada continues, one has to have three kinds of visual acuity, which he calls "the eye of the aesthete," "the eye of the master," and "the eye of the connoisseur."[6]

But while these would certainly qualify one as an otaku, they are not all necessary conditions. While they might describe an "otaku elite," they certainly do not encompass all otaku. My interest here is in determining whether there are certain necessary requirements for otaku status, and if so, what those requirements might be.

It is interesting to note that one can recognize oneself as an otaku only after one has somehow moved on or deviated from an otaku identity.

Okada may be the Otaku King, but as the king he occupies a slightly different position from the run-of-the-mill otaku. At times he takes on the role of "spokesman for the Land of Otaku." But by doing so he is already misrepresenting the supposedly self-enclosed nature of otaku culture. It would seem that the act of recognizing oneself as an otaku may be linked to some sort of deviation from otaku identity.

Perhaps this connection between self-recognition and deviation has something to do with the difficulty we are having in defining the otaku. Okada's work is fascinating as a kind of report from the front lines of otaku culture. And, being rare, it also has great documentary value. But unfortunately Okada has not managed to step very far outside the otaku perspective. His refusal to acknowledge the pathological side of otaku behavior is surely strategic on his part, but it does often give a rather one-sided impression. He does not, for example, deal sufficiently with the question of sexuality that lies at the core of the otaku. Actually Okada is not alone in this. Most theories of otaku have tended to avoid the question of sexuality.

Ōtsuka Eiji, who developed an all-out defense of the otaku after the Miyazaki incident, includes the following fascinating survey results in his *Critique of Virtual Reality:*

> Otaku have more friends of the opposite sex than most people. And more friends in general. They are sociable people.
> Otaku tend to have money. Many engineers and doctors are otaku.
> Otaku spend a high proportion of their income on entertainment.
> Otaku watch very little television.
> Otaku have a lot of hobbies.
> Otaku dislike the word "daraku" (degeneracy).[7]

Of course, there is no doubt some pro-otaku bias in these results. But they are also counterintuitive in interesting ways. Rather than attempt a clumsy definition of concepts like otaku a priori, it is often more meaningful to form a loose image on the level of the phenomena themselves.

Otaku are usually thought to be male, but one theory has it that fully 70 percent of the participants in the Comic Market (Komiketto; a regularly held comic market that attracts tens of thousands of fans who come to buy fan magazines [dōjinshi] relating to anime and comics) are female. Not all of them are necessarily otaku, but these are numbers that cannot be ignored.

Psychiatrists tend to think that people with schizothymic personality types tend to become otaku, and there are not a few cases that fit this description. But we cannot generalize from this either. The otaku king Okada has the body type of a cyclothymic personality (sociable and likable with a tendency toward manic-depressive mood disturbances, said to be common among obese individuals). Okada himself has published essays and diary entries about his manic-depressive mood swings. Even Taku Hachirō, in my opinion, would not be diagnosed as schizothymic. But I stop there.

The sociologist Ōsawa Masachi, in "On Otaku" ("Otaku ron"), provides the most rigorous definition I have found.[8] By abstracting as far as possible the phenomenon of otaku, he came up with this: "In the case of the otaku, the two types of other that determine identity, the transcendental other and the internal other, are almost indistinguishable."

He then goes on to translate these into psychoanalytic terms as "the approximation of the ego ideal and the ideal ego." Let me provide a bit of interpretation here. The ego ideal is brought into existence through the transcendental other. This is the self one wants to be. It is the self-image created through social value systems, the self that wants to get into a good university and land an intellectually stimulating and high-paying job. The ideal ego, on the other hand, is formed through the agency of the internal other. This is the narcissistic self-image that sets aside society's opinion for the moment and thinks, "It's wonderful to be me" and "If I were reincarnated I would want to be me again."

My only problem with Ōsawa's definition is that, as a psychiatrist, the phrase "the transcendental other and the internal other are almost indistinguishable" calls to mind not an otaku but a person who is mentally ill. According to this definition, the psychopathology of the otaku is a far too serious matter. As a result the term *otaku*, which ought to be able to cover everything from pathological phenomena to normal matters of taste, becomes far too narrow in its application.

And yet Ōsawa's perspective does provide us with a new approach to the otaku. It is significant in that it suggests a possible analytic interpretation of the otaku. Of course, there are also conflicting interpretations. As I discuss later, there is no difference between our psychic structure and that of the otaku: we are all no less neurotics than they are.[9] If the approximation of the ego ideal to the ideal ego has a certain validity as a metaphor, it is unquestionably inaccurate in psychoanalytic terms. At

the same time, Ōsawa's phrasing runs the risk of appearing to privilege the transcendent over interiority and the ego ideal over the ideal ego. The end result of that can only be to reinforce the same old calls for otaku just to "accept reality and grow up" and "acknowledge the gap between the real and the ideal."

I cannot accept Ōsawa's definition as is, but I can adapt it for my purposes. This relates to the question of "what mediates the subject" that I touched on earlier. Notions like growth and maturity, for example, can themselves be considered as instances of this sort of subject mediator. The ideal ego, then, is converted into the ego ideal and stabilized through the subject mediator of growth. If there is a difference between us and the otaku, it might well have to do with a difference in this process of mediation.

A faithful adaptation of Ōsawa's point would lead us to conclude that in the case of the otaku this mediation is rather weak. Because of this weakness, the ideal ego does not undergo sufficient conversion and stabilization into the ego ideal. As a result, the two appear to be very close. But is this really the case?

I don't think so. First of all, discussing this mediating function in terms of strength and weakness is too simple a solution and lends itself all too easily to the kind of moralizing I mentioned above. We have to take a very large detour before we can define this difference in the mediating function. So, having raised the issue, I leave it to one side for now, noting only that this emphasis on the mediating function foreshadows our later discussion of media theory.

Otaku and Maniacs

Now that we have made clear the limitations, and even the absurdity in some cases, of trying to understand otaku in terms of personality type, we can nonetheless abstract a few characteristics of the otaku. An otaku is

a person with a strong affinity for fictional contexts.
a person who makes use of fictionalization as a way to "possess" the object of his or her love.
a person who inhabits not just two but multiple orientations.
a person capable of finding sexual objects in fiction itself.

Before I try to explain each of these in turn, there are a few points I need to clarify. First, I defer all value judgments about otaku. Problems

of adaptation such as "fleeing from reality," "taking refuge in fiction," and "lacking common sense" may seem easy to spot in otaku, but they are not essential aspects. When value judgments become mixed up in the description they only create more confusion. If my descriptions are to be of any use at all, it will be because they are free of value judgments.

When describing a given type, it is often easier to grasp if one compares it with another very similar type. The closest type to the otaku is surely the maniac.

Although they are still often confused with each other, the otaku and the maniac are clearly different in subtle but important ways. If the two were in fact synonymous, there would be no point in theorizing the meaning for us today of the "psychopathology of the otaku." This is because the maniac is a universal type, while the otaku is historically specific. Understood as a kind of fetishism, mania has a history that may stretch back to the beginning of civilization.

Even if there are many areas of overlap, let us begin by discussing the differences between the two. To state my conclusion partly at the outset, I believe that today's otaku derive from a group of maniacs who have reacted to the changes in the media environment by a proliferating set of adaptations. Just as the marsupials on the Australian continent mimicked the specialization of the mammals as a whole, the otaku mimicked the specialization of the class of maniacs within the isolation of the media environment.

The difference between these two communities is made clear through the kinds of objects to which they become attached. The following is a provisional list of the types of object each group might choose.

Otaku Objects:
Anime, video games (mostly so-called girl games),[10] young-adult novels, voice actor idols, special effects, C-class idols, fan magazines (dōjinshi), yaoi (see note 19), fighting girls.

Potential Crossover Objects:
Trains, personal computers, film, manga, B-class idols, science fiction, American comics, the occult, amateur radio, police dramas, plastic models, figurines.

Maniac Objects:
Philately, bibliomania, audio, cameras, astronomy, bird-watching, insect collecting, all forms of music, and all other forms of collecting.

These classifications are based on my personal impressions rather than any empirical data. So there may well be many exceptions and disagreements. If I were asked whether collectors of "anime figurines" (see chapter 2, note 1) were otaku or maniacs, for example, I would be hard-pressed to come up with a satisfying answer. But I do still believe these classifications accurately reflect the tendencies of each group. And they provide the starting point for the discussion of the difference between the otaku and the maniac that follows.

What strikes us most about these objects is what I call the "difference in level of fictional context." Here we might think of the "fictional" as an abstraction of reality on the basis of some sort of bias. Of course, it is more complicated than that, but let us assume it is the case for now.

On the basis of this assumption, then, we can rank objects according to "degree of fictionality." Documentaries based on interviews and primary sources, for example, would have a low level of fictionality. Through techniques such as citation and parody, "fiction" itself can be limitlessly abstracted and further fictionalized. Thus metafiction can be understood as having a higher level of fictionality than fiction. To put it a different way, the more forms of media that mediate the original information, the higher the level of fictionality. This is what we call the "difference in the level of fictional context."

The term *context* here, following the work of Gregory Bateson and Edward T. Hall,[11] is used in the general sense of the term, as that which determines the meaning of a given stimulus. It is important to keep in mind here that we cannot assume a straightforward ratio whereby the higher the level of "fictional context" is, the higher the level of fictionality will be. I return to this point again later.

The term *maniac* referred originally to the kind of person who is obsessed with something that yields no practical advantage. But compared with the otaku, the objects of maniacs can look quite concrete (not practical perhaps, but concrete). Looking back at the list of objects, we can see that those preferred by maniacs, such as audio equipment, stamps, antiques, and insect collections, are certainly for amusement and serve no practical function. But compared with those of the otaku, the objects of the maniac do have a concrete materiality. By concrete materiality I mean simply that one can pick them up in one's hands and that they can be measured.

Generally speaking, maniacs compete with each other in terms of how effectively their hobbies translate into materiality. Collectors pride themselves on the size of their collections. And of course, this involves

speculations about their value and rarity. Audio maniacs want faithful playback of sound with as little noise as possible. For insect collectors, it is not enough merely to know about rare bugs; their reputations as collectors depend on actually owning specimens of them. The unspoken rule of a naive "orientation toward material objects" is still very much in force here.

Otaku are lacking in this orientation toward the material and the practical. They know that the objects of their attachment have no material reality, that their vast knowledge has no use for other people in the world, and that this useless knowledge may even (especially after the Miyazaki Tsutomu incident) be viewed with contempt and suspicion. And knowing all of that, they still enjoy the game of performing for each other their passion. The expression, "having a strong affinity for fictional contexts" is meant to clarify this sort of difference.

I just used the expression "performing their passion," which requires a bit more explanation. The passion of the otaku is more performative than that of the maniac. Otaku are in communication with other otaku through the code of "passion." They are certainly not cool or disinterested, but neither do they completely lose themselves when indulging in their passion. This sort of slightly "canted stance toward passion" is very closely related to the essence of the otaku's "affinity for fictional constructs." Later we will see how perfectly the expression "X-*moe*" describes this.

Of course, we should consider the possibility that this has to do with how otaku deal with the society around them. Most of the objects to which otaku find themselves attracted are "embarrassing" in one way or another. They can be very easily ridiculed for their infatuation with anime at an age when most people have moved on. As a defense against this, it is perhaps inevitable that they might want to give the appearance to others that they are "only pretending to be obsessed."

If we were to borrow a Benjaminian metaphor for what I have said so far, we could say that maniacs are enchanted by the aura of the original object, while the otaku fashion an original aura for their (fictional) reproductions.[12]

The Problem of Possession

The next characteristic of the otaku is the way they go about possessing the objects of their attachment. We know that they enjoy animation. And they like special effects. But unlike stamps or audio systems, these

are hard to collect. The fact is, moreover, that not all otaku are collectors in the first place. One might assume that anime fans are all interested in collecting actual cels from their favorite shows, but in fact this is surprisingly rare. Of course, such otaku do exist in fairly significant numbers, but this is not a necessary qualification for otaku identity. Part of this has to do with the fact that cels are not necessarily the material object-form of an anime. This may sound paradoxical, but cels are actually more like a by-product of an anime and occupy the same position as spin-off merchandise. So even if you owned every cel of an anime, this would not mean that you owned the anime itself. So how do the otaku make their objects their own?

Simply put, they do so through fictionalization.

What otaku enjoy is not making fiction into material form. Nor, as is often claimed, do they derive enjoyment from confusing reality and fiction. Their goal is simply to take fictions that are out there and promote them to fictions that are theirs alone. It is no coincidence that otaku like parodies. It may be that cosplay *(kosupure)* and fan magazines are best understood as examples of this process of fictionalization.[13] Popular anime always attract so-called SS ("short" or "side" story) writers, who borrow the setting and characters from these works, write novels and scenarios in different versions, and then upload them to online forums. What is the motivation behind this form of expression that does not earn them a penny? Is it self-promotion? A service to other fans? If it were just that, surely parody or criticism would be more effective. I believe that "SS" is precisely how otaku manage to possess these works. They let the work "possess" them, weave a different story out of the same materials, and share it with the community. This process is a kind of "ritual of possession" practiced within the otaku community.

Even if they are not that serious, otaku are generally critics. All otaku have something that should probably be called a critical drive, including even cases like Miyazaki Tsutomu. In fact, a fan who has forgotten his or her critical perspective is not an otaku. Otaku feel compelled to talk endlessly about a work and its creator. Their talk does not stop at the work itself but also extends to include their own relationship to it. When otaku engage in critique, their passion also merges with their enthusiasm for possession through the creation of new fictions. To put it very dramatically, the only way that otaku have of acquiring the objects they love is by fictionalizing them and turning them into their own works. This inevitably leads to the creation of new fictional contexts.

It was not his extraordinary intelligence or the accuracy of his information that made possible Okada Toshio's status as the Otaku King. More than anything it was his production of a legendary animated film called *Royal Space Force: The Wings of Honneamise* (*Ōritsu uchūgun: Oneamisu no tsubasa*, 1987) as a rank amateur. He was also involved in producing that masterpiece of the OVA, *Gunbuster (Toppu o nerae!)*. The careful and deliberate way in which he marketed these anime drew from his own experiences as an otaku and was itself a brilliant form of critique. The otaku business is one of those rare fields in which superb critical acumen can translate directly into highly creative work. If Okada is respected among otaku, it is because of his astounding ability to create fictions. For otaku, the kind of accuracy of information required by maniacs is nice, but not essential. And the fact is that Okada sometimes gets things wrong because of his own preoccupations. But this is tolerated as an aspect of his idiosyncratic style. This is a context in which even a mistake can be forgivable as long as it provides interesting fodder for fictionalization.

What Is Fiction?

The concept of fiction as I have been using it thus far is also probably in need of some elucidation. As I mentioned earlier, a high level of fictional context does not necessarily imply a high level of fictionality. One can easily imagine a paradoxical situation in which an autobiography overflowing with empty rhetorical flourishes might seem less realistic than a piece of honest metafiction. But the problem is more complex even than that. It may be, for example, that the rhetorical flourishes of that autobiography actually say something very real about the desires of its author.

There is really no objective set of standards to measure the fictionality of a given work. This is why I have introduced the neutral concept of the "fictional context." As I explained earlier, this is an "imaginary concept" determined by the number of forms of media necessary to mediate the creation of a work. I insist on the term *imaginary* for the following reason. We are not actually able to count the number of types of media involved. Only the recipient has the right to determine what is citation and what is parody. If a given citation is to be interpreted as the original, the fictional context for the recipient will be low. This involvement of the receiver's subjective viewpoint makes things even more complicated.

Of course, it is easy to understand fictionality as long as one does not insist on too much rigor in the definition. One could simply say

something along the lines of "what seems like a lie is fiction and what seems real is the thing itself." Faced with such a clear statement, the rigorous examination of fictionality seems like a meaningless detour. But is it really? Let's take a closer look. The statement "what seems like a lie is fiction and what seems real is the thing itself" is nothing more than a tautology. It is true enough, but it means nothing.

The discussion gets confusing because of the intervention of the adjective "real" (riaru). "Fictional" and "real" are not opposites. If they were, an expression like "real fiction" (riaru na kyokō) would be meaningless. Instead, it is fiction and reality that are opposites, which leaves us with the problem of how to define reality.

What is reality? A raw, unmediated experience? Is that what reality is? Since the Aum Shinrikyō incident this kind of simplistic equation no longer holds. Raw, real experiences are the most deceptive of all. The mystical experiences and altered states of consciousness that Aum members experienced during their training have made us all too aware of the fundamental fallacy in the idea that "actual experiences" equal reality. So we ask again: What is reality?

Indeed, it should go without saying that reality is itself a form of fiction. At least the word reality as we use it in general refers to the fiction that is "the everyday world we live in." It is the fiction that is shared most widely. Some people might attach conditions to their belief in it, but our degree of adaptation to society is judged according to whether or not we have accepted it. In this sense it is perhaps the most powerful of all fictions.

Psychoanalysis teaches us that we can never touch reality in its raw form. "Reality" is another name for the impossible, at least for Lacan. Let us review Lacan's triad: the Real, the Symbolic, the Imaginary. These constitute a topological division of the human psyche, where, in my understanding, the emphasis falls on how people experience things. The Real, as I just mentioned, is "the realm of the impossible": a parodoxical realm that exists because it is impossible to experience. The Symbolic is for the most part synonymous with the system of language. It is external to the subject and referred to as the "Other." That language is other to us means that it is a transcendental entity positioned outside the subject. When we speak we experience its existence, but we cannot be completely conscious of that experience itself. The Imaginary is the realm of images and representations, and also of narcissism, since it is located inside the subject.[14] It is here that "meaning" and "experiences" are possible.

What does it mean for us to experience "fiction"? Experience, we have seen, becomes possible in the Imaginary. Whenever we have a conscious experience of anything, that experience happens in the Imaginary. In this sense there can be no essential distinction between "everyday reality" and "fiction."[15]

So how is it that we are able to recognize "everyday reality"? Is it because the Symbolic and the Real have a greater share in it? Could we say that this "everyday world" we inhabit is the fiction that is closest to the Symbolic? If that were the case, it would be possible to determine that for otaku "imaginary fictions dominate the symbolic ones."

But, needless to say, that would be a mistake. It is a misreading of Lacan to suggest that one can grasp the Symbolic through the Imaginary. But this misreading is everywhere. Hiroki Azuma, for example, has claimed that in today's society "the Symbolic has stopped functioning." He points to the deterioration of popular song lyrics as an example.[16]

This is an interesting argument in itself, but it is based on the same misunderstanding.

Lacan's tripartite model would be just a tool for meaningless speculation if we did not accept its universality. And psychoanalysis would be impossible without the assumption that we are and always will be "neurotics" from the moment that we attain language. And as long as we are neurotics, this tripartite division of the world, or at least the topological relations among its parts, will hold.

Let me make my own position clear. From this point on I will keep the focus on the interactions between media and the Imaginary, and I will not postulate any transformations or shifts in the Symbolic or the Real. This means that otaku can be discussed only in imaginary terms. In other words, we can postulate no structural difference between the non-otaku subject and the otaku subject, because both are neurotics and both stand in the same relation to the Symbolic. Therefore we can now reject completely the claim made by Ōsawa quoted above. Similarly, it is impossible to identify anything psychoanalytically unique about the otaku as a community. In fact, it is not uncommon to find certain pathologies among those who insist on the uniqueness of the otaku. I have abandoned the attempt to speak of the psychopathology of the otaku in structural terms. Instead, I will stick with descriptions on the level of the Imaginary. This is unavoidable as long as psychoanalysis is my primary method.

I never answered the question I posed earlier: How is it that we experience "everyday reality"? Distinguishing it from fiction is always a function

of the Imaginary. In concrete terms, this has to do with our image of the degree to which experiences are mediated. Fiction can arise only out of the consciousness—and not the "fact"—that this experience is a mediated one.[17]

Thus the media have no other function vis-à-vis experience than to provide this kind of consciousness of being mediated. Or to put it the other way around, "everyday reality" is nothing more than a set of experiences that emerge from a consciousness of not being mediated. This difference between a consciousness of being and not being mediated, moreover, is only an imaginary one. Let me emphasize this once more. For us neurotics "everyday reality" has no essential privilege. This is also evident from the fact that patients suffering from dissociative disorder (a neurotic pathology) experience everyday reality as if it were fiction.[18]

Otaku and Fiction

People who have an otaku mentality, with a high affinity for fiction, are likely to have a latent discomfort with reality whether or not they have actually been able to adapt to it. But this is not a serious issue; for them, it is more on the scale of, "Everyday reality is a drag!" At the very least we can say that this refusal to adapt does not lead in any simple way to the flight from reality and thence to refuge in a fictional world.

Hard-core otaku have their own unique stance toward fiction and are able to enjoy anime, for example, on multiple levels. To put this in the terms I used earlier, they are able to switch freely between levels of fictional context. As I mentioned earlier, they see reality as a kind of fiction. Since this means they do not necessarily privilege reality, it can easily be mistaken for an avoidance of reality. So while otaku do not in any way "confuse fiction with reality," they are uninterested in setting fiction and reality up against each other. If anything they are able to find reality *(riariti)* equally in both fiction and reality *(genjitsu)*.

In fact, otaku discover a multilayered reality *(riariti)* even in the fictionality of fiction. They see and enjoy reality *(riariti)* in terms of every standard by which fiction can be judged, including not just the quality of anime characters but also the script and character design, visual direction, marketing, criticism, and particular points of appreciation. This is the otaku's special ability. When this is developed sufficiently, it becomes the three abilities that Okada describes as the "eye of the aesthete," the "eye of the master," and the "eye of the connoisseur." Otaku do not just command a great deal of information, they must also be able to identify

instantaneously these different standards of fictionality and shift to the appropriate level on which to appreciate them. This means not just falling in love and losing oneself in the world of a single work, but somehow staying sober while still indulging one's feverish enthusiasm.

Total immersion in the world of the work on the object level has nothing to do with the essence of the otaku. Stephen King's novel *Misery*, which was also made into a film, depicts a fan like this. She is in love with a certain series of novels and cannot tolerate its ending in a way that she does not like. So she makes the author a prisoner in her home and threatens him so that he will write the ending she wants. If such a woman actually existed, I would be happy to award *her* with the prize for confusing fiction and reality. But otaku try to stay as far away as possible from this kind of violence and crazed enthusiasm.

What would an otaku do if a story he liked ended badly? In fact, we have an excellent example of just such a case. *Neon Genesis Evangelion (Shin seiki Evangerion)*, which I discuss in more detail later) created a whole social phenomenon as a result of its ending. Until the last half of the series it was a giant robot anime of unprecedented sophistication. But the problem came with the last episode, when the protagonist suddenly started to talk at great length about his own inner struggles, leading to an ending in which he experienced inner salvation. Most of the fans were furious with this ending.

But did they criticize the creator Anno Hideaki directly? Of course, there were many who did. But at the same time huge numbers of fans began to write their own "Eva" stories. And this was certainly the proper otaku response. They did not see the author as absolute. They were not just fans, but connoisseurs, critics, and authors themselves. This blurring of the distinction between producer and consumer is another characteristic of the otaku. In that sense, if we limit the discussion to how they relate to fiction, Ōsawa's point is right after all. For otaku the place that is supposed to be taken by the transcendent author is extremely close to his or her own internal other.

Multiple Orientation

"Double orientation" is a psychiatric term. It refers to a phenomenon we see in patients suffering from schizophrenia and other mental illnesses who talk of delusional beliefs like being the mayor of Tokyo or being a billionaire, even as they help clean their hospital ward under their nurse's directions. No matter how severe the delusion, most patients are able to

distinguish between the delusional standpoint and their own. The understanding of one's own position is called "orientation," so these patients are said to have "double orientation." As we have seen thus far, otaku are capable of jumping freely between multiple fictional contexts and easily moving back and forth between the role of receiver and creator. So we could say, metaphorically, that otaku have the capacity not for double but for multiple orientation.

Kōkami Shōji has claimed that the objects of otaku are limited to "domestic products with traceable roots." This is a keen insight worthy of Kōkami, but not one without problems. He does not explain why otaku prefer domestic products. But this can probably be explained by the otaku's multiple orientation.

As I discuss later, there are no Disney otaku to speak of. Of course, this has something to do with sexuality, but another reason is that orientation is difficult with works of foreign origin. The reasons for this include the classic mode of reception that underlies Disney's works, an animation production process different from the Japanese one, and the biggest wall of all: the notion that Disney products have a certain materiality. This materiality stems from multiple sources: Disney's long and storied history, its merchandise, strict copyright protection, and, perhaps most of all, the existence of Disneyland. Yes, Disney is "reality." And then there is the fact that everyone knows that men past puberty are not supposed to visit Tokyo Disneyland unless they are on a date. The typical otaku is not likely to make it past this hurdle.

The overall image is hard enough to take, but when faced with the difficulties of actually gaining entrance to the Magic Kingdom, the otaku's orientation goes numb. Otaku function at a high level only when they are able to engage their skills at multiple orientation and discuss fictions with a view to the totality. Looking back at the list above, one can see that compared with the maniac objects, objects whose production process is relatively transparent and accessible are what capture the otaku psyche. Compared with this, Tokyo Disneyland, where one can neither see the creators nor glimpse what goes on backstage, is just as likely to paralyze an otaku's orientation as "everyday reality" itself.

The Psychopathology of the Otaku

Of course, the otaku do exist in reality, and it is important to recognize that. The Comic Market, which I mentioned earlier, for example, is a space

in which the logic of the otaku predominates over "everyday reality." But one cannot say it is not reality. It is a world in which fan magazines produced by serious otaku can generate revenues in the millions of yen. It is, in other words, a space in which the ability to produce enjoyable fictions is privileged above all else. And there we see on display only a small portion of the otaku's ability to modify reality. Their ability to see reality as a kind of fiction is certainly a strength. The elite of the otaku are capable of changing reality to fit their tastes, just as Bill Gates and Michael Jackson did.

But while multiple orientation has the advantage of allowing people to shift perspectives flexibly, it also has a sort of pathological limitation. The more accurately the otaku shifts from one perspective to another, the more the framework of the experience as a whole cannot help but shift toward the fictional. And when multiple orientations are given equal weight, we lose the singularity that is the essential quality of reality. This is probably why otaku often complain of dissociative episodes and seem lost in the ordinary world. Thus multiple orientation can sometimes be viewed as an escape from reality. Yet even the expression "escape from reality" may be only a provisional one.

What provides the impetus for people to become otaku? To an outside observer it may appear to be caused by an episode of adaptational failure of some sort. But is it not possible for someone to become an otaku without that sort of trauma? Could it be that the more fundamental cause that makes people into otaku is to be found in the excessive immersion in the multiple orientations that we have been discussing? If so, why is it that otaku engage in this kind of immersion?

I believe that this is where sexuality comes to have a very close relationship to all of this. We must recognize the fictionality and multilayered quality of sexuality. When people are sexually excited by the image of a woman in an anime, they may be taken aback at first, but they are already infected by the otaku bug. This is the crucial dividing point. How is it possible for a drawing of a woman to become a sexual object?

"What is it about this impossible object, this woman that I cannot even touch, that could possibly attract me?" This sort of question reverberates in the back of the otaku's mind. A kind of analytic perspective on his or her own sexuality yields not an answer to this question but a determination of the fictionality and the communal nature of sex itself. "Sex" is broken down within the framework of fiction and then put back together again. In this respect one could say that the otaku undergoes

hystericization: the otaku's acts of narrative take the form of eternally unanswerable questions posed toward his or her own sexuality. And the narratives of hysterics cannot help but induce from us all manner of interpretations. This is of course what has led me to the present analysis.

The Problem of Sexuality

Otaku are most otaku-like in their sex lives. Anyone whose sexual life is partly or wholly maintained in the aesthetic realm can be considered an otaku. For maniacs the situation is different. There may be moments in which they feel some sort of erotic attraction to their objects (such as cars or antiques). But their sex life (including masturbation) most likely revolves around objects with greater reality (such as the physicality of women). In any case, it is hard to imagine that the objects they collect bring them any direct sexual arousal. And this has to do with the pronounced materiality of those objects.

One of the essential characteristics of the otaku is their affinity for fictional contexts. Their fundamental desire is oriented by a sensibility able to appreciate the paradoxical idea that there is "reality in being fictional." The proof of this is that they love and genuinely desire the beautiful fighting girl, an utterly fictional being. Of course, being fictional is not the only requirement for the otaku's love. There are many exceptions, a major one being Disney animation that I just touched on. A young friend who is very knowledgeable about the otaku world tells me that there are no Disney otaku. This is probably not by chance, but because it would be impossible in principle for one to exist.

Sexuality is the defining issue when it comes to otaku. It is hard to imagine a Disney maniac feeling direct sexual desire for a character like Minnie Mouse or Pocahontas. Of course Disney also intentionally excludes representations of sexuality. And they do so with remarkable thoroughness. It is not a question here of an awkward avoidance of anything with the slightest whiff of sexuality. They know very well that so thorough an exclusion would only highlight it more.

The reception of *Nausicaä of the Valley of the Wind* (*Kaze no tani no Naushika*) provides a good example of the way sexuality can be read into a work independent of the creator's intention. Miyazaki Hayao's work does not completely exclude sexuality, but he does have quite an ascetic approach to it. Yet, as if to betray his intentions, *Nausicaä* still stimulates otaku sexuality.

How does this work with Disney? In *Toy Story,* for example, there is a scene in which Bo Peep seduces Woody the Cowboy. So sexuality is not excluded entirely. But what is important is that the acts themselves are seamlessly formalized and fictionalized until there is no room for real *(riaru na)* sexuality to intervene. It is an arid sort of sex only possible in a world of toys drawn entirely with computer graphics. In this way Disney's creations manage to avoid completely the danger of being consumed as sexual objects.

The naive horror people feel toward the otaku is strongest when it comes to their sexuality. Male otaku can hardly escape the stigma of the "Lolita complex." And it is hard to ignore the perversion of those female otaku who enjoy "yaoi"[19] and "shōtakon."[20] Hatred directed toward their sexuality has greatly biased our view of otaku.

It is easy to find fault with the perversion of otaku and to write them off because of it. Accuse them of having a taste for "rorikon" or "meka-fechi,"[21] and nothing more needs to be said. But the problem comes after that. Even if they are aficionados of *rorikon* and *mekafechi,* it is extremely rare for them to act these fetishes out in real life. The fact that, in the thirty-year history of otaku, Miyazaki Tsutomu was virtually the only one to cross that line says something about the distance between the otaku's sexual tastes and their actual sexual practices.

In recent years the term *moe* has emerged among the otaku. The young friend I mentioned before tells me that, "as the character Tomoë Hotaru from *Sailor Moon* became popular, fans who said they had the 'hots' for her *(Hotaru ni moe moe)* would substitute the second character of her family name (meaning 'bud') for the homophonous '*moe*' in that expression (meaning 'burn'). Eventually people started using the expression 'XX-*moe*' to mean that they were really into a character."[22]

The emergence of a term like this tells us something about the unique internal dynamics of the otaku community. It was here that I first became aware of the essential problem of otaku sexuality. They turn even their own sexuality into an aesthetic performance. Saying that one is a *moe* of a character is a way to comically objectify the self that experiences this attraction. Why is it that they put this kind of distance between themselves and their own sexuality?

Otaku do not necessarily consider characters sacred. One of the main genres of fan magazines sold at the Comic Market is called *jūhakkin mono,* or "over eighteens." These are pornographic parodies of famous anime characters, and they sell very well. For the most part otaku are very

tolerant of this kind of genre. There are sometimes fans whose idolization of characters has gone so far that they feel offended by these magazines .(see chapter 2). But this kind of "slobbering" fan is not behaving much like an otaku. In fact, the genuine otaku keeps a distance from fans like this. Being an otaku means being able to keep one's idolization of a character neatly within the boundaries of aesthetic performance. In otaku society, fans like this, who confuse fiction and reality, are considered heretical, if not perverted.

At the beginning of this chapter I wrote that the otaku lifestyle emerged as a result of the interactions between the modern media environment and adolescent psychology. Life as an otaku begins with adolescence; there are no otaku children. This is not because it is normal for children to like anime. It is because being an otaku requires the secondary sexual characteristics that emerge only with puberty. If the issue were simply one of liking anime past the age when it is normal to do so, there would not be a lot to talk about. If you want to find a "problem," you have to start by asking why full-grown individuals take girls in anime as sexual objects.

To put it very crudely, what distinguishes an otaku from a non-otaku is whether he is able to "get release" with an anime character. For those of you who are still not sure what I am saying, let me make it perfectly clear. I am saying that you can tell an otaku by whether he is able to use the image of a female anime character as an aid to masturbation.

Now, does the act of "getting release with anime" entail a level of reality that warrants calling the otaku sexual perverts?

Herein lies a crucial question that many people have missed: Why is it that otaku are not perverts in "reality"? As far as I know, in real life otaku tend to choose perfectly respectable members of the opposite sex as their partners. My personal impression is that marriage to another otaku of the opposite sex tends to be seen as the perfect ending to life as an otaku. For this reason I believe the otaku are characterized by a decisive gap between perverse tendencies in the imagination and "healthy" sexuality in daily life. (This is another way in which Miyazaki Tsutomu was entirely exceptional.) There are very few homosexuals among otaku, and even fewer who have an actual Lolita complex. Nor is this a question of idolizing anime characters and making do with real women as substitutes in their everyday life. Here, as in other contexts, the otaku very nimbly shift their "orientation of desire."

An examination of "otaku desire" provides some fascinating materials for tracing how imaginary forms of sexuality are transformed. No matter

how much otaku may appear to be pedophiles, we cannot simply write them off as sexual perverts. The problem of otaku desire has to be considered first in relation to "fictional context." Let us not forget that even as otaku adore images of beautiful young girls, they maintain quiet everyday lives as ordinary heterosexuals. The "Lolita complex" of the otaku is just an alibi for sexual perversion, or a method of fictionalizing sex. But why, then, do they typically choose "fighting girls" as their objects?

The image of the beautiful fighting girl contains every conceivable sexual perversion. It is easy to identify traces in it of homosexuality (the girl with a phallus), pedophilia, sadism, masochism, and fetishism. It is very nearly an image of polymorphous perversion itself. Much like fans of *yaoi*, otaku cannot resist the temptation to fiddle with fictional sexuality—reversing, recombining, and otherwise reshaping it into endless variations. In this sense, the beautiful fighting girl is a remarkable invention of otaku bricolage. Her universality as an icon is a demonstrable fact. She has propagated herself all over the world through the Internet, and the seeds of a new generation are sprouting everywhere.

Yet otaku sexuality is multilayered and complex, which makes it difficult to discuss in the same way one would fetishism or pedophilia. That complexity also has a lot to do with the emergence of the phallic girl. What is important is that the otaku be able to secure their own sexuality within the field of the imaginary and allow it to function. There sexual perversion is not a problem in the least. In the imaginary realm all human beings have the right to be perverts.

For now I leave my analysis of otaku desire at that. Many of the issues I have discussed here are developed in more general terms in the final chapter, "The Emergence of the Phallic Girls."

2 LETTER FROM AN OTAKU

As I have been emphasizing, no discussion of the psychopathology of the otaku can ignore the question of their sexuality. Western anime fans are proud to point out that, while they might like anime, they also have actual girlfriends in real life, but this is not a major concern for Japanese otaku. Although finding a companion of the opposite sex may be a requirement for otaku who wish to speak out in the culture, it is not necessarily that important for those who just want to be regular otaku.

On anime fan forums one often finds discussions about which characters the fans get off on. For these fans, anime images serve as masturbation aids, or so-called *onapetto* ("onanistic pets"), which brings to mind the remarkable changes that have taken place in recent years in the design of pornographic comics. This genre has now been completely taken over by anime-style drawing. You can no longer find even a trace of the legacy left by the old naturalistic pornographers like Ishii Takashi, Hirakuchi Hiromi, or Dirty Matsumoto.

This seems like a crucial issue. How can it be that people are most efficiently aroused by a picture of something that is not real? Pornography has everything to do with efficiency and nothing to do with eroticism. Eroticism introduces indirectness and mediation into sexuality and thereby makes it possible to maintain a refined distance from it. But the efficiency and directness of pornographic comics is at an infinite remove from that. What style of drawn image, when chosen as an object for the relief of sexual desire, has the most potential for efficiency in terms of reproduction, transmission, and manipulation? This is precisely the issue that must be investigated.

But it would be pointless for me to go on at length about my own impressions. Much better to go back to the otaku and listen to their voices. After

Wedding Peach

all, compared with otaku overseas, who are so uniformly defensive about sexuality, Japanese otaku are quite articulate and straightforward on the subject.

I was able to gather material for this book from a male otaku in his twenties whom I met by chance. He is a very orthodox fan of beautiful fighting girl anime who once loved Sailor Moon but is now passionately devoted to Wedding Peach. He is, of course, a Windows PC user, and his home page is full of pictures from *Wedding Peach*. He regularly organizes offline get-togethers of people he meets online and has lots of strong opinions about the epidemic of young people refusing to go to school. In other words, he is not at all pathologically introverted. Neither, I would add, are most otaku.

In conversations with him I found him quite easy to relate to, which made me think that I myself am not so different from an otaku. His sexuality, however, remained the one issue I couldn't understand, no matter how hard I tried. He said that he was actually able to "get release" with the character Wedding Peach, and this is something I cannot understand. I can't even imagine what makes it possible for someone to become emotionally involved in that way. But psychiatrists develop a sudden, burning

interest when they encounter a psychological phenomenon with which they are unable to empathize. So I decided to try to satisfy my burning curiosity by conducting a series of interviews with him via e-mail. With his permission, I reproduce here edited excerpts from his very interesting responses.

Recently when I was chatting on the Internet about life-size dolls of Ayanami with a graduate student who was also starting to get into Sailor Moon, some words that had long been in the back of my mind came to the surface: the phrases "for preservation," "for appreciation," and "for actual use." You get the general idea, don't you? It's that the really obsessed ones can't help buying three of each doll, even though they cost tens of thousands of yen apiece.

When I was a Sailor Moon *fan, I always bought two of everything. But once I realized that commercialism was the reason for the artistic demise of Sailor Moon, I restrained myself from that kind of buying.*

What do I mean by the "actual use" of anime and figures?[1] If this is the sort of thing you're interested in, ask me anything! Your wish is my command! (shifting into "maid" mode). But seriously, setting aside "maid" mode" for now [LOL], we're talking about "getting release," or "jacking off," to put it bluntly.[2] First I should give you some background on "getting release" with anime characters in general.

In a certain computer chat room, I learned that there are even some men—I guess it's probably a small percentage—who think it's dirty to imagine doing those kinds of things with "pure, adorable, whoever-chan." The anti–"over 18" faction, you know. There was one person who thought this way among the approximately one hundred who wrote about this in the chat room, so this "antirelease faction" represents about 1 percent. It's probably safe to assume that the majority of the others either accept it or approve of it.

But the upstanding gentlemen who disapprove are pretty adamant about it. Let me give you an example of an interesting conversation about this.

There was one devoted fan of a particular beautiful fighting girl manga who always said that erotic parodies not only defiled the characters in the work but also were a monstrous crime that hurt the feelings of the author. So even when he went to the Comic Market he was too afraid to walk around the exhibits. He said he was afraid that if he happened to see people selling an erotic parody fan magazine based on a work he liked, he wouldn't be able to keep himself from grabbing them in the heat of the

moment and calling them a bunch of pigs. He felt so strongly, that when he did go to the Comic Market, he simply made the rounds of the areas where he knew he could buy things and be completely safe and otherwise stayed in his own booth except to go to the restroom and have his meals.

He was, of course, able to control himself in situations like the Comic Market, where he had to be able to resist the urge to use force, but in places like computer chat rooms he waged his own solitary campaign to obliterate these vile erotic fan magazines from the face of the earth. The other members of the chat room were extremely critical of his position, of course. "Can't you appreciate fiction as fiction?" he was often asked. So he gradually became more and more isolated from the group.

But then one time he posted an uncharacteristically glum message. Surprisingly enough, it was his declaration of surrender in the fight to exterminate erotic fan magazines. So what do you think made him do that?

The transformation was triggered by one of those magazines. It was a pornographic comic version of a manga series of which he was a huge fan, precisely the kind of thing that his usual self would have torn to pieces in a fit of rage. But he wasn't able to do that in this case. Why? Because the creator of the original was the one who had produced the fan magazine and brought it to the market. The fact was that the original author, who he had supposed would have been hurt by the heartless otaku who defiled her creation (she happened to be a woman) by making a parody version, had actually created that version and was marketing it. He says that this came as such a shock that it completely changed his view of the world.

He says that when he gets hooked on a work, he gets totally emotionally involved with the characters. Sadness, joy, unhappiness, happiness, and so on—he tries to share all kinds of emotions with them. When he really likes a work he falls completely under the illusion that the characters have souls and actually exist. Of course, like any normal fan, he says he writes his own original stories based on the manga. But in his case the stories he creates are always outpourings of his love for the characters expressing his heartfelt wish for their happiness. Not really my kind of thing, but...

For this reason he assumed that the work's creator must also be expressing this kind of love and hope for the characters and that making a pornographic parody of something that was like the author's own child would have been an act as difficult to forgive as the rape of that child.

But for the creator of one of the works that he loved (she happened to be a woman) to produce an erotic fan magazine using her own beloved

characters and calmly sell it at the Comic Market. . . . His shock resulted from his being made aware, by the author herself, that all his feelings had been fantasies and illusions. When he found out that the one-man war he'd been waging was an attempt to maintain a purity that did not even actually exist, he fell into a panic. He realized for the first time that manga were, after all, fantasies made of paper and ink. You sorta have to laugh. But then again, it's no joke.

I have since asked this manga author who had created an erotic parody of her own work about his post. She said, "At the end of the day, manga are fiction," and pointed out that one writes differently for adults than for children. She never thought of herself as having defiled her characters.

Well, I think a person like him can be considered an extreme rarity. It's probably safe to say that, in general, otaku naturally make assumptions along the lines expressed above by the manga author and enjoy reading the works on that basis. To put it in extreme terms, even if a person describes himself as an "X-chan moe" and gets release with her image, it wouldn't be possible for him to be an otaku if he couldn't at the same time take a completely detached view of the work and the character. In other words, even while, on the one hand, it is natural for them to passionately enjoy reading the work and talking about it, at the same time they are able, on the other hand, to have—what would you call it?—a completely dispassionate attitude toward it. Being an otaku means being able to play around a little with the works you like; if you sanctify and worship them too much, you've fallen to the level of a mere maniac or a fan.

When it comes to manga with little girls as heroines, the older the works, the more readers tend to treat them as sacred. Gigi and the Fountain of Youth (Mahō no purinsesu Minkii Momo) and Creamy Mami (Mahō no tenshi Kuriimii Mami) were still very much purely aimed at young girls, so making an erotic parody of them would have been a little awkward. What really changed things was the appearance of OVA—anime that went directly to video for home consumption without being released in theaters. Cream Lemon (Kuriimu remon) was first released as an OVA, and when it became popular a market steadily grew up around it. Since then, pretty much every anime has a version for children and a version for adults.

With this lengthy introduction out of the way, we can finally get to the heart of the issue.

I think people who can "get release" with anime characters can also "get release" with figures.

When you look at a figure through the lens of sexual desire, it will change to fit your desires exactly. If it's Ayanami, say, you can become totally immersed in the act with a sweet Ayanami that you have customized just for yourself.

I know this because I myself have experienced release with an anime figure. My object was a ⅙ Hanasaki Momoko.[3] She was one of those so-called Janey[4]-doll-types[5] that became popular around 1996; frankly, she wasn't as perfect as a garage kit.[6] But she had enough parts to be recognizable as Momoko, so I could get release with her.

First of all, this makes it possible to do what you could otherwise only dream about—touch a character—which isn't possible with a cathode-ray tube. You see what I mean, don't you? (Although apparently there have been people who tried to kiss through the cathode-ray tube [LOL].)

Second, you create the Momoko you prefer inside your head.

At that time, it's like the image of the figure itself both does and does not have a material reality. When I am really turned on, I can convince myself that my Momoko can do things that a figure could never do, like caress my hair and whisper "I love only you." At that moment, the owner becomes an "all-powerful god" and can control the character completely. So it's not like you get release with the figure just as it is. That is only possible once you have added your own personal bits of drama and performance.

For your reference, I will quote here the poem I wrote exploring my thoughts about my relationship with my 1/6 Momoko (which is also on my home page).

> *Enlightenment*
> *I wonder why I love you.*
> *It is a destiny determined by you.*
> *As long as you need me, I will continue to love you blindly.*
> *When you no longer need me, I will stop appearing before you.*
> *The freedom that has been given to me exists only within the confines of*
> *your will.*
> *I metamorphose into the form you wish.*
> *Everything is as you wish it to be.*
> *You are the all-powerful god.*
> *Because I am inside you.*

If all you see is the surface, this sort of thing might strike a lot of people as disgusting and "perverse." But most otaku are able to consider their obsession with fiction objectively and actually make a game out of it. They

can even find ways to make the disgust that other people feel for them into material for more play . . . Um, as long as it is legal, of course . . .

For example, you often hear otaku saying things like, "When I bought that picture book of Cardcaptor Sakura at the supermarket, the cashier and the customers all went pale and looked at me like I was a monster!" I mentioned earlier that some otaku like to "get release" with a life-size Ayanami doll, but some of them will actually bring friends into their rooms and purposely leave the lotion out right next to her just to make sure it's clear what they're doing.

Come to think of it, the people selling scatological anime fan magazines at the Comic Market are always super proud of them. And the people buying them are proud too! [LOL]

Once when I was walking around Shinjuku with a group of about ten male otaku in an offline gathering of an anime chat room—it was when we happened to be walking around Kabukichō—one of those pimps came up to us saying he had some cute girls for us. To which one member of our group responded, "I prefer Sailor Moon." The guy walked away a little sheepishly, and we all exploded in laughter.

We are very sensitive when people, even other otaku, express shock that we would go so far. But we just turn those feelings into an excuse for more play. And the cycle continues.

As far as I know, the actual sex lives of otaku are extremely wholesome, even boring. Which is to say that their sexual desires are wholesome and ordinary, not that different from regular folks. As far as I know there are no otaku who are homosexuals or have a Lolita complex in their real lives. It's not unusual for male and female otaku to date, and once the men are able to earn a living and attain a position in society they go on to marry normal women completely as a matter of course. I don't really know whether, as Ōtsuka Eiji says, otaku have more friends of the opposite sex than the general population. But I am sure that there is not much of a connection between being an otaku and sexual perversion.

For example, even if you find a sexually perverse expression in a fan magazine, the readers are going to be otaku first and foremost and not sexual perverts. They just like to use perversion as a kind of generally recognized convention to enhance their enjoyment of the work and its characters. Of course, some people who participate in the Comic Market are perverts before they are otaku, and you have to make a distinction between them and otaku. Frankly, it is a nuisance when the actions of this small segment are used as a way to understand all otaku.

Females who have otaku-like preferences—"female otaku," if you will—are generally very popular. If a man gets married and his wife turns out to be an otaku, people are very envious. Nishimura Tomomi is popular among otaku probably partly because she is kind of cute, but her being an otaku is certainly a huge plus as well. There are also many otappuru— *otaku couples—among those active as creators. Okada Toshio's wife works for Gainax, so she is probably an otaku to a considerable degree, and there are the husband-and-wife teams Karasawa Shun'ichi and Sorbonne K-ko and Kaida Yūji and his wife, Aya, who are famous for their monster movies. Another famous example is Akai Takami (director of the Princess Maker series) and Higuchi Kimiko (manga artist). Anyway, it is probably quite natural for a strong affinity to develop between a male and a female otaku.*

However, from now on I don't think it will be possible to call someone an ideal mate simply because they are an otaku. I think it will probably be more important that they be able to do costume play and be really into it.

I'm sure you know how popular people who do costume play have become recently. In Jamaru *and other magazines where people write in about anime and computer games, the personal ads used to say things like "would like to correspond with people who like X," but these days more and more of them are from people looking for partners to do costume play.*

In addition, it's also important to note that anime-related cosplay sex businesses have gotten more popular, for example, St. Cosplay School (http://www.stcosplay.com/), COSMan (http://www.cosman.net/fr.html),[7] and "Wedding Bell."

I think St. Cosplay School is pretty well known by the nickname "S of Shibuya," and it seems that there's a certain group of customers who go there just to talk to girls. COSMan, which came later, seems to have picked up on this phenomenon and established a 5,000-yen talk-only option.

I've been to St. Cosplay School about four times. When I went the other day, I chose the longest option they have, forty-five minutes, in which you choose the girl who appeals to you, and I did that very thing, just talked to her and came home. The only act we engaged in was an American-style hug at the end.

Non-otaku men might think that was a waste of ¥10,000, but to me it was worth the money, and anyway that is typical of people who go to that shop.

You can talk to cute girls doing cosplay (of course, they know games and

anime). A market for just that is already being established in the city center. There are apparently some places where they have non-otaku simply do cosplay, but judging from the conversation of the girls I pick at that other store, they are true otaku.

"What games have you played lately?"

"Raystorm" (PlayStation/Taito) and "Densha de Go!"

"I guess I liked 'Rayforce' better."

Rayforce was sort of the previous version of Raystorm. I think that only a gamer who was a real Taito fan would know that title.

I think that St. Cosplay School's "Data about Our Girls" probably reflects pretty closely the kind of ideals otaku are seeking in real women. Incidentally, one thing that you can see from the data is that they all have small breasts. But despite that, the business is doing very well. This probably hints at something quite significant.

In terms of my own personal ideals, since my requirement is that she be able to do Momoko cosplay, I'm happiest if she is no larger than a B cup, and the skinnier, the better. And if she could really do the cosplay while walking around the Comic Market with me, that would be the best day ever. [LOL] (By the way, you also see a lot of ads in those magazines that say "Seeking a girl to accompany me to the Comic Market.")

But if you think that the age group we're talking about is the early teens, you're wrong. When it comes to real females, I am not interested in girls in their early teens. I'm in my early twenties now, and my ideal would be a woman in her mid-twenties who's more mature as a human being than a teenager but still youthful. (Probably because I'm at the age when you like someone older.)

This is the same reason that fans of anime with little girl heroines don't go around raping real girls. I think that in this respect there isn't a particularly big difference in sensibility between otaku and non-otaku.

Otaku might be into Lolitas, Shōtas, or even animals [LOL]. . . . But just because they appreciate a wider range of fiction than non-otaku, I've never heard of an otaku who would molest a nearby dog or cat.

We can't talk about recent booms without mentioning Shōta. Right now we are in the middle of a huge, unprecedented Shōta boom. Interestingly, even many male otaku are caught up in this, which includes anime like Bakusō kyōdai Let's & Go!! (Bakusō kyōdai Rettsu & Gō), YAT Budget: Space Tours (YAT anshin: uchū ryokō), *and* Brave King Gao Gai Gar (Yūshaō Gaogaigaa: King of Braves). *I myself have been taken by male*

otaku friends to NHK Studio Park, the only place where you can see a YAT film. [LOL]

In terms of girls in beautiful fighting girl works, I feel like the ratio of head size to height keeps getting smaller every year. Compared with 1992–93, when Sailor Moon got its big break and most characters had a head-to-height ratio of six or more (with the exception of Red Riding Hood Cha Cha, who had an extremely low head-to-height ratio), recently, as you can see if you look at Nadesico's Ruri or the main characters of Akihabara Cyber Team (Akihabara dennōgumi), you get the feeling that otaku are into really young looking girls. Lain, of Serial Experiments Lain, is supposed to be a middle-school student, but she really looks like a young child, and otaku who say they prefer the "little girl version" of Ayanami are not uncommon. Similarly, there are more and more over-eighteen PC games in which you engage in acts with what looks like an elementary school girl rather than a mature woman.

To talk about these things, I have to start with the word "smooth." When girls and boys with smooth chests, in other words, prepubescent children, are portrayed as characters in children's anime, their cuteness and sweetness are emphasized, and they become the objects of moe. Conversely, that kind of raw cruelty that all real children have to a greater or lesser extent is often filtered out. For example, it's hard to imagine the brothers Let's and Go tormenting a bug, right? [LOL] So you couldn't say that Shōta fans necessarily like real children; moreover, it's extremely doubtful that they would be capable of seeing them as sex objects. I don't think you'd have any problem declaring that there are actually almost no girl otaku who want to go around abducting little boys. And if they did exist, wouldn't it already have become a major issue?

Even as far as Shōta are concerned, among otaku they are just a signifier used to generate sexual excitement, and you can't say that has anything to do with a real-life sexual preference. The vast majority of otaku don't have any particular interest in young boys and girls. I know because that is true in my own case.

In terms of other trends in erotic parodies in recent years, other than the rise of the Shōta genre that I just mentioned, the stories basically center on consensual sex, and I don't think there is any other particular boom that stands out. However, every once in a while there will be a "novelty work" featuring scatological content or superhuge breasts, but rather than see these as something that appeals to one sector of otaku, I think that these are just created to target people who have those particular sexual habits.

One of the fan magazine anthologies of beautiful fighting girl manga I have includes one in which Ririka of Ririka SOS is made to have a bowel movement and then eat it; I, at least, am the type who would skip over that.

The kemono, or "beast," genre, which has a lot of fans among some otaku, seems to be partly an offshoot of the Loli fan magazines, and in recent years it seems to have caught on among Shōta fans as well. The basic idea seems to be that if you put cat ears and a tail on a very cute little girl she will become even cuter. Loli itself is a very old genre, so I would guess that beast versions have existed for a very long time, but there aren't very many established fan magazines featuring young girl anime characters with animal features. I think this is a genre you see more in original draw-ings by individuals. I don't know that much about those, so I don't know when these would have come into existence.

While we are on the subject, Pokemon's Pikachū is a character we can't ignore. I'm sure you heard that the other day a woman was arrested for making an erotic parody of Pikachū. This thing is quite popular. Because there is even such a thing as Pikachū cosplay. So of course there will be fans who can get release with Pikachū. Also, bestiality with animal subchar-acters and between young girl heroines and animals is not uncommon. In the case of Sailor Moon, there's a fan magazine that depicts Luna vs. Artemis, in other words, copulating cats. Although that should probably be considered a straightforward parody.

There was one woman (!) with a Lolita complex in the network I partic-ipate in who liked Eva and Conan, the Boy Detective (Meitantei Konan); she was a rarity—a Sega Saturn gamer who loved "Tokimemo." I felt uncomfortable when she'd send me a lot of Lolita images during network meetings, but at the same time I remember being surprised and thinking, "I didn't realize a female could be this hooked on pictures of real young girls."

Apparently she sent them to me thinking that I'd relate because I said I liked Momoko, but it's not possible for me to be aroused by actual girls, not to mention little girls. As for her, she said that when she saw a kindergar-tener her reaction would be "I want to abduct her [LOL]." By the way, she said she'd never been to a Comic Market. . . . Perhaps she was an example of someone hovering on the borderline of becoming an otaku?

Because I've exchanged opinions with this young man on a number of occasions, I can't deny the possibility that his views have shifted subtly toward mine. In any case, however, it is clear that a distinguishing feature of otaku is the coexistence of a healthy sex life with a "desire for fiction"

and "fictional perversion." The distinguishing features of otaku are most apparent in how they relate to something as fundamental as sex, especially its imaginative components. They live, so to speak, in a dissociated subjectivity. And isn't what is indicated here a kind of generative relationship between the beautiful fighting girls and a dissociated or mediated sexuality?

This problem is examined in more detail in the last chapter of the book.

3 BEAUTIFUL FIGHTING GIRLS OUTSIDE JAPAN

A Survey of Non-Japanese Otaku

Like sushi, sake, and karaoke, the Japanese terms *otaku* and *anime* are now commonly used in the West without any need for translation. Nearly all of the major universities in the United States have an anime fan club of some kind, and each of those clubs has its own elaborate Web site.

On November 24, 1999, I used AltaVista, the world's largest search engine at that time, to find words related to these topics (I typed in my search terms using the Latin alphabet). For *otaku*, I got 69,420 results. For *anime*, I got 1,703,605; for *manga*, 1,356,310; and for *comic*, 1,997,490. Together, these figures indicate that these terms have achieved an astonishing degree of penetration into global culture.

For comparison, here are the results I got for some other popular words. *Star Trek*, 447,430; *Superman*, 277,330; *Batman*, 426,250; *Beatles*, 670,512; *Spice Girls*, 162,425. For *nerd*, the word that roughly corresponds to *otaku* in the United States, I got 374,920 results.

We cannot, of course, expect these results to be a reliable indicator of anything at the present time. I have thus included them above merely as a point of reference, nothing more. They may, however, help us get a sense of just how pervasive the word *otaku* has become.

In every encounter I had with "otaku" in the West, I sensed subtle differences between their consciousness as fans and that of Japanese otaku (in this chapter I use the term "otaku" in quotation marks to refer to otaku outside Japan). How, then, do "otaku" really see beautiful fighting girls? I decided to do a simple survey of anime fans in the West by identifying the relatively well-known anime fan Web sites and sending them some questions by e-mail. Here are the questions I asked.

I have been wondering about something for years. Why, in Japanese manga and anime (for example, *Sailor Moon*), do pubescent girls take up arms and fight enemies? Many fighting heroines appear in Hollywood movies, but they are not young girls—except for Tank Girl and Léon. Henry Darger, the best known American outsider artist, depicts many young armed or fighting girls drawn from his imagination. If you know of any fantasies in which armed or fighting girls appear, please tell me about them.

As a psychiatrist, I am examining these heroines from the viewpoint of sexuality. As you know, in Japan people who love anime and manga are called otaku. Miyazaki Tsutomu, perhaps Japan's most famous otaku, was also a serial killer of young girls, for which he recently received the death penalty. Since the Miyazaki case, the public perception of otaku has gotten much worse. Even intelligent people mistakenly believe that otaku are pedophiles. I hear that an Italian psychologist has argued that children who watch anime featuring young girls in battles (he is referring to *Sailor Moon*) grow up to become sexual perverts. Is it possible that these beautiful armored girls are products of perverted desire on the part of otaku? How do you see this issue?

In response to these somewhat blunt questions, I received many unexpectedly serious responses. I particularly want to call attention to the significance of these as evidence against the stereotype-laden critique of otaku as pathologically introverted, irrational, and asocial. My impression was that, compared with the average Internet users in English-speaking countries (and even compared with the average otaku on the Internet in Japan), they were extremely polite and serious, and their opinions were intelligent and nuanced. Below, I attempt to present an overview of the reception of beautiful fighting girls outside Japan, using quotations from the "otaku" I contacted.

The Beautiful Fighting Girl in the West

First, I present some of the reactions to my central concern: Are there beautiful fighting girls in the West?

M, of MIT, told me about several very interesting examples in the United States.

> Recently the movie *Buffy the Vampire Slayer* was made into a TV series. It's the story of a teenage girl who kills vampires. A fighting heroine appears in a TV show that's very popular now, *Xena: Warrior Princess*, and I think she is either an adolescent or college-student age.

Many young female superheroes appear in American comics. A thirteen-year-old girl (Kitty Pryde, or Shadowcat) was added to the force in the *X-Men* series. She was very popular when she was in her teens, but not as much now that she is in her twenties.

M understood a comment I made about the difference between Amazonian women warriors and beautiful fighting girls and observed that most of the female heroines in American manga were simply tough and lacked "cuteness." He cited Kitty Pryde in *X-Men* as an exception—at least when she first appeared in the comic, she was a quite cute and innocent heroine.

Many fighting heroines also appear in paperback novels. The author Mercedes Lackey sometimes creates characters who are young female fighters. And some heroic young girls appear in the main Saturday morning cartoons, such as the Wonder Twins and Scooby Doo, but there is very little violence.[1]

I provide basic descriptions of several of the works M mentions toward the end of chapter 5, so I won't touch on them here. However, it is extremely interesting that these types of heroines have been garnering popularity in the United States in recent years. Of course, they are nowhere near as widespread as in Japan, but the fact that the number is increasing is, at least, symptomatic of something.

Regarding beautiful fighting girls, D of Johns Hopkins University says, "Other than in fantasy and manga, nothing comes to mind," but he points out that "bad girl works" are a recent trend. Dan Hollis, who maintains the American Web site anime.net, says that a lot of fighting girls appear in American anime, but most of them are not worth watching. One member of the anime research club at the University of Colorado gave the example of the animated movie *Heavy Metal*. As far as I can see, however, the fighting females who appear in this work are closer to Amazonian woman warriors than beautiful fighting girls.

R, an anime fan from Spain, says that armed heroines are not unusual in European history and legend. He suggests that what is important instead is why young girls are donning armor in a place as far from European tradition as Japan. The examples he provides, of course, are first Joan of Arc and Conan's Red Sonja. But apart from the case of Joan of Arc, he is confusing the beautiful fighting girl and the Amazonian woman warrior. Therefore it is difficult to accept at face value his point that "a lot of SF in the 1960s and 1970s had examples like that." Like R, Alex McLaren,

who maintains the American Web site otaku.com, pointed out that there are numerous examples in European history. However, the examples he gives are Joan of Arc, Elizabeth I, Queen Victoria, and the Amazons, and so, like R, he has widened the definition to encompass women warriors and brave women in general.

Citing Don Cameron's *Cyberella* and Chris Bachalo's *Generation X*, M of Greenwich College (England) writes that there are beautiful fighting girls in England and the United States, although not as many as in Japan. He also refers to *Tank Girl*, which I have mentioned, pointing out that it was a truly exceptional work. In other words, he says, relationships among genres, such as manga, anime, novels, and films, are few in England, and it is rare for a comic to be made into a movie. .

M appears to have a sensibility close to that of a Japanese otaku, and his analysis, based chiefly on anime, can be considered relevant. Here are a few of his comments about beautiful fighting girls.

> When *Ghost in the Shell (Kōkaku kidōtai)* was made into an anime, Major Kusanagi lost her weapons and her cuteness. But her appearance is shocking, and her success in the United States depends on that.
>
> . I don't think of Buffy the Vampire Slayer as a tough fighting woman. She is a typical American Valley Girl, more suited for dating and shopping than vampire slaying—well, that aspect of the program is supposed to be funny. But I think that the stereotype of the American female college student is different from its Japanese counterpart.

He also sent a very interesting comment about magical girl works, that is, about their transformations.

> I've never seen *Little Witch Sally (Mahotsukai Sarii)*, but I've seen its successors *Rayearth (Majikku Naito Reiaasu)*, *Nurse Angel Lilika SOS (Ririka SOS)*, and *Sailor Moon*. I think that these are more like superhero-type works than comedies, like *Bewitched*. I can't say that the characters are that out-of-place, though.
>
> The concepts of transformation and secret identity make me think of American superhero works. Like Superman or Spiderman. They lead normal lives, but when they change clothes they acquire superhero personae. Aren't these an influence?

But most important among the points he makes is the following one, about the tendency toward juvenilization in anime.

What surprises me about anime is that the heroines look younger than their age. Minnie-May in *Gunsmith Cats (Gansumisu kyattsu)* is supposed to be seventeen, but she only looks about fourteen. Is this tendency of the heroines to get younger a recent thing? In the new *Yamato, Macross (Makurosu)*, and *Battle of the Planets (Kagaku ninjatai Gatchaman)* series, the heroines have become even younger girls. To compete with *Gall Force (Garu fōsu)* and *3x3 EYES*? Whatever the reason, Japanese tastes seem to be moving in the direction of younger and younger characters.

Sailor Moon is an important work in connection with the issues of "magical girls" and "younger and younger heroines." It's also probably highly significant that *Sailor Moon* was the topic that elicited the most diverse responses in this survey. I feel that this is where the differences between Western "otaku" and Japanese otaku become apparent. I said that opinions on this were divided, but most said things like, "That work is intended for very young girls," "Too much viewing of that will turn you into an imbecile," or "Our club prohibits watching it"; there were many negative responses about it, even though they were phrased as jokes.

A, who maintains an anime Web site in Finland, was one of the few anime fans surveyed who was a supporter of *Sailor Moon*, and he was also the one most similar to a Japanese otaku. He is also a fan of *Fushigi yūgi: The Mysterious Play* and Miyazaki's anime. He was originally a movie fan, he says, but he stopped seeing films almost entirely after he got into anime.

He also says that he couldn't really think of any examples of fighting girls in the West. At first he thought *Sailor Moon* was intended for little girls and couldn't relate to it. But he kept forcing himself to watch it, and one day it suddenly became one of his favorites. He says that he thinks it's because the heroines are young girls with supernatural powers. As someone who does not like pornographic works, he absolutely cannot believe that a lovely, cute anime like *Sailor Moon* could cause perversion.

I know that there are fans of pornographic manga. The only anime you can get in Finland are about five action anime. That's why there are a lot of fans of action anime in Finland. You have to go to a lot of trouble to become an anime fan here. The first anime I ever saw was *Legend of the Overfiend (Chōjin densetsu urotsukidōji;* a porn-action work), and at the time I liked it a lot. Now my preference is shifting from porn-action works to romantic comedies. I haven't seen many porn works lately. In the magical girl

category, I only know *Pretty Sammy*. The only Western magical girl works I know are books.

The anime illustrations in the game "Tokimeki Memorial" were beautiful, and I liked them. But it makes me feel weird when I hear that there is a Fujisaki Shiori music video and a fan club. Don't videos like that blur the line between reality and fantasy?"

The e-mail from this person so partial to Japan concluded, "When my military service is over, I'm going to Japan." When I consider these responses as a composite, I think I can say that my predictions were not that far off. I can say with certainty that the genre known as beautiful fighting girls has had a unique course of development in Japan. We can conclude that it doesn't appear to have emerged as a genre in the West the way it has in Japan. At least, these types of heroines aren't used blatantly as part of a marketing strategy to the extent that they are in Japan, and there is no established strategy in which they are used intentionally to generate hits.

But I had not foreseen the recent popularity of live-action dramas featuring heroines very similar to beautiful fighting girls. I think it is almost certain that anime made in Japan have been a major influence on this development.

Anime and Feminism

Harvard's Benjamin Liu is such a die-hard anime fan that he has written a thesis on the subject in Japanese; he analyzes the phenomenon chiefly from a feminist point of view. Liu cites *Candy, Candy (Kyandi, Kyandi)*, *Oh, My Goddess (Aa! Megamisama)*, *Video Girl (Dennō shōjo)*, and so forth as works featuring stereotypical, that is, feminine, females. He contrasts these with works such as *The Rose of Versailles (Berusaiyu no bara)*, *Gigi and the Fountain of Youth (Mahō no purinsesu Minkii Momo)*, and *Sailor Moon*, in which females act masculine, undergo transformation, and engage in witchcraft. He assumes that works in the latter group symbolize improvement in the status of women. And he cites Miyazaki Hayao as the most feminist creator.

Of course, I have some doubts about his comparisons, and I have to say it's disappointing that he doesn't refer to the pre–*Sailor Moon* genealogy of young fighting girls. But his views are valuable in that they call attention to issues of gender in anime. Below I summarize some other important opinions that he expressed.

The first thing Liu points out is that Japanese heroes in general are quite young. For the most part, heroes in American comics are mature males (he cites X-Men as an example). In contrast to this, in Japan pubescent boys and girls are selected as heroes and heroines a lot. He makes a number of similar points along these lines.

For the reasons given below, Liu completely rejects any relationship between beautiful fighting girls and sexual perversion.

1. There is no evidence that the sexual tastes of the Japanese differ significantly from those of other peoples.
2. Depictions of violence in anime are often mentioned as a problem in Japan, but this does not mean that the Japanese are particularly violent.
3. Although it is true that social conditions are reflected in popular media, it is inaccurate to assume a direct correspondence between the ideas expressed in anime and social ideologies.
4. It is going too far to regard every creator of anime as sexually perverted.
5. Japanese anime and manga are the equivalent of American TV and movies. In other words, they can be considered equal in terms of reception and their power to influence. Looked at in this light, the way young girls are depicted does not constitute such a fundamental difference (if anything the question is why there are so many monsters in Japanese anime).

 For that reason, rather than look at beautiful fighting girls as a product of masculine desire, I would like to think that there are more rational reasons for the existence of beautiful fighting girls.
 A. In Japan women's identities are ambiguous and circumscribed. Beautiful fighting girls offer an escape from these kinds of bonds. For young Japanese girls, there is value in the idea that they protect themselves and the people they love.
 B. The feminist movement is by necessity related to sexuality. Women must break out of the young-girl ideal that males find desirable and declare their own sexual freedom. Characters who attain sexual maturity and are able to control their outward appearance and sexuality represent another form of female independence.

 There is a similar connection between the young heroes of anime and the status of Japanese young people. Japanese youth are in a weaker position than their American counterparts. American children are trained to be independent. But the Japanese have deep-seated notions of age-based hierarchy. Might the prevalence of very young protagonists in anime be understood as an attempt to destroy the

stereotype of "the powerless young" analogous to the feminist challenge to gender roles that we see in beautiful fighting girl anime?

C. Some anime characters are created as objects of sexual desire, but not all beautiful fighting girls exist to supply that kind of male amusement. What about Nausicaä? Iyari? Sailor Moon is too childish for me. (Don't tell anyone, but I think that if you watch too much of *Sailor Moon*, you become an idiot. Just kidding!) *Streetfighters'* Chun Li is, first and foremost, a strong, independent-minded character, but she is also an "otaku" idol.

D. While beautiful fighting girls do contest the traditional image of women, they may at the same time be a reflection of the idea of the "weak female." As long as fantasy has any basis in reality, young girls will always be weak beings; they cannot fight until they change into their battle uniforms.

People who theorize that beautiful fighting girls are damaging have the analysis of this social phenomenon backward. It's easy for someone with sexual problems to become immersed in the world of anime. For a person unable to attain satisfaction in reality, this kind of fiction, which is like a paradise with no counterpart in the real world, is safe. But the reverse is not true. Anime don't cause perversion. Only those with perverted fantasies see perversion there.

I like the anime *Video Girl*. I'm attracted to the idea of possibility. The possibility of the impossible. A young girl jumps out of the television screen to fight monsters. I want to believe that this kind of magic is real. I want to dream of a real possible world, not create an impossible reality.

Liu's analysis is superb, and there is nothing to say about it other than that it is completely correct as is. I was particularly struck by the fact that his argument included not only the discriminatory treatment of women in Japanese society but also of young people, and by his assertion that "Japanese anime and manga are the equivalent of American TV and movies." His observation that social conditions are reflected in anime may be somewhat naive, but it is correct in the context of his argument.

An anime fan of around twenty years old makes an analysis as accurate as this and writes a thesis about it *in Japanese*. Already I have to say that this marks a decisive difference from the average Japanese otaku. When Japanese anime fans get together there is nothing but an endless procession of insider talk and insider gags: one can never expect this sort

of critique. Even when they talk seriously, they still seem to be playing a role.

However, I do not intend to accept Liu's assertions verbatim. He is correct to argue that the structures of social oppression are projected onto anime in a paradoxical form. But the very persuasiveness of this thesis too easily negates the uniqueness of anime. Also, as far as the relationship between anime and feminism is concerned, my sense is that Saitō Minako's *Kōitten ron* (A single drop of crimson) has already said everything that needs to be said on the matter.[2] So I will keep my focus on the relationship between anime and sexuality.

Anime, Perversion, Sexuality

What do sexuality and sexual perversion have to do with anime, and what can be said about the particular way in which anime have developed in Japan?

R, the Spanish anime fan mentioned earlier, says that the foremost problem facing European anime fans is that of censorship. He says that in Spain, even Miyazaki's *Porco Rosso (Kurenai no buta)* has a mature audiences designation, and the showing of nearly all other Japanese anime is prohibited, so the only way they can see anime is on video. Pornographic anime seem to have made such an impression that all Japanese anime are viewed with suspicion and strictly censored, which is an overreaction. Of course, this kind of misconception is quite common and not confined to Spain. The question, then, is why, when Japanese anime are considered in terms of Western standards, the genre itself is treated as though it were full of sexual taboos.

M, mentioned above, provided a detailed report on the reception of anime in England.

> Anime have a hard time in England as well. Sales of tentacle porn like *Legend of the Overfiend* and several episodes of *La Blue Girl* (actually, *Inju Gakuen La * Blue Girl*) are prohibited.[3] In many cases, scenes of violence and sex are cut when anime are released. Although the same is true of Hollywood films.
>
> I've seen some of the episodes of *Sailor Moon* edited for showing in the United States, and it appears that they were sensitive to sexual implications. The scenes in which she becomes nude while transforming are cut out, and the gender of Zoicite (one of the enemy Four Heavenly Kings) has

been changed so that she is female. I think this is probably out of concern that her relationship with Kunzeit not be construed as homosexual. It all seems pretty harmless to me. Perhaps because the manga is directed at girls, the heroines are girls, so little girls probably find it easy to identify with them. That so many "otaku" want to place them in pornographic situations is a way of making fun of the purity of the original work, identical to what slash fiction does. Like the fan magazines based on Star Trek. But I don't think that all fans are like that at all.

Although he says, "Miyazaki (Tsutomu) should be put to death," Alex McLaren also sarcastically retorts, "Why didn't that Italian psychologist mention the Catholic Church (as a cause of sexual perversion)?" Saying, "Everyone has the right to see what he or she wants to see," he had quite a few sarcastic responses to my questions, such as "Perverted 'otaku' desire exists only in fault-finding politicians, profiteering newspapers, and masochistic minds."

"*Evangelion* is boring. The only thing original about it is the robot you plug into the socket," concludes Dan Hollis. "It's a mistake to look for sexuality in magical girl works." According to him, beautiful fighting girl anime are not directed at "otaku"; *Sailor Moon, Little Red Riding Hood Cha Cha (Akazukin Chacha), Super Pig (Ai to Yuki no piggu gaaru tonde burin)*, and *Pretty Sammy (Mahō shōjo Puriti Samii)* are all intended for little girls. "If you think that sexuality is an issue in manga, you had better study yourself first," he says, giving me a very psychoanalytic suggestion.

P of St. Cloud State University (Minnesota) is an ardent fan of *Evangelion*. He says the following about the issue of "otaku" and sexuality.

Being an "otaku" has nothing to do with perversion. In the United States, "otaku" means an obsessive anime fan. It's like "Trekkie." Of course there are some fans who only want to watch adult-oriented anime. Did "anime" make them that way? I can't believe that. If there weren't any anime, that bunch would just watch live-action porn. I watch anime because the depth of the stories and the complexity of the characters pull me in.

Even so, I wonder what the attraction of children with weapons is. I'm 21 years old, but I watched every episode of *Sailor Moon* that was broadcast. At first I watched it because it was refreshing compared to stupid American anime, and out of curiosity. But gradually I started to like it. It's not because I like the gang of fighting girls; it's that I think it's well done as a fantasy. But I didn't end up a pervert, and I still have a normal dating relationship with

my girlfriend. I don't think "otaku" and anime fans deserve the bad reputation they have.

Although B, the vice president of the University of Colorado's Otaku Animation Association, thinks highly of *Evangelion* and Miyazaki Hayao, he says that he is probably different from Japanese otaku.

> I like series with women who fight. Like *Bubblegum Crisis (Baburugamu kuraishisu)*. The women in that anime are pretty, and they aren't afraid to be independent. I don't have much interest in the wide-eyed "totemo kawaii onna no ko" (he says in Japanese) who are always giggling.[4] My type is more like Priss in *Bubblegum Crisis*, the kid who rides a motorcycle and is a rock singer.
>
> I like smart, aggressive women. Women who are good at math and computers, like I am. The ideal of the quiet, obedient female doesn't appeal to me. I'm not interested in young girls either. I like women my age (twenty-two).

B's image of the ideal female appears to be what I consider the phallic mother. He definitely differs from the typical otaku in a number of ways. And not just in terms of taste. His ideal woman is roughly the same in anime and in reality. This sort of consistency would certainly disqualify him as an otaku.

As we have seen, nearly all of my interviewees had a negative view of the connection between "otaku" or anime and sexual perversion. In real life some of them date girls normally, like B, and some don't. However, quite a few of them pointed out that most "otaku" (or nerds) are male and don't have much in terms of relationships with the opposite sex. This is not so different from the way it is in Japan.

Beautiful Fighting Girls and Cultural Background

M of Harvard University is a fan of Miyazaki's anime who really likes *Nausicaä of the Valley of the Wind (Kaze no tani no Naushika)* and *Laputa: The Castle in the Sky (Tenkū no shiro Raputa)*. He attempted a fairly thorough analysis of the beautiful fighting girls' coming into being.

> First, you have young-girl manga. They are intended for girls, so it is natural for the heroines to be young girls. *Sailor Moon* is intended for elementary school girls, and although there are some guys who like it, most of the fans (in the United States, at least) are girls. Of course I personally am not a fan

of *Sailor Moon;* I prefer anime intended for older people, like *Legend of the Overfiend* and *Marmalade Boy (Mamareedo bōi).*

The reason otaku preferences have such a large influence on manga and TV games is, more than anything, because the ones who create them are themselves otaku.

The relationship of sexuality to manga and anime is complicated. There are some porn manga that exist only to stimulate sexual desire. This is true not only of manga and anime, but also of some TV games. The fact that *Tokimemo* has become mainstream and the debut of Datekyō (Horipuro International's virtual idol Date Kyōko) are the reflection of otaku ideals. What made that possible in Japan? Japanese men are sexually repressed. And they aren't as energetic as the women. This is connected to the uniqueness of Japanese culture. That's the impression I got from my encounters with Japanese people.

Anime, manga, and computer games are more popular in Japan than in other cultures. There are manga and TV games in the United States, but they are mostly aimed at children. "Cartoons" are intended for young children, or like Disney's, for families. A young girl heroine wouldn't be out of the question, but boys in general don't show much interest in young girls; they prefer violence and action. When American boys start to become interested in girls they throw away their TV games. There are hardly any boys over fourteen who are interested in TV games and manga.

Compared to other societies, Japanese society is tolerant of an otaku-type lifestyle. It would be inconceivable for an anime character to become an idol in the United States. Also, most Americans are shocked by the fact that high school girls are made to wear sailor suits as their school uniforms. In a society that emphasizes the purity of adolescence it is hard to accept this sort of objectification (he uses the Japanese term for this) of high school girls. This isn't a value judgment; it's a cultural difference. Of course, I can only speak about things in the United States, and even then I may be falling into stereotypes. A role model like *Sailor Moon* seems to me less about seeking equality for women and more about treating women as objects. *Sailor Moon* was broadcast in the US for more than a year, but it didn't really catch on among fanatics and "otaku"; it was actually a hit among its original intended audience of very young girls.

Disney's target audience is everyone. That's why they take time and trouble and spend a lot of money to get famous actors to do the voices. But even so they don't have the same appeal as anime. Anime and other "otaku" activities (he uses the words Japanese words "otaku no koto") change lives in a

big way. In that respect their influence is stronger than that of any Disney work. That's the difference between a mere fad and "otaku" activities. You could also say it's the difference between anime and *tamagotchi*.[5] *Sailor Moon* is midway between the two in that it appealed both to general audiences and to "otaku."

I can't believe that Date Kyō was meant to be an idol in the usual sense. I think it's very interesting as a challenge to the limits of technology. Friends of mine bought her CD. It's very cool, but watching the video gave me the creeps (uses the Japanese words "bukimi na kanji"). She tries to be real, yet she can't quite pull it off. Anime characters don't try to be real. "Otaku" can love Sailor Moon, but they know she isn't real. If Sailor Moon were real, it would be creepy and bother them. I know very well why Date Kyō didn't catch on. I think that the world probably isn't ready for a virtual idol yet. If technology advances, this kind of idol (like Sharon Apple of *Macross Plus* [*Makurosu purasu*]) will probably become more popular. For now it's still in the realm of curiosity.

You almost never see a cute hero like Sailor Moon in the US. I think that there are a lot of Americans who like that kind of character, but there are also many who would find it confusing. The characters are often cute in the way little children are cute, which gives it a nuance of pedophilia. However, I predict that American manga will have characters that gradually grow to resemble Japanese "cute kids."

Here, M provides some valuable material in terms of understanding taboos in the American consciousness. The process by which sailors' work uniforms came to be used as uniforms for schoolgirls is definitely worth our attention. The recent Japanese obsession with high school girls contains an element that cannot be dismissed as merely desire for young women. At the very least it involves a clothing fetish. But taken to its extreme, the love for the combination of sailor clothing and young girls suggests a tendency toward polymorphous perversion, encompassing a preference for homosexuality and a clothing fetish in addition to pedophilia.

He had the following to say about the issue of "transformation."

It is probably the transition from a cute young girl into a tough woman. This two-tiered personality gives them everything the mature male "otaku" want in their females. It makes them into perfect beings.

I agree entirely that "transformation" is a metaphor for accelerated maturity.

Next I introduce J, a student at the University of California at Berkeley. Also a fan of the anime *Fushigi yūgi*, he observes that beautiful fighting girls are in the minority in Western movies and TV shows. He cites *Terminator* and *Nikita* as exceptions.

> I don't really know why (there are so few), but maybe it's a difference in animation styles. The mighty Disney tries to depict characters realistically. Also, audiences want to see realistic works. So it's hard to depict beautiful fighting girls. The anime style of "large eyes and small noses and mouths" works best in Japan.
>
> I read a psychological study that calls anime in which beautiful fighting girls appear "magical girl works," and points out that they are strong female characters who also have a delicate femininity. They can hurt males if they want to, but if a male confesses his love for them, they become rapturous, kind, and passionate. Isn't that what appeals to "otaku"?

D, quoted earlier, points out that fighting girl anime are designed to pervert and to make a profit. He says that *Gigi and the Fountain of Youth*, for example, was created with young children in mind, but that the kind of armed young girls that appear in *Legend of Lemnear (Kyokuguro no tsubasa barukisasu)* are clearly a product of perverted desire. Regarding the armor they wear, he says, "Outfits like those are unnecessary and useless," and, about *Pretty Sammy*, "There is no need for clothing that revealing." One could say that his remarks show good sense.

Asian Complex?

The last e-mail message I quote is a little different from the others. It is the story of a young Caucasian man whose outlook on life has been warped by anime. He gave me permission to make his message public under conditions of anonymity, so I quote it almost in its entirety.

> Your opinions were interesting. When I was little, *Macross*, *Yamato*, and *Battle of the Planets* were my favorite anime. I had no idea that they were foreign-made. I rediscovered anime when I went to high school and became completely addicted. My own life also changed completely: all my friends are Asian, and I major in Asian history in college. My parents are a little confused by how much I've changed. Sometimes it seems strange to me, too. Anime has even totally influenced my taste in girls.
>
> All things Asian have an abnormal attraction for me. Among these, anime are particularly important. I am especially partial to Japan, Manchuria (?),

and Korea. I major in East Asian history. All my friends are Asian and one of them is a girl from Niigata, Japan.

But it wasn't always this way. I was raised in a white suburban home and had almost no opportunity to encounter anything Asian when I was a child. At most I might have said "I want to be a ninja," or heard my grandfather talk about his time in Japan (he was there in the Navy). I saw the anime I mentioned earlier and kung fu movies (as growing boys tend to do, we watched a lot of martial arts movies and things like the *Karate Kid* and Bruce Lee stuff), but that's about it. There were hardly any Asian students in my school, and the ones there were were Asian Americans.

In ninth grade (my third year of junior high school) I started learning tae kwon do, where I met a girl who was half-Korean, and we started dating. It's a long story, so I'll make it short, but the upshot of it is that we broke up.

Right after the breakup, a friend showed me some anime—*Akira* and *Vampire Hunter D (Kyūketsuki Hantā D)*. I was really depressed, so I shut myself up at home and got so all I did was watch anime. The girl in the anime reminded me of the girl who broke up with me. I immersed myself in anime on the weekends, too. I was really miserable.

Even thinking about it now, I'm amazed that she was so much like the young girl in the anime. On top of being cute, she was so strong that she was dangerous (she was the state champion in tae kwon do and a cheerleader). Her appearance was like that of the girls in the anime, too—she was glamorous and had big eyes. Perhaps the fact that she was half-Asian made her seem like a special being, to the point of unreality.

Mamono Hunter Yōko took her place and became the girl I considered the cutest. If the young girls in anime had been the real thing, I probably would have loved them. A Japanese professor warned me, half-jokingly, that I should probably stop watching anime so much. If I didn't, I might start expecting real girls to act like the ones in anime. That observation stayed with me, because I had never properly analyzed my own thinking.

But I think that I am definitely not a pervert. In the first place, I don't like porn, whether anime or otherwise. I like Takahashi Rumiko's works, like *Ranma ½,* and *DNA² (Doko ka de nakushita aitsu no aitsu)*. This semester I wrote a paper about gender roles and their representation in *Ranma.*

I gradually became fascinated with all aspects of Asian culture, not just anime. My area of interest shifted from European history to Asian history. Soon after I entered college, I became friends with a Korean student who likes anime as much as I do. Eventually it got so all my friends were Korean, Chinese, or Japanese. Even though I could barely speak Korean,

I was always with them, the only white person. It was a little strange. But among the other Asian students, this group of Koreans had the reputation of being snobs. I lost interest in my white friends a long time ago. Even before I made Korean friends—there were various reasons for this. Do you know what fraternities are? Mine was anime-related and changed my life dramatically.

The symbolic connections between anime and the memory of my ex-girlfriend reinforced one another, and each fascinated me all the more. Until that time I had never liked an Asian girl or dated one (my Korean friends tell me that the half-Korean one doesn't count). For me, Asian girls (that is, Korean, Chinese, and Japanese) are just as attractive as white girls and I think more of them are beautiful. Whether white or Asian, I think that the cutest girls are equally pretty. I'm not into the stereotypical submissive Asian girls. I just like the way they look. None of these things are normal for an American guy. I guarantee it. You're a psychiatrist, so you can probably make judgments about the meanings of these kinds of things, but I can't.

When I suddenly look around a room and see that everyone is Asian except me and whenever I realize that most of the time they can't understand what I'm saying, I think about that. I wonder what I'm doing, and it seems strange that I ended up this way.

I think it would probably be wrong to blame all of this on anime. Because there are deeper, more complicated things involved.

My mother seems to think that I have been this way since a particular incident.

When I was two years old, my family took a trip to Seattle. There was a Japanese family with a little girl about my age there sightseeing. I don't remember it, but according to my parents I was running around and I tackled the little girl and wouldn't let her get back up. My parents felt terrible and apologized to the little girl's family, who couldn't understand English. There must be something about this episode deep in my unconscious, but I don't really know. This is all I can write about it now. It'd be good if it is useful to you, but please don't use my name. I'm going to Japan this December and January. To meet my friend from Niigata.

I like Japan; I even like the part of it that is militaristic and not very well thought of. I think the Greater East Asia Co-Prosperity Sphere is very interesting. I am also a big fan of ukiyo-e, Tanizaki's novels, and Japanese music like Cibo Matto. I'm also interested in the war between the Heike and the Minamoto. I think that Japan is the most attractive, paradoxical, and contradictory society in the world. I will always admire it.

I have no intention of "analyzing" a personal confession that is this frank. He is of course not typical, but he is also probably not too unique an example. I merely wanted to emphasize the diversity of "anime fans" to avoid the naive misunderstanding that the whole world has become "otaku"-ized because of the invasion of anime.

Reading their e-mail messages, I was made to recognize once again the uniformity of Japanese otaku. They may exhibit a strange omnivorousness and performativity, but rather than diversity, doesn't that ultimately bring about a kind of monotony? My assumption is that that monotony is parallel to the monotony that is semi-inevitable in the manga and anime space. It would probably be possible to see this as the monotony of a representational space in which there is too much uniformity between the creativity of the creators and the sensibilities of the receivers. In the last chapter, "The Emergence of the Phallic Girls," I have more to say about the inevitable connection between the special quality of what I am calling this "space" and the emergence of the beautiful fighting girl.

Outsider

I mentioned in the beginning of this book that the work of the artist Henry Darger provided me with important hints that helped me conceptualize this project. The value of Darger's works on the art market continues to rise—whatever their value may be in art historical terms—evidence of the growth of international knowledge and appreciation of them. In Japan, however, he is still not well known, which is why I have decided to devote this chapter to an introduction to the life and works of this unique artist.

One cannot discuss Darger without reference to the recent boom in "outsider art," so let me begin with a brief discussion of outsider artists. Put simply, this term designates artists who have no formal education in art and do not belong to the art world. In Europe their work is known as *art brut*, and in the United States by the English translation of that term: "raw art."

While the term includes the work of all amateurs who are not part of the art world, it most often refers to work by individuals with a mental illness. Since the German psychiatrist Hans Prinzhorn published his *Artistry of the Mentally Ill (Bildnerei der Geisteskranken)* in 1922 based on the works of art he collected from patients on his visits to several mental institutions, there has been widespread interest in painting and plastic arts by the mentally ill. The French painter Jean Dubuffet looked at this work from an artist's perspective and has contributed more than anyone to the introduction of outsider art to the art world. It was Dubuffet who coined the term *art brut*.

John M. MacGregor, who first introduced Darger's art, discusses outsider art in the following terms: "My definition of outsider art requires

that the artist create a vast, encyclopedically rich, and detailed alternate world—not as art—but as a place to live in over the course of a lifetime."[1] They create maps of the world their insanity has created and draw icons of their own gods. They draw pictures explaining the panaceas they have discovered and the surface of Mars as they have experienced it. They describe in detail the apparatus by which their oppressors manipulate them from afar. They inhabit their own private kingdoms, where they mint coins and explicate religions that they have created. It is not a question of "fictional drawings." For their creators these images are equivalent to reality.

Outsider artists have little interest in exhibiting or selling their work. It is not meant as a fiction to entertain others but as a tool or method they can use to change reality itself. It is so important and personal to them that they cannot imagine showing or relinquishing it to anyone else.

Darger's creative acts certainly adhere to this definition of outsider art. Nevertheless, how best to describe his work presents something of a conundrum. One wonders if he is best understood as a painter or an artist who kept his work secret for his entire life and wanted it to be destroyed after he died. Or, from the perspective of a psychiatrist, purely in terms of his pathology and his perversion. But, as I explain, Darger's "pathology and perversion" is of a sort that repels any such simple "diagnosis." And in any case we still do not know everything about Darger's life. The core of his creativity will, as a result of a variety of difficult circumstances, most likely remain obscured for some time. But here let me open just a few pathways that allow for a discussion of his unique talents.

For sixty years, from the age of twenty-four onward, Darger worked alone and in complete obscurity on a single project. It consisted of a manuscript of more than fifteen-thousand typed pages, accompanied by a large quantity of illustrations. Darger's opus is perhaps the longest work of fiction ever written by a single individual, and partly because it was not properly preserved, it has never been published in its entirety. The world represented in these illustrations has a strange power to move whoever sees it. But the most important thing is that Darger made these works entirely for himself and never showed them to anyone.

Seven heroines, called the "Vivian Girls," appear in Darger's work. They arm themselves with guns and fight determinedly to liberate child slaves from the control of evil adults. The battles are often bloody and extremely cruel. His images are characterized by the contrast between

the innocent eroticism of the little girls and this sort of bloody cruelty. Strangely, the little girls all have penises like little boys. People's attitudes toward Darger's work are largely determined by how they react to this. Some reject it as the product of perversion, and others find themselves riveted by it, however hesitantly at first, as a mirror of their own desire. My interest here is not, of course, in determining which of these responses is correct. As someone who could not help but read his work with the second of those two attitudes, I felt compelled to take a closer look.

Darger had no formal art training, and in technical terms his paintings appear childish. Yet it is precisely that childishness that makes them succeed. The placement of the little girls in landscapes and interior scenes is skillfully conceived. His lively sense of color touches them gently and fleetingly. The marvelously naturalistic depictions of clouds and lightning in the background wear human expressions that plainly reflect an artless and devout belief in a clearly anthropomorphic god. Darger was in fact an extremely ardent Catholic.

The most striking characteristic of Darger's paintings is their strange naïveté and self-authorizing innocence. His creative acts were deeply connected to the fact that he had the innocence of a child. But what is the nature of this innocence? Darger's paintings overflow with turbulent tensions between innocence and horror, wholesomeness and sexual desire. As we look at them we face the shadows of our own desires. Inevitably, this is a profoundly unsettling experience.

In the words of MacGregor, today Darger's work is considered "the single most important example of American outsider art in existence."[2] His paintings fetch tens of thousands of dollars on the art market. MacGregor, an art historian who has also studied psychoanalysis, was the first to try to illuminate Darger's art from a pathographic perspective. After becoming acquainted with Darger's oeuvre through sheer coincidence in 1986, he spent the next ten years studying it and has published a number of essays about it. In the next section I introduce Darger's life and work, based on several of MacGregor's publications.

Life History

Henry Joseph Darger was born in Chicago, Illinois, on April 12, 1892. It is said that he did not leave Chicago once in his entire life. His mother died while giving birth to a younger sister when he was four years old. The

sister was immediately given up for adoption, and Darger was brought up by his father, who was disabled, until age eight, when he was placed in a Catholic home for boys. At age twelve he was moved to the Asylum for Feeble-Minded Children in Lincoln, Illinois. His nickname there was "Crazy," but needless to say he was not in fact feebleminded. His diagnosis at the Lincoln asylum was "self-abuse" (a euphemism for masturbation). In early-twentieth-century America many children with psychiatric problems were placed in institutions of this sort. His father died in 1908.

Darger tried to escape the asylum many times and finally succeeded in 1909 at age sixteen. At seventeen he found a job at St. Joseph's Hospital as a dishwasher and janitor and from that point on settled into an outwardly uneventful and monotonous life. He lived his entire life without marrying and earned his living doing odd jobs at several hospitals in the Chicago area.

A small rented room on the third floor of a house on the north side of Chicago was Darger's residence and his entire world. His work as a security guard, dishwasher, and janitor was monotonous and taxing. He went to work every day, ate his meals at nearby restaurants, and worked on his secret project when he came home. A devout Catholic, he attended mass every day, sometimes as many as five times.

Having almost no friends, he was, in MacGregor's words "pathologically lonely," and always seemed afraid of something. When he met acquaintances all he could talk about was the weather. At one point he did have a close friend named William Schloeder. But this friend eventually moved away, and Darger's loneliness intensified. It was this loneliness that most likely drove Darger to create his own imaginary world and record its voluminous history without ever telling anyone else about it.

Discovery

On a snowy day in November 1972, the eighty-year-old Darger was put into a home for the elderly, never to return to the rented room where he had lived for forty years. When his landlord asked what he wanted to do with his belongings he simply said, "It's all yours."[3]

Whether it would have pleased Darger is hard to say, but his landlord, Nathan Lerner, who discovered his work, was a fairly well-known photographer, painter, designer, and an art professor associated with the Chicago Bauhaus, and it was this coincidence that saved Darger's works from destruction.

When Lerner entered Darger's room after his death, it was so full of junk that there was barely room to walk. Darger never threw away the things he collected, and he lived his life virtually buried in trash. The floor was scattered with empty Pepto Bismol bottles, bundles of old magazines and newspapers that seemed to have been picked up off the street, hundreds of balls of twine collected for some unknown purpose, and other bizarre collections of objects. Lerner began to clean the room together with his student David Berglund. It was a cleaning job that would lead to a life-changing discovery.

The first text they found was an eight-volume, ten-thousand-page text titled *The History of My Life*. Darger had begun writing it after he retired in 1963. But another, more important discovery was waiting in a large old trunk that had been carelessly left around. It contained a typewritten manuscript bound in fifteen volumes that stretched to fifteen thousand pages. (MacGregor calls it the "longest piece of imaginative prose ever written" and "as long as the *Encyclopedia Britannica*.") Three volumes of illustrations accompanied the text. In addition there was a detailed *Book of Weather Reports*, scrapbooks, diaries, and letters, along with notes, sketches, and statistical tables about fictional battles.

The discovery was a complete coincidence, but Lerner understood its value immediately and resolved to preserve everything left by this great artist. For the next quarter of a century he would keep Darger's room exactly as it had been when he lived there.

In the home for the elderly Darger was introverted and melancholy, a quiet and inconspicuous old man. Berglund visited Darger at the home immediately after the discovery of his works. He could barely contain his enthusiasm as he told Darger what he and Lerner had found. But Darger's reaction was a strange one: "It was like I had punched him in the stomach, taken the wind out of him, and he said 'it's too late now.' He didn't want to talk about it."[4] Six months later Darger died alone. As this episode makes clear, Darger was completely free of any worldly ambition to publicize or promote his work. And yet today there are frequent exhibitions of his work in New York and Japan, and he is becoming known in Europe. Of course, we cannot know if this is something that Darger would have wanted. MacGregor reminds us that no matter how respectfully we treat his work we still run the risk of being trespassers in his world. It may be a contradiction for someone like MacGregor to say so, since it is he more than any other person who is responsible for introducing Darger's works to the world. But when we think of the irresistible charm of Darger's works

it is easy to understand why he did so, and his self-doubting stance is an understandable attempt to preserve at least some sense of the ethicality of his actions.

In the Realms of the Unreal

The epic to which Henry Darger literally devoted his entire life was titled *In the Realms of the Unreal, or The Story of the Vivian Girls, in What Is Known as the Realms of the Unreal, of the Glandeco-Angelinian War Storm Caused by the Child Slave Rebellion*. It consists of seven hand-bound volumes of tightly packed thin typewritten pages and eight bundles of handwritten pages. The total length of the text is 15,145 pages. It is so massive and so poorly preserved that not even MacGregor has read it in its entirety for fear that the handwritten pages might disintegrate in the process of unbundling them. He points out that the only way to publish it would be to carefully scan the entire text and put it onto a CD-ROM. In addition, there are the more than three hundred illustrations accompanying these manuscripts, along with the paintings that have secured undying fame for this as-yet-unread author. Many of the paintings were done in the form of scrolls, the longest of which measure up to 360 centimeters. Darger often painted on both sides, which has meant that they are usually exhibited pressed between large pieces of glass rather than in conventional frames.

It is likely that Darger conceived the work as an adolescent but actually worked on it over the sixty-one years from age nineteen to eighty.

Initially imagined to take place on another planet, the otherworldly narrative relates the history of the war between an army of angelic slave girls and an evil male slave owner who has seized control of the Kingdom of Glandelinia. In his early notes about the novel Darger wrote, "This description of the great war, and its following results, is perhaps the greatest ever written by an author. . . . The war lasted about four years and seven months in this story, and the author of this book has taken over eleven years in writing out the long and graphic details, and has fought on from day to day for the christians side this long and bloody war."[5]

The seven "Vivian Girls" (also known as the "Vivian Sisters" or the "Vivian Princesses") who are the heroines of the story are beautiful blonde girls from five to seven years old. The sisters are devout Christians, brilliant strategists, and crack shots. Darger extolls their virtues:

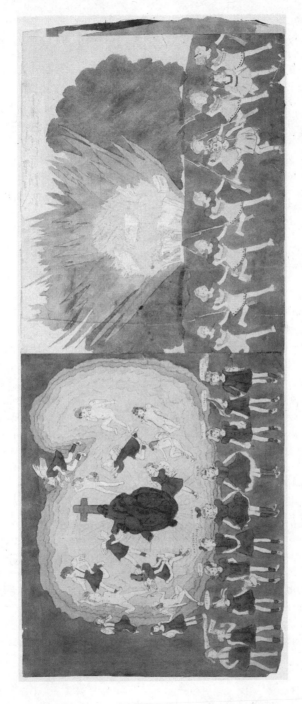

Henry Darger, untitled. Watercolor and pencil on paper, 19 x 49 inches (48.3 x 124.5 cm). Copyright Kiyoko Lerner. Courtesy of Andrew Edlin Gallery, New York.

Robert Vivian himself was the father of seven little Vivian girls whose beauty could never be painted had they been seen for real. Of Violet, Joice, Jennie, and Evangeline, their beauty could never be described, but their nature and ways in goodness and soul was still more pretty and spotless. And no Evangeline St. Clare could beat them in their kind loving ways and their love for God. They were always willing to do as they were told, keeping away from bad company and going to Mass and Holy Communion every day, and living the lives of little saints.[6]

Wearing matching outfits, they are watched over by God as they subdue giant dragons and head into battle, sometimes escaping torture or death by a hair's breadth, but they invariably come out alive. They are always bright and cheerful, and their religious faith is steadfast. Often compared to the Virgin Mary, they are supernatural beings endowed with immortality. As is always the case in stories of this sort, the Vivian girls never age.

The "Blengiglomenean serpents" that accompany the Vivian girls are kind beasts with huge wings, goats' horns, and long serpents' tails. These female creatures have individual names and vary in shape. Sometimes the "Blengins" transform themselves into girls and are capable of speech. They love children dearly and often appear in the story to protect them from their enemies.

Darger was both the historian recording this war epic and a character within the story. The descriptions of the battles were based on his extensive knowledge of the American Civil War, a subject of great interest to him. But the slaves to be liberated by this war were "child slaves." As the war engulfs several nations, a complex network of battle lines is drawn. On the seas the ports are blockaded by ships, submarines, and mines. Darger describes all of this as if he were a war correspondent sending in reports from the front, written in journalistic style. The war gradually intensifies and expands to embroil even noncombatants. The cities are occupied by the Glandelinians, and their inhabitants become starving refugees who flee to the Christian lands. And orphanages everywhere overflow with children who have fallen victim to war and natural disaster.

At one point the Vivian girls discover an old book that contains detailed descriptions of an imaginary war. They find out that this war has something to do with them and that Henry J. Darger has signed it as author. Yes, this narrative is metafictional as well!

When the girls' uncle sees the narrative he says that he wants to buy it and publish it.

"I think I'll try to have him sell me these books and I'll have them published. There is a big fortune in these books for him. He could make three hundred thousand dollars on one of them alone, and there is over nineteen of them here. And I'd like to buy the pictures too if he would sell them."

But the girls object.

"I'm sure he won't Uncle," said Catherine, "On the back of them is written the words,

'All the Gold in the Gold Mines
All the Silver in the world,
Nay, all the world,
Cannot buy these pictures from me.
Vengeance, thee terrible vengeance on those who steals or destroys them.'"[7]

From this passage it is evident that Darger believed that his book was good enough to publish. But he never tried to do so. Why would this be? Most likely because he needed to keep it for himself alone. Perhaps it was only through this sort of secretive monopolization of the work that he could both heighten and safely maintain the reality of his fictional world.

There are other places throughout the narrative expressing Darger's fear that his paintings might be stolen or destroyed. And this is precisely what happened after his death. His works are now treated as excellent investments, and their prices continue to rise. It is not clear why his works are circulating on the market at all, given the fact that Lerner donated the collection to the Collection de l'Art Brut in Lausanne. MacGregor, for his part, believes that it is morally wrong to buy and sell Darger's work.

Darger's Technique

Darger is best known for his paintings, but his narrative also overflows with the strange charm of outsider literature. "The writing style is characterized by unusual grammar, the rhythmic repetition of words, and the use of neologisms. The punctuation is bizarre when there is any. This is outsider literature, the equivalent of outsider art."[8] MacGregor refers to it as Darger's "reinvention of language."

The children were frightfully massacred about the prison yards until their life blood covered the streets. Everywhere there was a howling tumult, the poor children being intermingled in a howling sea of gray coats. . . . many of these poor little ones with even women and nuns sank hewn asunder. One after another sank with dying cries and soon there formed a pile of corpses and the streets began to run red.

Fancy the yells of these wicked Glandelinians, their faces covered with sweat and blood, the fiercer shrieks of more women and children crying "Mercy, oh please have mercy." But there was no mercy.[9]

Scenes of destruction and slaughter are described at great length, and the scenes follow on each other like cinematic cuts. As I discuss later, his descriptions are clearly preceded by internal images. It is as if Darger is simply recording the visions that he is seeing in his own mind. Perhaps because of this, the scenes unfold vividly without seeming verbose or monotonous, despite the text's enormous length.

As Darger wrote this massively complex narrative, he used many supplementary notes and created tables with statistics noting the deaths of generals and battle wins and losses, as well as the number of casualties. He made maps, flags, and military standards for each of the regions involved.

It appears that Darger began making the illustrations only after he had almost completely finished writing the narrative. He was convinced that he could not draw, but his desire to draw grew so great that he finally began to do so using his own original techniques. He made tables showing the illustrations that would be needed for each chapter and checked off each one as he completed it.

The main protagonists in the paintings are, of course, the girls, who number in the thousands. Darger was clearly fascinated by very young girls. He had collected thousands of images of girls that he cut out of newspapers and magazines picked up on the streets and from comic books, coloring books, and children's clothing catalogs. These "adopted children" (MacGregor) became the basis for his illustrations.

Darger used collage techniques to compose complex battle scenes. These collages were often extremely detailed and complex, so much so that some of them cannot even be captured in photographs. Often he ran into difficulties because the size of the horses and the people he had clipped out of magazines did not match. But in 1944 he discovered a new method of collage. He began to take the cutout images of people, horses, and buildings to a nearby drugstore to have negatives made, of

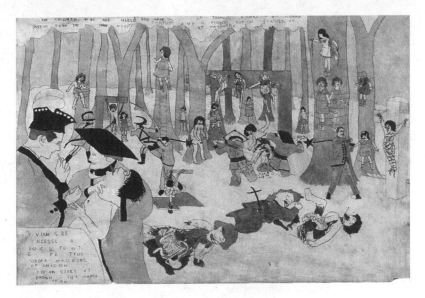

Henry Darger, untitled. Watercolor and pencil on paper (detail), 22 x 88 inches (55.9 x 223.5 cm). Copyright Kiyoko Lerner. Courtesy of Andrew Edlin Gallery, New York.

which he then ordered eleven-by-fourteen-inch prints. This made it easy to adjust the scale of the images, and by tracing them it was possible to create large-scale, relatively simple drawings. The traced images of the little girls were then carefully arranged within the painting. The paintings often used several little girls traced from the same image, the repetition producing a unique rhythmic effect.

When he set his mind to it, Darger was capable of painting extremely beautiful landscapes: black clouds portending a storm, bleak battlefields strewn with exploding bombs, and gardens overflowing with huge flowers in bloom. One of the greatest charms of Darger's painting is the lyrical quality of his watercolors. When even the most gruesome battle scenes are rendered in these pale tones, they are infused with a mythical sublimity. It is not mere technique that enables this sort of effect, but a simple faith in the possibility of *using images to rival reality.*

Pathology or Perversion? Viewing Darger as a Shut-In

According to MacGregor, the psychiatrists he consulted about Darger all insisted that his illness was unique, and none could agree on a precise

diagnosis. Among the possibilities raised were autism, Asperger's syndrome (high-functioning autism), multiple personality disorder (more correctly known as dissociative identity disorder), Tourette's syndrome, and other nervous disorders involving hypergraphia. My clinical knowledge suggests to me that he was not autistic. It is, however, worth noting that multiple personality disorder is included on this list. The following anecdote is one of the pieces of evidence that have been put forward for this diagnosis. According to Lerner, Darger would have conversations lasting many hours with imaginary guests, even acting out their voices. These included high-pitched women's voices and gruff masculine voices. And sometimes he would sing to himself. If these were not hallucinations on Darger's part, we might be right to assume that they were manifestations of multiple personality disorder. I would disagree with that diagnosis, however, based on the fact that these "multiple personalities" did not have any effect on Darger's relations with other people. It is highly unlikely that multiple personalities would have no impact on an individual's personal relationships. The conscious manipulation of a separate daytime and nighttime self is, moreover, quite another thing than multiple personality disorder.

Consequently, all we can advance at this point is the negative assertion that it is unlikely that Darger was mentally ill. If he did suffer from multiple personality disorder, we could only say that he was able to use it in an adaptive fashion; it would be meaningless to argue anything further. As for autism, Darger did exhibit some symptoms of social anxiety and anthropophobia, neither of which is found in autistic children. Autistic children do not close in on themselves to avoid other people. They simply have very little interest in others.

If we leave aside the question of diagnosis for a moment and consider Darger's sexuality, we are confronted with a great deal of truly diverse material. His narratives, of course, do not contain any overt descriptions of sexual acts. They are limited to romance between boys and girls and a light kiss here and there. According to MacGregor, it is in the scenes of violence that Darger gives full expression to sexuality in his writing, as in the following scene, for example.

A frenzied mob of Glandelinians came swarming for the prisons of Violet and her sisters. The standards they followed were the heads and even gashed bodies of six beautiful little children, with their intestines protruding from

their bellies, and every one of these were on pikes dripping with blood. . . . they thrust the heads into their laps ordering them to make a copy of them in pencil. . . . And though it seemed as if they would die of horror they thought it best to obey, and as their arms were freed, and paper and pencils had been given to them, they started in to draw the hideous bodies and heads, being good at drawing pictures in the most perfect form.[10]

The atrocities committed on the little girls appear to be motivated by extremely sadistic impulses. Here already is the stamp of pedophilia and sadism. But in terms of sexuality, the most remarkable thing is the penises on the little girls. Darger may in fact have lived his entire life as a virgin. But could it be true, as several theorists have speculated, that he remained ignorant of the physical difference between males and females? I am extremely skeptical of this claim. The fundamental lack implied by an ignorance of sexual difference would make any sort of desire completely inconceivable. This makes Darger's case extremely interesting from a psychoanalytic perspective. Clearly he recognized that there was a difference between the sexes. But at the same time he had no clear knowledge of its basis. Are we to understand this as a pathology of "disavowal"?

Darger's refusal to grow up appears to be a refusal or disavowal of castration. He remained a child in the true sense of the word for his entire life. In his autobiography he writes, as if he were mumbling to no one in particular: "Do you believe it, unlike most children I hated to see the day come when I will be grown up. I never wanted to. I wished to be young always. I am grown up now and an old lame man, darn it."[11] Darger lived his entire life experiencing the emotions of puberty. Leading a life completely void of any opportunity for encounters with important others, he saw nothing desirable in the idea of "growth" or "maturity."

As is well known, the disavowal of castration is at the root of a number of sexual perversions. Did this make Darger a pervert? As far as his work goes, one could hardly ask for more signs of perversion. But what about his actual life? Compared with someone like Lewis Carroll, who wrote similarly pedophilic narratives and was also quite active in "practice," Darger's perversion was quite modest. It appears that what Darger loved were the images of little girls he cut out of magazines and the little girls he wrote about. The only exception to this might be the fact that he did once try to adopt a child himself. He failed to fulfill this desire because he did not meet the requirements of the adoption agency, and this incident

awoke in him an anger toward God. Should we see traces of perversion in this episode? It would perhaps not be impossible to do so. But neither would it be very meaningful.

In my opinion Darger's difficulty adapting and his creativity both originate in his adolescent mentality. The question, then, is how he was able to preserve his adolescent mentality undamaged for so long. Like his creative activities, his habit of collecting was marked by a conspicuous degree of compulsion. His belief system also incorporated certain magical elements that go beyond what might be explained by his devout Christian faith. All of these tendencies can be considered the result of a prolonged adolescence made possible by his complete isolation.

Darger clearly desired relations with others but was unable to have them. If he suffered from any pathology, it was the tendency toward anthropophobia and social anxiety mentioned earlier. It would not be at all surprising if the cruelty he experienced from early childhood through his youth had caused him to exhibit these sorts of symptoms. It may also have caused him to live the life of a shut-in *(hikikomori)*, which in turn could have been decisive in preserving his adolescent mentality. As I mentioned earlier, "shut-ins" are not autistic. They desperately desire contact with others but are so afraid of being rejected that they isolate themselves instead. Autistics, on the other hand, are largely uninterested in other people, which only makes them *appear* isolated. We now know, moreover, that autism is the result of a physiological impairment to the brain. In the case of Darger we cannot of course say for certain that he had no intellectual impairment at all, but if he did it was a mild one. Impairments can arise in harsh conditions like those in which he was raised. So I would argue that Darger's "impairment" was psychogenic, a result of his upbringing and his experiences of trauma. I say this partly from a clinical perspective but also because I want to establish as clearly as possible that what happened to Darger could happen to anyone, depending on the environment. In other words, I want to argue that Darger was a neurotic.

But let me get back to the discussion of the shut-in. In my experience this sort of voluntary isolation has an addictive quality, and when it continues beyond a certain point it can be virtually impossible to break out of on one's own. It can also become a breeding ground for a variety of other pathologies. Defense mechanisms such as dissociation, splitting, and projection tend to run wild, giving rise to all sorts of symptoms. And in fact all of the "symptoms" that Darger displayed can be interpreted as

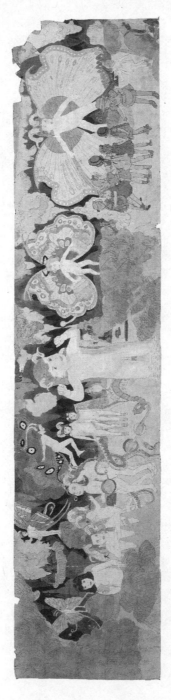

Henry Darger, untitled. Watercolor and pencil on paper, 24 x 110 inches (61 x 279.4 cm). Copyright Kiyoko Lerner. Courtesy of Andrew Edlin Gallery, New York.

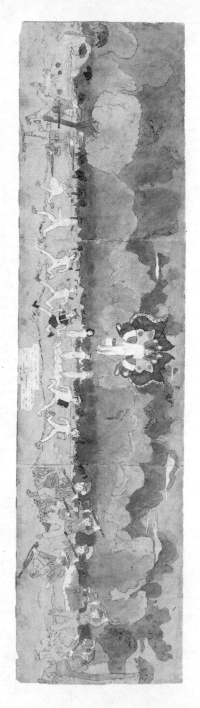

Henry Darger, untitled. Watercolor and pencil on paper, 22 x 88 inches (55.9 x 223.5 cm). Copyright Kiyoko Lerner. Courtesy of Andrew Edlin Gallery, New York.

the result of these sorts of mechanisms. Even the "other world" that he created could easily be interpreted as one such symptom.

It is highly likely that Darger's "Realm" had its origins in sexual fantasies from his adolescence. These fantasies seem to have developed almost entirely autonomously. In other words, Darger did not have to struggle to conceptualize his "Realm." It is likely that he felt that he was simply recording the world as he saw it, as a conscientious historian would. His ability to continue this sort of practice uninterrupted for sixty years was attributable to his isolation. MacGregor also argues that the secrecy in which he worked contributed to his persistence, but it was his shut-in condition that enabled the secrecy to begin with.

Often Darger's creative output would move forward in ways outside his control. In 1912, for example, he lost a photograph of a child whom he called Annie Aronberg. The child in the photo was the victim of a kidnapping and may, in Darger's mind, have overlapped with the younger sister he had lost. He did everything he could to find the photograph again, including setting up a shrine to her, saying mass for her, and renouncing some of his pleasures. But his wish was not granted. He became furious and threatened the God who refused to heed his prayers. At the same time the course of his narrative changed drastically. The battles became more intense, and the Vivian girls were subjected to torture. Darger, who had been a protector of children in his narrative, left the Catholic Church and entered the Glandelinian Army. Was he becoming confused about the distinction between fact and fiction? The Realm, in any case, began to overflow with cruelty. Where, for example, was Darger drawing the line between reality and fiction when he wrote this passage:

> Am an enemy against the Christian cause, and desire with all my heart to see to it that their armies are crushed! I will see to the winning of the war for the Glandelinians. Results of too many unjust trials. Will not bear them under any conditions, even at the risk of losing my soul, or causing the loss of many other, and vengeance will be shown if further trials continues! God is too hard to me. I will not bear it any longer for no one! Let him send me to Hell, I'm my own man.[12]

Tens of thousands of child slaves are crucified, hanged, burned at the stake, and strangled. Their stomachs are cut open, carved up, and minced into pieces, and the earth becomes a sea of their mutilated organs and blood. Descriptions of this carnage apparently go on for several hundred pages.

As the war intensifies, for some reason nature itself begins to take part in the slaughter. Natural calamities such as hurricanes, earthquakes, mysterious explosions, floods, and forest fires wreak havoc and destruction everywhere. The earth is covered by floods, and the hills and forests are engulfed in flames. "There were fierce fires burning in the wreckage, which afforded the only light there was. When no fires were burning, everything was in total darkness, save where the red glow could be seen in the sky."[13] Darger described the burning of the forest with a strange passion. MacGregor points out that these descriptions contain sexual overtones.

> Bigger and bigger grew the fire sea, rushing forward like a wild cyclone, a roaring rushing sea of flame. It is now a veritable sea of fire clouds, leaping hundreds of thousands of feet, and driven forward by an unusually strong gale evidently originating in the heat of so much fire. It was a most dreadful fire hurricane of enormous magnitude, beyond description horrible.[14]

As these quotations show, Darger's prose is extremely visual. In many sections it seems that he is directly describing scenes that have appeared to him in visions or hallucinations. I would suggest that he may have had a photographic or "eidetic" memory. Such individuals have an extraordinary ability to remember and manipulate visual images. While this is very common among children, it tends to diminish with maturity. This is where Darger's status as a shut-in comes into play. Not only might it have helped prolong his adolescence, it might have helped preserve his eidetic memory.

Darger's eidetic memory may also have been complemented by his work with visual media, such as photographic enlargements. Enabling this chain of processes, perhaps, was the world of his creation as an autonomous space of reality; in other words, an autonomous economy of desire. These processes might also be theorized as actions taken by neurotics in certain situations to transform their fantasies into a motive force for creative acts. In this case, the eidetic images are external to representation and work recursively to activate fantasies through narcissistic circuits. If we are to see Darger not as someone who was mentally ill but as a neurotic like the rest of us, we cannot overlook this productive coupling of his adolescent mentality with the media environment. It is here that we find the basis for a connection linking Darger with the otaku in Japan today.

So let us ask the question once again. Why do little girls head off to war? What is behind the iconic universality of the armies of beautiful fighting girls? I am now convinced that this coupling of adolescent mentality with the media environment renders their emergence inevitable. But before I discuss the basis for this assertion I want to make a few "clinical detours" exploring the genealogy of the beautiful fighting girl.

A GENEALOGY OF THE BEAUTIFUL

FIGHTING GIRL

The Beautiful Fighting Girl Today

Disney's *Mulan*, which was released in 1998, is based on the story of a legendary Chinese girl, Hua Mulan. This work will probably prove momentous in the history of Disney in at least two respects. As already mentioned, it is the first Disney anime to be set in East Asia. And it is the first time a Disney story has had a beautiful fighting girl as its heroine. The point is not simply that Disney made an anime, but that Disney animation was Japanized, or turned into "Japanimation." So it unexpectedly blew the cover on Disney's continual denial of the influence of Japanese anime—we cannot, of course, forget the *Lion King* incident. This confirmed for us once again that disavowal means acknowledging something by denying it.

In this chapter I would like to present as empirical a genealogy and history of the beautiful fighting girl as possible.[1] This genealogy, however, consists of many works, which span a number of spheres: animated films, live-action films, comics, and even computer games of recent years. If I included short works, there would be hundreds on the list, and it would be impossible to include them all in one book. There are, however, several principal lines of descent in the genealogy of beautiful fighting girls, and so I aim to present a broad outline of those.

Let's begin with a brief look at how things are today. It's a bit old, but I have at hand the June 1997 issue of *Animage (Animēju)*. This issue of the venerable anime magazine lists the results of its nineteenth annual "Anime Grand Prix," a poll they conduct in which readers vote for their favorites. I'm going to discuss it in segments because it is teeming with items of great interest in terms of present-day beautiful fighting girls.

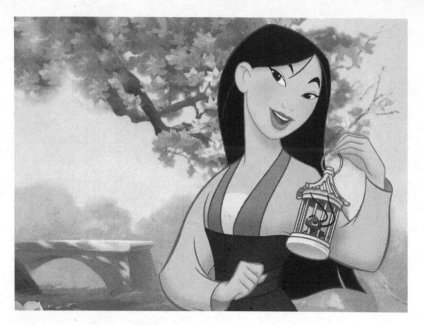

Fa Mulan, protagonist of *Mulan* (1998)

First, the top ten anime titles are as follows.

1. *Evangelion (Shinseiki Evangerion)*
2. *Slayers Next (Sureiyaa NEXT)*
3. *Nadesico (Kidō senkan Nadeshiko)*
4. *Gundam Wing (Shin kidō senki Gandamu W)*
5. *Sailor Moon Sailor Stars (Bishōjo senshi Seeraa Mūn Seeraa Sutaazu)*
6. *Escaflowne (Tenkū no Esukafurōne)*
7. *After War Gundam X (Kidō shinseiki Gandamu X)*
8. *Saber Marionettes J (Seibaa marionetto J)*
9. *Rurō ni kenshin (Samurai X)*
10. *Bakusō kyōdai Rettsu & Go!! (Bakusō kyōdai Let's and Go!!)*

It's difficult to tell just from the titles, but beautiful fighting girls appear in numbers 1 through 9 (including female soldiers in squadrons). Moreover, if you include numbers 11 through 20, they have active roles in sixteen out of twenty works. In other words, about 80 percent of the representative anime released in Japan in 1996 had beautiful fighting girls as their main characters.

If we think of anime as a means of representation like manga, film, and television—that is, as a neutral medium—then this percentage cannot help but strike us as extraordinarily high. Consider that, until *Mulan*, there had not been a single Disney anime featuring a fighter heroine (one who literally fights—not one whose personality was that of a fighter), or alternatively, think about the list of that year's top films. You can readily see how unique this type of heroine is, even in the fantasy genre. Inexplicably, there has been almost no critique or analysis of this singularity.

Of course, fighting heroines per se are not particularly unusual even in the West. Amazonian heroines are depicted frequently in the world of science fiction and fantasy. Tough fighting women also appear frequently in Hollywood movies. However, such works are still relatively few compared with the number of them in Japan. And those few characters differ considerably in nature from the Japanese form of the beautiful fighting girl in the strict sense. I have more to say about this later.

Moreover, this difference is not confined to anime. Nowadays the beautiful fighting girl character is practically a staple in the world of video games and comics as well. Furthermore, as we will see, the beautiful fighting girl is so much a part of the fabric of television anime history that it has already attained its own particular universality. The spread of this in Japan; its rarity in the West: the contrast is fascinating when we consider the interaction of media and desire. This universality seems to have accelerated in the 1990s. My goal here is to trace the history of the beautiful fighting girl and, in doing so, to interpret the transformations of our desire as it has been mediated by the media.

However, I must stress that it is impossible to explain the origin of the desire directed toward the beautiful fighting girl (assuming that it is possible to specify this kind of thing) in terms of a single cause or a simple cause and effect relationship. Based on my own clinical experience, I can say that it is not possible for any phenomenon that persists over time to have a single cause. Even for a psychological wound to be able to persist over time, repeated reinforcement is necessary. Conversely, there must be frequent flashbacks in order for persistent damage to result from a trauma caused by an accident, for example. If there is nothing to reinforce the injury, that type of damage is not difficult to treat. The same is true of the causes of desire. It is probably necessary here to posit a number of factors and some mechanisms in the environment that would reinforce them.

Okada Toshio, whom I mentioned earlier, made the following remarks about the beautiful fighting girl—boom, shall we say?—when we both appeared as commentators on AXEL, the TV Asahi news program, broadcast on June 21, 1996.

"It isn't that the fighting girl is attractive on her own. What is important is that she can be woven into the media-mix strategy—into a movie, into an anime, into a game—from the beginning."

"Sex and violence are the foundations of otaku culture."

"We can no longer place our dreams in boys. People are seeking catharsis in the fighting of the weak."

Here, too, Okada's pronouncements are backed by the confidence and persuasiveness of someone who has been there. We should pay particular attention to the part where he mentions the "media mix." It would probably be difficult for someone who has never had the experience of being on the production side to come up with an idea like this. But it is also difficult to fully understand the inevitability of the fighting girl on this basis alone. The same holds true of the interpretation "catharsis in the fighting of the weak": considered in this context, there is nothing at all unique about a beautiful fighting girl. It could just as easily be an old man or a young boy. Of course, there is an actual example—the anime *Rōjin Z* (Old man Z, 1991)—but this should probably be considered an exception. The part where Okada alludes to otaku sexuality is also important, but the way he dismisses it with the rather stereotyped expression "sex and violence" is extremely problematic. Even as we recognize that there is a certain persuasiveness in Okada's clarity, it is also necessary now to find an analytic perspective capable of taking us beyond this sort of privileging of experience.

As a creator of anime, Okada knows exactly what he is doing when he uses the icon of the beautiful fighting girl. As I mentioned at the beginning of the book, the plans for the OVA masterpiece *Gunbuster (Toppu o nerae!)* originated in the strong conviction that the combination of "a girl and a giant robot" would be popular.[2] However, the actual production process of the work clearly deviated from the initial plan. As a result, a first-rate anime was produced, which was not only successful commercially but also as a parody and a story. This fact raises an extremely important problem in terms of thinking about beautiful fighting girls. Of course, it's possible that the initial plans were consciously created with the thought in mind that "if we put a half-naked girl on a giant-size robot and make her fight, we'll have a hit." However, what we must consider

is that, paradoxically, a work's success can manifest in a form that transcends or betrays the intent of the creator. This would be inconceivable in the absence of the particular reality of the representational object known as the beautiful fighting girl. This work is very important in relation to the examination of the genealogy of the beautiful fighting girl, so I will touch on it later in a bit more detail.

Miyazaki Hayao's Experience with *Panda and the Magic Serpent* (*Hakuja den*)

Miyazaki Hayao dates his own beginnings as an animator to his seeing the 1958 Tōei animation *Panda and the Magic Serpent* during his third year of high school. His feelings toward the heroine, which resembled romantic love, made this first experience of anime a formative one. This work, depicting the tragic love between Bai-Niang, the spirit of a white serpent, and a human youth, was Japan's first genuine full-length, animated color film. Of course, in later years Miyazaki criticized *Panda and the Magic Serpent* as a shoddy work not worth thinking about and recalled that the kinds of romantic feelings he had had were merely a "substitute for a girlfriend," or rather that this is what they should have been.[3] This episode is quite interesting in many respects.

To love an animated beautiful fighting girl: this is tantamount to finding sexuality in an animated work. It would seem that the expression of sexuality via an animated film was already built into Japan's early animated works. Because there is a scene in which she does battle with a monk who tries to obstruct her love, the heroine Bai-Niang qualifies as one of the earliest beautiful fighting girls. Regardless of whether this fighting girl was intentionally sexualized, she clearly held a sexual attraction for the adolescent Miyazaki. This fact is heavy with meaning. And on two levels.

There are almost no examples of intentional representations of sexuality in the major animated works of the West. The very idea that anime could be used as a way to express sexuality is difficult to conceive there. Rather, the fact that Japanese anime deal with sex is itself a scandal, to which a number of countries are already overreacting. For example, in Spain even Miyazaki's anime receive a "for mature audiences" rating at present. Let's withhold judgment for now as to whether to regard this as healthy intuition or a strange immune reaction on the part of a weakening nation-state.

In any case, we should remember that the representation of sexuality in animated works, a circumstance unique to Japan, was something for which the way was prepared (at least latently) at the beginning of animation history. And the experience of this sexuality exerted an influence close to that of a trauma on one of the most important artists in the history of Japanese animation. This fact has another, more crucial significance, because it appears that animated beautiful girls have actually fostered a continuous repetition of the trauma.

Why is *Panda and the Magic Serpent* a "trauma" for Miyazaki? This is also clear from the ambivalent attitude Miyazaki assumes when discussing this work. As an anime he rejects it as rubbish, while repeating the story of its being a formative experience for him. Isn't the traumatic nature of this experience inscribed in Miyazaki's words, "I like this work, but it's bad"? Miyazaki can keep refusing to acknowledge this work, but he can never, ultimately, repudiate it.

Of course, it is true that Miyazaki has not been directly hurt by this experience, nor is he trying to forget it. In other words, there is no "repression" here. Some will claim that for this reason it cannot be considered a trauma, but they would be wrong. The young Miyazaki fell in love with the heroine of this film despite the fact that it was a work of animation. The experience itself may have been like a sweet dream, but he is still plagued by the fact that he had been made to experience pleasure against his will by a fictional construct. The heroine that becomes an object of love at that moment is an object of desire, but at the same time, because she is fictional, she also contains already within her the occasion for loss. And the traumatic nature of this experience goes on to manifest itself as a definite, if modest, "split" later in Miyazaki's career.

Miyazaki is cool toward so-called anime fans (he discreetly avoids the word *otaku*). His utter disregard for what anime fans think of his films comes out in remarks like "No matter how bad a piece of rubbish you make, it will always attract a few anime fans" or "I know my work will be popular with anime fans, so I direct my efforts toward others." As mentioned earlier, Miyazaki insists that loving an animated heroine is a substitute satisfaction, nothing more than a stage on the way to maturity. Young men who become attached to an anime heroine are dismissed with the single phrase "Lolita complex."[4] The stance Miyazaki adopts when talking about his works is invariably a wholesome one. Nevertheless, there is no doubt about the fact that the heroines Miyazaki creates (Clarice, Nausicaä) occupy a position of supreme importance in terms of the

expression of sexuality in anime. Why does he place so much importance on young girls? Miyazaki himself has tried to talk about this, but it always results in ambiguous expressions like "Because it's more real that way" or "Because that way I'm able to depict them with feeling." This is quite strange when contrasted with the fact that he speaks about the characteristics of Japanese anime expression with an analytic clarity you would not expect from someone so closely involved. I would argue this strangeness can be interpreted as the trauma and its repetition. Miyazaki's preoccupation with the animated girl clearly originates in his traumatic experience with *Panda and the Magic Serpent.*

The trauma and its repetition, moreover, are intertwined with the history of anime, at least latently. This is most evident in the genealogy of the depiction of the beautiful young girl in the history of Japanese animated expression. A generation traumatized by anime creates its own works that repeat the wound. That wound is taken over and repeated by the next generation. With this kind of repetitive pattern in mind, let us now turn to a sketch of the history of Japanese anime.

A Short History of the Beautiful Fighting Girl

The 1960s

The 1960s constitute the "prehistoric age" in terms of the history of representation of the beautiful fighting girl. We can see several important precursors, but the kinds of manifestations that are of central significance to this book are not yet in evidence. Here I take up the group of works that can be considered forerunners.

First is the initial serialization of Ishinomori Shōtarō's *Cyborg 009 (Saibōgu 009)* in the weekly magazine *Shōnen Sandee* (Shōnen Sunday) in 1964 (it was made into an anime in 1968). A typical Ishinomori work, it belongs to the early period of the science fiction squadron genre. One of its nine cyborg warriors (Françoise Arnoul) is female, and from this point it became standard practice for nearly all works in the squadron genre, whether anime or tokusatsu, to include a female soldier.[5] We'll call this the "single splash of crimson" lineage. Ishinomori employs the beautiful fighting girl somewhat self-consciously, a tendency that became more noticeable in his 1967 work *009 no ichi (Zero zero ku no ichi,* later made into a live-action drama). The females in both of these works were more women than girls, so in that regard they should probably be considered precursors rather than full-fledged members of the beautiful fighting girl

genre. But there is no mistaking Ishinomori's importance as an author because of his "discovery" of a unique combination of sexuality and violence.

Ishinomori was also active as one of the creators of *Rainbow Battleteam Robin (Reinbō sentai Robin)*, an anime first broadcast in 1966, in which a female robot named Lily appeared. The female (little girl) robot Uran in *Astro Boy (Tetsuwan Atomu)* was an earlier example of this, but *Rainbow Battleteam Robin* was the first anime in the single splash of crimson lineage, and Lily was a pioneering depiction of a female soldier character in anime. The female group members in non-Japanese dramas such as *Star Trek* are frequently given nondescript roles as noncombatants, such as communications officer. In contrast to this, female soldiers were already appearing in works created in the early days of the science fiction squadron genre of Japanese anime. Lily does participate in combat, but her main role is as nurse to the soldiers. Portrayals of the beautiful fighting girl as a healer—of which there have been an increasing number in recent years as well—were already established by this time.

Ishinomori continued to contribute works in the beautiful fighting girl genre after this: even in the 1990s he furnished the script for works such as *Bishōjo Kamen Powatorin (Bishōjo Mask Poitrine)*, a popular work in the Tōei tokusatsu fantasy series. He is one artist who has greatly influenced the beautiful fighting girl genre from its inception to the present day. His work is worth remembering as a particularly creative contribution to the genre.

Television broadcast of the anime *Little Witch Sally (Mahotsukai Sarii)*, based on a script by Yokoyama Mitsuteru, began in 1966. The "magical girl" lineage is another unique genre that has been passed down continuously to the present day. Here I want to emphasize the current that connects this genre to the genealogy of the beautiful fighting girl. The recent megahit *Sailor Moon* is both a beautiful fighting girl work and a magical girl work, making it the ultimate crossover between the two genres. In that sense, we can consider *Little Witch Sally* to be another starting point for the beautiful fighting girl. Incidentally, this work was partially inspired by the popular American broadcast television series *Bewitched*. By making the housewife a young girl, the Japanese adaptation was already implementing a process of juvenilization. Of course, it was probably natural to make the heroine of an anime aimed at children a young girl. But what is interesting here is that they looked to a drama for adults as a model for a program designed for children.

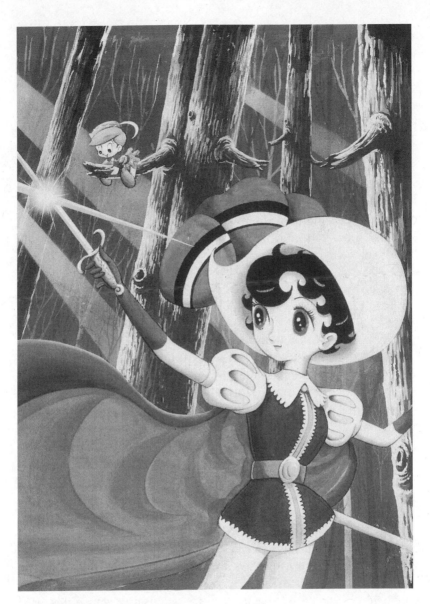

Princess Knight

The broadcast of the television anime *Princess Knight (Ribon no kishi)* began in 1967. Based on a work by Tezuka Osamu, the gist of the story concerns the struggles of the androgynous girl Sapphire, who is raised as a prince and heir to the throne. Sapphire is more of a fighting girl than a "beautiful woman in male clothing," yet this work belongs to an off-shoot rather than the mainstream of the beautiful fighting girl genre. Tezuka was a fan of the Takarazuka all-women theater revue, and this work clearly shows that influence. So we can call this and subsequent related works in which girls fight in male drag the "Takarazuka" lineage.

It is extremely significant that Tezuka chose the beautiful fighting girl genre for his third work here at the dawn of the anime tradition. As I discuss below, not only Tezuka but also the other masters of comics and anime, Ōtomo Katsuhiro and Miyazaki Hayao, each created representative beautiful fighting girl works. This in turn also suggests the effectiveness of the beautiful fighting girl itself as an expressive genre.

The year 1967 also marked the beginning of the initial broadcast of an anime based on Fujiko F. Fujio's *Pa-Man (Paaman)*, in which Pa-ko appears as a companion to the hero, Pa-Man. This work is important because it is the first instance of the "transforming girl" lineage. We also can't overlook the fact that Pa-ko's real identity is that of the pop singer/ idol Hoshino Sumire, anticipating the later anime tradition of "idol works."

Serialization of the manga *Lupin III (Rupan Sansei)* by Monkey Punch (pseudonym of Katō Kazuhiko) also began that year. This work, which inaugurated the charming fighting heroine Mine Fujiko, has been animated numerous times and was still being serialized in 2000 (although by a different artist). The establishment of ingenious characters that give rise to limitless variants by different authors in various media is reminiscent of the Chinese Monkey King tale. However, Mine Fujiko is depicted as a kind of Bond girl, a mature female in the fighting woman lineage, and so this work must be treated as ancillary when considering the genealogy of the beautiful fighting girl.

I mention here the live-action tokusatsu *Ultra Seven (Urutora Sebun)*, which is part of the "single splash of crimson" lineage, because of Yuri Anne, who is a member of the Ultra Seven squadron. Of course, this series featured female members throughout, but the sheer feminine presence of the heroine Anne, played by the actress Hishimi Yuriko, was quite remarkable. The character of Anne was a major idol and is still a legendary object of yearning for the young boy fans of *Seven*. That this principal actress has eluded oblivion—she continues to be so popular that

her autobiography is still read—has everything to do with the fictionality of her character. Anne was another charming beautiful fighting girl to emerge in the space of fiction.

Also in 1967, the unusual science fiction film *Barbarella*, starring Jane Fonda, was released in the United States. The film depicts in quite an erotic manner the battles of its heroine Barbarella, who travels to outer space to defeat Durand Durand, the incarnation of evil. This work belongs to the "fighting woman" lineage; the cute, brave figure cut by Barbarella dressed in her battle costume became an iconic portrayal of sexuality. This masterpiece is still talked about, along with *One Million Years B.C.*, released in 1966, which is remembered only for Raquel Welch's portrayal of the glamorous and gallant heroine.

Mochizuki Akira's manga *Suin wa V!* (V is the sign!), which began serialization in 1968, and Urano Chikako's television anime *Attack Number One (Atakku No. 1)*, first broadcast the following year, are both tales of grit and determination in sports featuring girl volleyball players and belonging to another source of the beautiful fighting girl genre. We can call this the "grit and determination" lineage. *Gunbuster*, mentioned at the beginning of this chapter, was a parody of this lineage and was also groundbreaking for its portrayal of a girl who is able to fight without sacrificing her girlishness. Because they had to maintain consistency of character, the Western fighting heroines that I discuss in detail below were forced to sacrifice their surface femininity. Japanese fighting girls are beloved precisely for the purity, frailty, and sweetness they evince at the height of battle; a similarly receptive environment is rarely seen in the West.

The feature-length anime *Little Norse Prince (Taiyō no Ōji Horusu no daibōken)*, which premiered in 1968, is a monumental work; two legendary anime artists, Takahata Isao and Miyazaki Hayao, were part of its production team. Although not a beautiful fighting girl, the heroine, Hilda, was quite popular. Her presence in it is one of the main reasons that this work attained the status of a masterpiece that attracts gatherings of fans even today.

The other creator of the 1960s who must be considered as seriously as Ishinomori is Nagai Gō, the author of *Shameless School (Harenchi Gakuen)*, which started serialization in 1968 in *Shōnen janpu* (Shōnen jump). Nagai helped invent the beautiful fighting girl as an object of sexuality and was also one of the fathers of the giant robot genre through his work *Mazinger Z (Majingaa Z)*. The beautiful fighting girl Yagyū Jūbei already appears in the first work for which he is known, *Shameless School*. This

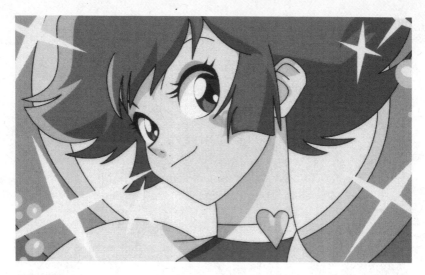

Cutey Honey

beautiful fighting girl icon, who fires a machine gun half-naked, recurs later in a number of different contexts.

Cutey Honey (Kyūtii hanii), a beautiful fighting girl of the transforming girl lineage created by Nagai, was broadcast as a TV anime in 1973, and recently there have been concurrent productions of both a new series and a feature-length anime version. Honey, the daughter of Dr. Nyogetsu, who developed the airborne element solidifier, does battle with Panther Claw, the crime syndicate that killed her father. Cutey Honey was explicit about the sexuality of the fighting girl, and the fact that she appeared naked when she transformed herself caused quite a stir. In addition, Nagai's masterpiece *Devilman (Debiruman)* is said to have been an intellectual influence on *Evangelion,* one of the most important works of the 1990s. From these things alone it is possible to grasp the range of influence of Nagai's works. Nagai somehow managed to discover (or invent?) an original otaku-esque sexuality. This becomes clear when his works are compared with those of George Akiyama, the other master of sexual expression active during the same period.

I can't go into this in too much detail here so I mention only the most conspicuous differences between the two. There is no doubt that Nagai's works have the potential to transform reality through the power of fiction. One sees hints of this in his frequent depictions of the deaths of

major characters. On the other hand, Akiyama paradoxically affirms reality through hopelessness and despair. His works are often unintentional hymns in praise of life. For him, fiction is merely something that serves reality. We can see this subordination of fiction to reality in the fact that Akiyama's *Zeni geba* is basically an indictment of the corruptive influence of money and *Haguregumo* a collection of proverbs without a story. The line that separates Nagai Gō from George Akiyama is essentially the same line that separates "otaku" from "non-otaku." In their expression of sexuality it is crucial to note that while Nagai privileges young girls, Akiyama stresses the maturity of his female heroines.

I discuss Nagai's 1970s works below.

The 1970s

The 1970s was a time when the outer moat of "otaku culture" was almost entirely filled up. It was also a time when several new streams flowed into the beautiful fighting girl genealogy. Particularly during the first half of the decade, the *Onna banchō* (Woman gang boss) series, shown with Tōei's yakuza films, is worth noting because of their distinctiveness in terms of genre. I won't discuss these works in detail because they were not generally popular, but I mention them because of their groundbreaking achievement in depicting sex in a new way and as a pioneering group of works that will relate to later works like *Delinquent Girl Detective (Sukeban deka)*.

Suki! Suki!! Majo Sensei (We Love You, We Love You, Magic Teacher), the live-action TV drama broadcast in 1971, tells the story of Heiwa Kanshiin Kaguyahime Sensei, the Shining Princess Teacher, Guardian of Peace, who protects people on Earth by transforming into a masked android to fight her enemies. Although not an anime, I bring this up here because it was the first work in which a beautiful fighting girl appeared as the protagonist. Transforming girls had already been depicted in works such as *Pa-Man* (1967) and *Secret Akko-chan* (*Himitsu no Akko-chan*, 1969), but this was the first live-action work in the "transforming girl" lineage. It was based on Ishinomori Shōtarō's *Sen no me Sensei* (Thousand-eyed teacher), another example of his wide influence. Rather than a beautiful fighting girl work, Tezuka Osamu's *Marvelous Melmo (Fushigi na Merumo)*, broadcast the same year, was intended for sex education. The scene in which a young girl eats a piece of magical candy and

transforms is a superb demonstration of the underlying meaning of the trope of transformation. That's right: transformation is none other than accelerated maturation.

Battle of the Planets (Kagaku ninjatai Gatchaman), a television anime that began broadcasting in 1972, was also an epoch-making work. The level of detail in the drawings and the sophistication of the setting were like nothing that had been seen in anime before and definitely played a part in preparing the ground for otaku culture. I myself experienced this work in real time, and I remember it having a completely different feel from the anime that came before it. A girl named Swan June is a member of the Science Ninja Team, which puts it in the "single splash of crimson" lineage. Her distinctive characteristic, unusual for the heroine of a squadron work, is that she is good at hand-to-hand combat. She mortally wounds members of the enemy squadron Gallacter with wire or a throwing knife. Even in the long history of beautiful fighting girl works, there are very few examples of this kind of "direct" depiction. This work also established the robot anime in which a robot doesn't appear, a fundamental form in the tidal wave of works that would constitute the giant robot genre.

The major works of the beautiful fighting girl master Nagai Gō came out one after another at the beginning of the 1970s. Here is a list. First, in 1972, *Mazinger Z* (anime version) and *Devilman* (anime version); in 1973, *Cutey Honey* (anime version) and *Violence Jack (Baiorensu Jakku);* in 1974, *Kekko Kamen* (live-action version), and so forth. I should probably single out *Cutey Honey* and *Kekko Kamen* because they have beautiful fighting girl heroines and they depict her sexuality intentionally. Nagai originally made his professional debut after having been an assistant to Ishinomori Shōtarō, and when you compare his works with those of Ishinomori, to whom he is otherwise very close in disposition, his shamelessness with regard to beautiful fighting girl sexuality really stands out. Both have a background in science fiction and are widely known for their successful fantasy manga. Also, as I mentioned earlier when discussing Ishinomori, it is not conceivable that they were unaware of the sexuality in their works. Nevertheless, the two have decisively different ways of expressing themselves. In Nagai there is a disposition toward excess that makes even Ishinomori look like an ascetic. This is discernible in the difference in the way time is portrayed in the works of the two, for example. Because these differences in the depiction of time are crucial to our understanding of the impact of manga on anime, I will examine them in detail in chapter 6.

Aim for the Ace!

The television anime based on Yamamoto Sumika's *Aim for the Ace!*
(Eesu o nerae!), which began broadcasting in 1973, portrays a young girl's
growth as a tennis player under the tutelage of a strict coach at a famous
tennis school in the midst of various stormy emotional dramas. This
work, part of the "grit and determination" lineage, had a definite influ-
ence on otaku culture: for example, *Gunbuster* (the Japanese title literally
means "aim for the top"), a work that I have already mentioned many
times, is a parodic adaptation of this work, as its title indicates.

Nagai Gō's work peaked in the 1970s, after which the next major work
was the TV series *Star Blazers (Uchū senkan Yamato)*, based on a work
by Matsumoto Reiji (his first name is usually spelled Leiji in roman let-
ters), which began broadcasting in 1974. The crew of the Yamato, who
are battling the pollution of Earth from radioactivity by Gamilon, are in a

race against time as they head to the planet Iskandar to obtain cosmos-cleaning equipment that can remove radiation. Although neither the manga nor the television series on which it was based were what you could call popular at the time of their release, the feature-length anime version became a record-breaking hit as soon as it came out in 1977. Its premise was plausible and more evolved and refined than that of *Mazinger Z*, and its characters were more complex. It made huge contributions to the beautiful fighting girl genre by hugely expanding the otaku market and by incorporating a "splash of crimson"–style heroine named Moriyuki. As the archetype of a female whose role as a soldier enhanced her femininity all the more, Moriyuki would go on to exert a huge influence on later works. Also, the migration of this work from manga to television anime to its breakthrough as a feature-length release set the standard for media mix at that time. With this work, the anime fan audience sector expanded all at once, and the dawning of otaku civilization came into full flower.

The birth of the otaku market and its rapid expansion were the most important historical movements of the 1970s. The first Comic Market (abbreviated as Komike) was held in 1975. This event has grown consistently in scale; it is now an enormous three-day gathering involving a half million people. There is no event in Japan today with comparable drawing power.

And then in 1976 came the first sales of the VHS videocassette recorder for home use. According to Okada Toshio, the advent of the videocassette recorder was a crucial event in the history of otaku. That year also marked the inaugural issue of *OUT*, which would later be known as an anime magazine, more precisely an *aniparo* (anime parody). The magazine, which was originally centered on subculture, published a special issue devoted to the anime *Star Blazers*, which remains a milestone in otaku history.

Ishinomori Shōtarō's television show *Himitsu sentai gorenjaa* (Secret squadron five rangers), a pioneering live-action squadron work, began broadcasting in 1975. This led to a massive revival of the squadron branch of the single splash of crimson lineage, which had ceased with *Cyborg 009*. From this time on, series featuring five-person squadrons appeared continuously in the form of live-action tokusatsu programs. The structure of a ranger unit with one or two female warriors remains basically unchanged to the present day.

The television anime *Star of the Seine (Ra Seenu no hoshi)* was broadcast the same year. This work continues the line of Takarazuka works that

Simone, in *Star of the Seine*

includes *Princess Knight* and *The Rose of Versailles (Berusaiyu no bara)*. Set in Paris on the eve of the French Revolution, it is the story of the Star of the Seine, a masked knight fighting the violent aristocrats who are tormenting the people. The premise was that the masked knight was actually a girl, the younger sister of Marie Antoinette. The television anime series *Time bokan (Taimu bokan)*, which also began broadcasting this year, was an extremely popular comedy. The standard format was for each series to center on a different treasure, which was the object of a struggle between a boy–girl pair and a trio of enemies who opposed them, which consisted of a female boss and two dense underlings. The position of the girl in this series puts it in the splash of crimson lineage. This work also established the pattern of conflict that would become standard in beautiful fighting girl works: pitting the righteousness of the beautiful fighting girl against the immorality of the mature woman. (The "mature = bad" pattern is frequently found in beautiful fighting girl works, but here we should also remember the theme of war between little girls and adults depicted by Darger.) Koga Shin'ichi published the manga *Eko eko Azaraku* in the same year, a popular horror work whose heroine, Kuroi Misa,

is a beautiful girl who practices black magic. Very few works continue the lineage of this one, which is really more that of the hunter, which came after it, than the magical girl. That may be why this work can boast such long-lived popularity, with a television series and three feature films produced in the 1990s.

Wada Shinji's manga *Sukeban deka*, serialization of which began in 1976, became a hit as a live-action drama in the 1980s. The legendary girl boss *(sukeban)* Asamiya Suki uses a yo-yo with a cherry blossom design as her weapon against evil while she patrols schoolyards that the police are unable to infiltrate. Wada's original manga was aimed at an audience of young girls who liked strong heroines and had nothing to do with otaku sexuality. The 1980s television drama version, however, which starred the top idols of the day—Saitō Yuki, Minamino Yōko, Ōnishi Yuka, Asaka Yui—significantly changed the reception of this work. The heroines in the original were tomboys with short hair, but when they engaged in battle on the television screen they were sweet girl idols rather than tough females. It's also very interesting to note that sailor outfits, which were not worn in the original, were used a great deal in the drama. The outfits themselves are androgynous, and they have a real impact when they are used as a signifier of girlhood. *Sukeban deka* proved that the beautiful fighting girl's peculiar synthesis of sweetness and strength could be deployed in a live drama without seeming out of place. Let's call this line of works, which privileges the transsexual attraction of the fighting girl, the "sartorial perversion" lineage. These include the Takarazuka lineage mentioned earlier. I didn't call this the "androgynous" because I want to emphasize the way the sexuality of each gender is apparent in the protagonists even though it is obscured by characteristics of the other.

Song of the Baseball Enthusiast (Yakyūkyō no uta), the television anime broadcast in 1977 based on a work by Mizushima Shinji, is a grit and determination piece depicting the career of Mizuhara Yūki, the first professional female left-handed pitcher, who joins the Tokyo Mets, the worst team in the Se League. Although this work was not a big hit, it was later made into a movie. There have been few works featuring girl professional baseball players (there was a novel, Umeda Yōko's *Shōri tōshu*), but this genre was picked up again nearly twenty years later with the 1998 television anime *Princess Nine (Purinsesu Nain)*.

The year 1977 saw a boom in girls' professional wrestling. Professional wrestling itself as a form of expression is a unique sports genre meant to be enjoyed on the border between truth and fiction. Women's pro

Future Boy Conan, the first television anime directed by
Miyazaki Hayao

wrestling developed by exploiting the fictionality of the genre, and in the
context of this book, it can be considered part of the sartorial perversion
lineage of the beautiful fighting girl genealogy. That is to say, the popular-
ity of women's pro wrestling would be inconceivable if its fans were not
able to revel in its fictionality. Furthermore, if that weren't the case, it is
unlikely that popular wrestlers would ever have appeared in concerts and
commercials.

The television anime *Future Boy Conan (Mirai shōnen Konan),* which
began broadcasting in 1978, is a well-known work remembered as the
first television anime directed by Miyazaki Hayao. In addition to Conan's
partner, a young girl named Lana who is one of this work's main char-
acters, there is a female soldier named Monsuri. This work is based on a
Japanese version of Alexander Key's *Incredible Tide;* the ages of the char-
acters were lowered significantly in the adaptation.[6] Here again we see
an example of the tendency for Japanese heroes to be adolescent or pre-
adolescent boys or girls.

This was a historic year in another sense as well, and along with
the following year, 1979, constitutes a peak in otaku culture. Takahashi
Rumiko's first major work, *Urusei yatsura (Those Obnoxious Aliens),*

Urusei Yatsura

began serialization in *Shōnen Sunday*. An alien girl named Lum comes
down from space to force Moroboshi Ataru, a high school boy unlucky
in love, to marry her, and all kinds of commotion occurs. When Lum gets
angry she can do a lot of damage to people by sending out strong elec-
tric shocks. There are also other beautiful fighting girls in *Urusei yatsura*
with various special powers. With this work Takahashi pioneered the
unique genre of the science fiction campus love comedy. *Urusei yatsura*
was also an early example of the lineage of beautiful fighting girl works
about unusual or freakish girls who somehow end up living in the every-
day world. Other representative works in this line, which I'll call the "alien
girl next door" lineage, include the anime *Outlanders (Autorandaazu,*
1986), Takada Yūzō's *3x3 Eyes* (1987), Katsura Masakazu's manga *Video
Girl (Den'ei shūjo,* 1990) and anime series *Tenchi muyō!* (No need for
Tenchi, 1992), and Fujishima Kōsuke's OVA *Oh, My Goddess! (Aa! Mega-
misama,* 1993) and anime *Save Me, Guardian Shaolin (Mamotte Shugo-
getten,* 1998).

The 1979 publication of the inaugural issue of *Animage,* the first anime
magazine, was another sign of the prospering of otaku culture. *Galaxy
Express 999 (Ginga Tetsudō 999),* the television anime based on a work

Galaxy Express 999

by Matsumoto Leiji, is also worth noting. Tetsurō, a boy who dreams of obtaining the body of a machine, and Maetel, the heroine who guides him, appear in this popular work, a feature-length version of which was released later. Maetel is also the princess of the Mechanization Empire, which she tries to destroy in a battle. Her unique character, which was soft and maternal rather than brave or sweet, attracted many fans.

Like 1978, 1979 was an important year. The biggest development was the debut of the television anime *Gundam (Kidō senshi Gandamu)*. This work gave greater depth to the expansion of otaku culture that had begun with *Star Blazers*. In that sense, it should probably be considered a classic already. A boy named Amuro Rei is caught up in a battle to protect White Base from attack by the Principality of Zeon. Amuro, who possesses advanced psychic powers known as "Newtype," takes control of the Earth Federation's new mobile suit Gundam and heads for battle with Char, the archenemy. For more detailed discussion of the massive Gundam saga, refer to the myriad books of analysis that have been published on the subject. However, I do want to point out the possibility that the "depth" resulting from the overwhelming individuality of Tomino Yoshiyuki, the director of this anime, became a kind of fetter on later serious science fiction anime. In particular, hasn't having doubts about battle become an inevitable part of the depiction of the struggles of the hero of serious anime?

This work, which falls into the splash of crimson subgenre, also has great significance in the history of the beautiful fighting girl. The many complex female soldiers who surround Amuro Rei (Mathilda, Sayla, Lalah, etc.) all play important roles. Moreover, the configuration of the love–hate relationship between the hero and the fighting heroine also became a special characteristic of this subgenre that was passed down for a long time.

I have to place particular emphasis on Tomino's obsession with sexuality. The scenes of the heroine in the bath were popular among fans, and it is rumored that this inspired *Cream Lemon (Kuriimu remon)* and other adult anime. This emphasis on the sexuality of an anime heroine remains one of the major contributions of *Gundam*.

Alien, directed by Ridley Scott, must be remembered as practically the first major science fiction action film to feature a fighting heroine. There were foretastes of this in other works, including Princess Leia of *Star Wars*, but Sigourney Weaver's Ripley was the first example of a heroine who combined toughness and sweetness in a major work. Of course, in the sequel, *Alien 2*, the maternal was emphasized over the sweet.

The television anime *The Rose of Versailles* also began in 1979. As one would imagine from the fact that this was also put on as a play by the Takarazuka, this work belongs to the Takarazuka lineage, which ran continuously from *Princess Knight*. This tale, which takes the French Revolution as its backdrop, centers on Oscar, a pretty girl in boy's clothing who was born into the house of General Jarjayes.

It is well known that at the time of its release the feature-length anime *Lupin III: Castle of Cagliostoro (Rupan Sansei: Kariosutoro no shiro)* drew very small audiences. The work became extremely popular later when it went to video, and there are some who declare this Miyazaki's best work. There are many examples of works that became legendary when released on video, as was the case for the movie *Blade Runner*; this also illuminates the "after-the-fact" nature of otaku culture. Although there are no beautiful fighting girls in *Lupin III*, it is possible to see the formation of a personality that was carried down years later into Nausicaä in the central figure, twenty-year-old Princess Clarice. A fragment of the aggression that the pure, gentle Clarice unwittingly displays can be seen in the car chase near the beginning.

The feature-length anime *Nezha Conquers the Dragon King (Naajakai o sawagasu)*, which was released in China, was also much discussed in Japan. Many anime are produced in China, but the protagonists tend to

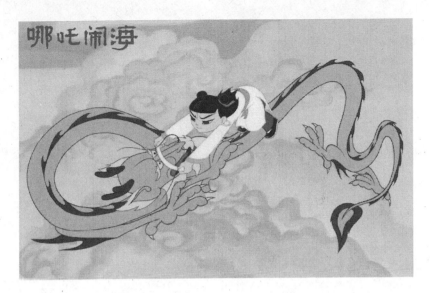

Nezha Conquers the Dragon King

be boys. A boy is also the hero of this work, but as you can see from the picture, his gender is depicted very ambiguously. The unisex style and ornamentation of his costume make him look like a girl at first glance. The fact that it centers on an adolescent hero of ambiguous sexuality places this work close to the Japanese anime tradition. Of course, we must bear in mind the possibility that Chinese anime have been strongly influenced, directly and indirectly, by Japanese anime.

The 1980s

Anime reached full maturity in the first half of the decade and declined in the second half. But what is of great interest here is that, whether anime were flourishing or declining, beautiful fighting girls appear in nearly all of the important works. First I will summarize the first half of the decade.

Of particular note is the serialization of Toriyama Akira's *Doctor Slump* (*Dr. Suranpu*), which began in *Shōnen Jump* in 1980. Arale-chan, the little-girl robot that appears in this work, ordinarily causes comical commotion with her pure naïveté, and once she gets angry, she displays an explosive superhuman strength. Considered in the context of psychiatric medicine, this is precisely the kind of angelic disposition often seen in

cases of epilepsy, which Yasunaga Hiroshi has called the "centrothymic temperament."[7] This personality type has become an important frame of reference in the formation of the beautiful fighting girl. *Doctor Slump*, which centered on the empty subjectivity of a girl created as a robot or cyborg, later became popular as a television anime and originates what I call the "Pygmalion" lineage.[8]

The year 1980 also saw the serialization of *A Child's Dream (Dōmu)*, one of Ōtomo Katsuhiro's best-known works. Ōtomo Katsuhiro, one of the most important creators of manga, profoundly changed the course of its history. It is said that the quality of the line in manga before and after Ōtomo was entirely different.[9] In my opinion, one of the genres that declined decisively with the appearance of Ōtomo was the *gekiga* manga. Faced with Ōtomo's hyperrealism, *gekiga*-style realism did not stand a chance. In addition to manga, Ōtomo also made anime, and both were highly regarded. In particular, the influence of mechanical design completely changed the depiction of machines in science fiction anime (an example is Shirō Masamune, whom I discuss later). *A Child's Dream*, the first work for which Ōtomo is known, is still considered by some to be his masterpiece. A girl with supernatural powers fights against a backdrop consisting of smart, clean, and intricate lines adopted from the French comic artist Moebius and flavored with Ōtomo's own dynamism and emotion. The premise puts the girl at an age that appears younger than a lower-level elementary school student, and there is no intent to depict her in a sexualized fashion. However, the choice as protagonist of a girl with the power to turn a high-rise apartment building to ruins instantaneously is certainly suggestive. Of course, *A Child's Dream* itself is somewhat different in nature than other works in the beautiful fighting girl genealogy. It can be considered a forerunner of the "medium" *(miko)* lineage, which reaches its peak later, with *Nausicaä of the Valley of the Wind*. In any case, it is worth noting that even someone like Ōtomo, who opts for a European style of drawing, achieved masterpiece-level success by placing a fighting girl at the center of his work.

Actually, *A Child's Dream* contains prescient examples of several other relevant phenomena as well. One is its depiction of a "plastic model otaku," a shy, chubby, bespectacled student who has failed the college entrance examinations. This character, who is manipulated by an old man guilty of mysterious crimes into killing himself in front of the girl by gouging his neck with a box cutter, is an obvious precedent for the type of person later classified as the otaku personality type. The way the suicide scene is

drawn is an extraordinary testament to the success of the manga form in capturing this historical moment.

This was also the year in which the founding of *seinen* magazines (aimed at men roughly ages eighteen to thirty) reached its peak, and *Maison Ikkoku (Mezon Ikkoku)*, another of Takahashi Rumiko's representative works, began serialization in *Big Comic Spirits*. There was also a boom in "rorikon manga" at about the same time, and artists like Uchiyama Aki achieved a certain popularity with the manga they serialized in *shōnen* magazines (aimed at boys roughly ages ten to eighteen) depicting extreme instances of rorikon. I note him here as a creator who had a distant influence on the formation of the beautiful fighting girl character.

The first thing that must be noted about the following year, 1981, was the October start of the television anime series *Urusei yatsura*. One of the most popular beautiful fighting girl television series, it ran for four and a half years. The premise was in effect that of the science fiction campus love comedies that I described earlier, but this was a very important work because at the same time it also established the alien girl next door genre.

Serialization of Hōjō Tsukasa's *Cat's Eye (Kyattsu ai)* began this year in *Shōnen Jump;* it became a hit and was later made into an anime and a movie. This is a "sexy action" *(sekushii akushon)* story of three beautiful leotard-clad sisters who work as highly skilled art thieves. This work can be placed alongside the "hunter" lineage that I discuss later, but it is also significant as the first example of the "team" subgenre that features fighting girls in groups.

Both contextually and chronologically, the team subgenre emerged from the splash of crimson lineage. In these works either a pair, a trio, or a whole squad of beautiful fighting girls do battle with criminals or monsters from outer space. The following works were descendants in this lineage, which had one of its peaks in the 1980s: the television anime *Southern Cross (Chōjikū kidan sazan kurosu*, 1984), the television anime *Dirty Pair (Daati pea*, 1985), the OVA *Megazone 23 (Megazon 23*, 1985), the OVA *Project A-ko (Purojekuto A-ko*, 1986), the OVA *Gall Force (Garu fōsu*, 1986), the manga *You're Under Arrest! (Taiho shichau zo*, 1986), the OVA *Bubblegum Crisis (Baburugamu kuraishisu*, 1987), the manga *Silent Möbius (Sirento Mebiusu*, 1988), the manga *Gunsmith Cats (Gansumisu kyattsu*, 1991), and so forth.

The twentieth Japan Science Fiction Convention, known as "Daicon," was a memorable event in the history of the beautiful fighting girl. The short films *DAICON III Opening Animation*, which was shown at this

Bubblegum Crisis

convention, and *DAICON IV,* from 1983's opening, are considered masterpieces bursting at the seams with otaku fantasies. Both pieces, which were directed by then-unknown amateur Anno Hideaki, are highly accomplished despite being minor works. The artist Murakami Takashi extols *DAICON IV* as a high point of the postwar Japanese art scene.[10] It is certainly an impressive compendium of the images that otaku of the time most wanted to see. Both works have beautiful fighting girls as their heroes. In the first work, a small girl wearing a red backpack fights enemies who try to prevent her from delivering a cup of water to the convention.[11] In the second work, a girl wearing a Playboy bunny costume hurls a giant robot with her bare hands and flies from side to side on a swordlike rocket.

The television anime *Jarinko Chie* also began broadcasting in 1981. This anime version of Haruki Etsuji's long-running manga serial appealed more strongly to intellectuals than to otaku. The television version followed a feature anime directed by Takahata Isao that depicted the everyday life of a girl who does battle using her sharp tongue and *geta* (wooden sandals) as her weapons. This work is not exactly a beautiful fighting girl work, but I mention it here because it had a big impact on me personally.

Jarinko Chie

Whatever might be said about the Kadokawa movie *Sailor Suit and Machine Gun (Seeraafuku to kikanjū)*, repeated showings of the commercial featuring the scene in which Yakushimaru Hiroko plays a high school girl who expresses her pleasure by shooting a machine gun made her a memorable beautiful fighting girl icon in the sartorial perversion lineage.

The year 1982 was the golden age of love comedies, beginning with Adachi Mitsuru's *Touch (Tatchi)*, but we should not forget that this year also saw the beginning of several important trends. Miyazaki Hayao's *Nausicaä of the Valley of the Wind* began serialization in *Animage*, and the television anime *Macross (Chōjikū yōsai Makurosu)* began broadcasting as well. I discuss these works later. Also, Ōtomo Katsuhiro's representative work *Akira* began serialization in *Yangu magajin* (Young magazine).

It is said that the television anime *Gigi and the Fountain of Youth (Mahō no purinsesu Minkii Momo)*, a popular magical girl work, was partly targeted at otaku fans of rorikon. In fact, this work became fodder for parody fan magazines. In the last episode of the anime, just as Momo loses her magical powers and returns to daily life as an ordinary girl, she is run over by a truck and killed. This episode is an important one in terms of understanding how anime creators of the time understood the relation between fiction and reality. It seems likely that they believed that to portray reality *realistically* in an anime was itself an expression of reality.

A 1983 work that must be mentioned is the television anime *Nanako SOS*, based on an Azuma Hideo manga. Nanako, a beautiful girl in a sailor

outfit who suddenly falls from the sky, has supernatural powers and has lost her memory. Yotsuya, who calls himself a scientific genius, and his accomplice Iidabashi plan to profit from her powers. The pure, empty subjectivity of Nanako belongs to the *Doctor Slump* Pygmalion lineage mentioned earlier, but what is distinctive about this work is its added sexual flavor. Beautiful fighting girl sexuality is one of the central aspects of manga artist Azuma Hideo's style. This work is important because it established the orthodox line of the Pygmalion beautiful fighting girl sub-genre. Later works that belong to this category include the manga *Battle Angel Alita* (*Gunmu*, 1991), the OVA *All-Purpose Cultural Cat Girl* (*Bannō bunka neko musume*, 1992), and Koyama Yū's manga *Azumi* (1994).

Stop Hibari-kun *(Sutoppu!! Hibari-kun)*, the television anime based on the work of the popular manga artist Eguchi Hisashi, debuted in 1983. Although not a beautiful fighting girl work, the hero is a beautiful gay boy who might as well be a girl. This work, which achieves a dizzying reality by contrasting a girlish exterior with a male interior, can also be understood as a continuation of the sartorial perversion lineage. Takahashi Rumiko's *Ranma ½* (*Ranma nibun no ichi*, 1987), which adds the element of reversible sex change, perfects the development of this subgenre. Other representative works include the manga *Kuru Kuru Kurin* (1982) and *The Asukas of Flowers* (*Hana no Asukagumi!* 1985), the movie *V Madonna daisensō* (V Madonna war, 1985), and the OVA *Birdy the Mighty* (*Tetsuwan baadii*, 1996).

The television anime *Captain Tsubasa (Kyaputen Tsubasa)* tells the story of Ōzora Tsubasa, a boy whose dream is to lead Japan to victory in the World Cup as the world's top soccer player, and his friends. This work attracted more female fans than boys and sparked the fan culture known as *yaoi*. In *yaoi*, which stands for *yama nashi, ochi nashi, imi nashi*,[12] fans write parody versions of anime and manga in which they place the characters in fictional homosexual relationships. This phenomenon has a lot to suggest in terms of what sexuality in anime is for female otaku. Works centering on a group of beautiful young boys, such as *Saint Seiya* (*Seitōshi Seiya*, 1986), *Rōnin Warriors* (*Yoiroden samurai turūpaa*, 1988), and *Reideen: The Superior* (*Chōja Raidiin*, 1996), continue this lineage.

Although it is difficult to consider it as a direct contribution to the genre, it is worth remembering that Nakamori Akio coined the term *otaku* in 1983.

The following year, 1984, was the most productive in Japanese anime history. First and foremost, the March opening of the feature anime

All-Purpose Cultural Cat Girl

Nausicaä of the Valley of the Wind must be noted. Miyazaki Hayao directed this anime based on his own original manga. This work, which feels as if it has already been theorized to death, can be considered of supreme importance in terms of the beautiful fighting girl. The setting of the story is Earth one thousand years after the "seven-day fire," thought

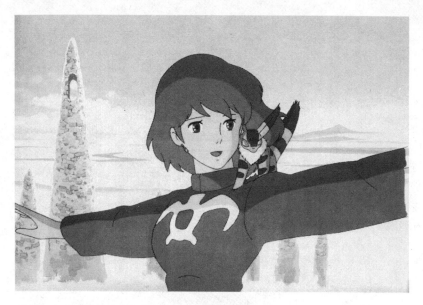

Nausicaä of the Valley of the Wind (Miyazaki Hayao, 1984)

to be the war to end all wars. Most of Earth is a poisonous Sea of Corruption occupied by groups of giant insects; people survive by trying to seize the small amount of land that has not been polluted. Princess Nausicaä was born and raised in the village Valley of the Wind, which is protected by winds from the miasma of the Sea of Corruption. Rather than fight against the sea and the insects, she has been seeking a way to coexist with them. But one day a spaceship crashes in the valley carrying the embryo of the God Warrior, the creature thought to have destroyed the world. The Tolmekian Army invades the valley in pursuit of the embryo, and Nausicaä is caught up in the battle against her will. Because there are so many books that analyze this work, I will refrain from doing more than giving this introductory feel for the story.

In any event, this work is not merely a classic in anime history but is also valuable for many other reasons. For example, the contrast between Nausicaä's origin and the past of Kushana, queen of Tolmekia, provides the most important clue for understanding the narrative structure of all beautiful fighting girl stories. Among the works of Miyazaki Hayao, this work and *Princess Mononoke (Mononoke Hime,* 1997) are the only ones that have true beautiful fighting girl heroines, and the similarities

in construction between the two are of great interest. Both works belong in a category apart from the lineages discussed so far. The heroines, Nausicaä and San, both occupy unique positions as mediators between two worlds. Nausicaä mediates between the human world and the Sea of Corruption, and San symbolizes the confrontation between civilization and the forest. It is as a result of their positions as mediums, or *miko*, that the two are forced into battle. Let's call the lineage of works like these the "*miko*" lineage. Joan of Arc would of course count as an ancestor of this line. The girls depicted by Darger can probably also be placed in the *miko* lineage. Related heroines include Hilda of the feature-length anime *Little Norse Prince* (1968) and Etsuko in *A Child's Dream* (1980), a manga mentioned earlier. The *miko* lineage is far from the most populous subgenre, but it is one of the most important in the genealogy of the beautiful fighting girl.

Macross: Do You Remember Love? (*Chōjikū yosai Makurosu: Ai oboete imasu ka*), a feature-length anime that opened in 1984, is remembered as the first work in anime history produced by anime fans. To the basic premises of the splash of crimson and giant robot genres, this work added intricate mechanical drawings based on science fiction research and a romance centered on a beautiful girl idol; it is so popular that it has spawned sequels in recent years and it has been used as the basis of games. In this work the girl heroine, an idol singer named Minmei, is placed in the important position of using her songs to repel the enemy.

Oshii Mamoru, one of the major anime directors, issued the feature-length anime that would become his first representative work, *Beautiful Dreamer* (*Urusei yatsura 2: Byūtifuru doriimaa*), in 1984. In addition to being one of the most important works in anime history, in terms of beautiful fighting girl history it is known as the last work before the director abandoned the genre.

The *Cream Lemon* series was a product of the early days of the OVA, which means that it was released only in video. It was followed by a rapid expansion of the market for adult-oriented anime, a genre even more uniquely Japanese than the beautiful fighting girl. I discuss this work here not only because it clearly targeted the sexuality of otaku but also because it included episodes like *Superdimensional Legend Rall* (*Chōjigen densetsu Lalu*) and *POP CHASER* in which girls did battle and also had sexual intercourse. Thus beautiful fighting girls were also foundational in the early days of the unique genre of adult-oriented anime.

It's easy to understand how the difficulties associated with broadcasting adult-oriented anime on television supported the development of OVA during the early years. But after that the market for the OVA genre itself expanded, and things have become reversed to the point that for anime in general the video edition is now considered the definitive one. This is extremely interesting as a typical example of the pattern in which the media format drives the content of the work.

Leda: Fantastic Adventures of Yoko (Genmu senki Reda), which went on sale in 1985, is a hit work that sustained the OVA genre early on. The basic premise of this minor work, in which an ordinary high school girl is suddenly summoned to another world where she engages in battle as a warrior, is a staple of the beautiful fighting girl genre that is repeated in many works, beginning with *Sailor Moon*. I discuss this strand, which I call the "other world" lineage, later.

OVA works published this year, such as *Dream Hunter Rem (Doriimu hantaa Reimu)* and Shirō Masamune's manga *Appleseed (Appurushiido)*, belong to the hunter subgenre. This is the general term used for works with beautiful girl heroines who fight because they are entrusted with a special mission or with the explicitly conscious goal of winning prize money. Its roots go back to the 1967 movie *Barbarella*, discussed earlier; Mine Fujiko, the heroine of *Lupin III* (1967), also belongs to this lineage. This was originally the domain of the fighting woman personality, but beginning in the 1980s the beautiful fighting girl hunter lineage overwhelmingly dominated the mainstream. Examples include the television anime *Ghost Sweeper Mikami (GS [Gōsuto suwiipaa] Mikami*, 1993), the OV (original video) *Zeiram (Zeiramu*, 1991), the OVA *Devil Hunter Yohko (Mamono hantaa*, 1991), the television anime *Slayers* (1995), the OVA *Agent Aika (Aika*, 1997), and the television anime *Hyper Police (Haipaa porisu*, 1997). Because there isn't very much that is remarkable about this lineage, I confine my discussion of it to this list of examples.

The serialization of Urasawa Naoki's manga *YAWARA* began in 1986. This story of a girl judo prodigy aiming for world fame attained mass popularity and became so widely known in society that the title character's name became the nickname of a real judo wrestler. It was first broadcast as an anime and then made into a movie starring the idol Asaka Yui. With this work, the focus of the grit and determination subgenre, which had been primarily ball sports, shifted almost entirely to the martial arts.

The latter half of the 1980s was a period of decline for anime. Many anime magazines ceased publication, and conditions persisted that were

not conducive to the emergence of a hit anime. The beautiful fighting girl survived all this, however. The feature-length anime *Wings of Honneamise (Ōritsu uchūgun Oneamisu no tsubasa)* was released in 1987. Why am I bringing up this work, in which a beautiful fighting girl does not appear? Precisely because one does not appear.

The production company Gainax, which would later conquer the world with *Evangelion*, was first formed by amateur students in the Osaka area to create this work. Yamaga Hiroyuki, who was just twenty-four at the time, wrote the script and directed, completing this masterpiece with a huge investment of capital and staff. This moving story, of the frustrations and maturation of a youth aspiring to become a spaceship pilot in an elaborately imagined world, enjoyed critical acclaim but did not become a hit. Okada Toshio himself, who was involved in the planning of the production, analyzed the reasons for this. "It had neither a robot nor a beautiful girl." *Gunbuster*, the OVA hit of the following year, emerged in reaction to this.

The serialization of *Jojo's Bizarre Adventures (Jojo no kimyō na bōken)*, a representative work of Araki Hirohiko, also began this year. Here I am bringing up yet another masterpiece in which a beautiful fighting girl doesn't appear, but I have personal reasons for doing so. Quite a few fascinating things came to light in an interview I did with Araki for the journal *Yuriika*.[13] The first was that Araki had intentionally tried to exclude otaku elements. *Shōnen Jump*, in which Araki serializes his works, is an environment in which a complex mix of works are published—child-oriented, otaku-oriented, and general reader–oriented—but he particularly avoids otaku-oriented design because he finds it monotonous. This is probably the reason that beautiful fighting girls almost never appear in his work. Araki loves film, novels, and rock—all genres that do not appeal to otaku. As can be seen in a work like *Jojo 6045*, Araki's designs are so intoxicatingly magnificent that they can be appreciated merely as illustrations. To the best of my knowledge, Araki's desire to make every idea visible brought to fruition an extremely clever manga with the most complicated perspectives and execution of changes in point of view in the history of major manga. But that alone is not enough to maintain reality in a manga. If, as I argue in the next chapter, beautiful fighting girl works place the sexuality of the girl at the core of their reality, what is Araki's core?

Araki cites Kajiwara Ikki as one of his greatest influences. This may be surprising, but something reminiscent of Kajiwara is definitely perceptible in Araki's words and expressions of emotion. Indeed, at the

core of his own works Araki consciously places expressions of emotion and pathos reminiscent of Kajiwara's. Because of this artistic consciousness, *Jojo 6045*, which can appear at a glance to be a grotesque romance, manages to be the very epitome of shōnen manga. In a clear rejection of works like *Evangelion*, discussed below, his works are sustained by the classical technique of foregrounding emotions in order to avoid the self-conscious struggles of anime.

However, we cannot overlook the fact that Araki also wrote the minor work *Gorgeous Irene* (*Gōjasu Airin*, 1985). Featuring an innocent girl from an unhappy background (amnesia!), the story is typical of the transforming girl subgenre. A male friend has been kind to her, and she fights on his behalf, using makeup to transform herself into a female warrior, initiating battle with a set phrase, and defeating the enemy (often mature women who are actually ghosts) using "death makeup." The utterance she makes during the transformation scene corresponds perfectly to the definition of transformation for this subgenre. That's right, the "transformation of the girl"—which is so often accompanied by passage through a nude silhouette—must always be expressed as sexual ecstasy. Araki's non-anime-type drawings are more refreshing; he says that *Gorgeous Irene* led him to discover that "I can't draw girls." This declaration is highly significant because it suggests the possibility that anime expression is not simply a matter of design but may be constituted by the artist's tastes and preferences.

Even if one isn't a good consumer of films and novels, it is probably possible to create an outstanding film or novel. For example, the creativity of the film director Kitano Takeshi and the novelist Nakahara Masaya appear as if it might even be based on ignorance of the history of the film and the novel and the contexts in which they are working. But a non-otaku artist ignorant of the traditions and contexts of anime probably could not create a quality anime. To be an anime creator, one must be able to bear that monotonous world and also have the ability to be partial to it. And it is the act of finding *moe* in anime that provides the impetus to foster that talent. As I have already pointed out in the case of Miyazaki Hayao, to love an anime is, in other words, to love *(moeru)* the beautiful girls in anime. An anime creator is born from the experience of *moe* as a trauma, and the next generation of anime fans finds *moe* in the heroines he creates. I am almost certain that this chain of *moe* as trauma underlies the currents of today's anime culture.

Although the Gainax OVA production *Gunbuster,* which I have referred to numerous times, can hardly be called a big hit, it was an important work in terms of "otaku" self-consciousness and as a harbinger of what was to come in the 1990s. A dull, clumsy outer space high school student named Takaya Noriko is found to have a natural gift for piloting the giant robot *Gunbuster,* and under a rigorous coach she grows up to become a first-rate pilot. The basic plot falls into the splash of crimson category— with a hybrid premise of the giant robot and grit and determination subgenres. As such, it was the first example of the "hybrid" subgenre that peaked in the 1990s. The heroine, an adorable, somewhat comical young girl, isn't aggressive in the usual sense. In contrast, her partner is given a mature, relaxed, maternal personality, and brilliant, war-loving women are situated as their rivals. All of them, in fact, are nothing less than "phallic mothers." Piloting the *Gunbuster,* they vanquish a giant space monster, saving Earth from destruction.

I've already mentioned that *Gunbuster* was produced by Gainax in the wake of the box office failure of *Wings of Honneamise.* In its stoic pursuit of cinematic reality, *Wings of Honneamise* had excluded both the giant robot and the beautiful girl heroine that is the glory of anime. The despair and defiance that resulted from their understanding of how they had failed led the Gainax team to create a work that quickened and concentrated the anime context to an extreme degree. In so doing they demonstrated the true backbone of otaku creativity. In other words, it was a typical case of otaku-esque nihilism being converted into creative fervor.

At the planning stage, the focus may have been on the three subjects: a beautiful fighting girl, a giant robot, and a space monster. It may have been a matter of "Then all we have to do is cram it full of the kind of parody and detail that appeal to otaku, and it will sell fairly well." But didn't the development that occurred from that point on surpass the intentions of the planning stage? This is where we get a glimpse of the moment when the beautiful fighting girl icon went beyond being a simple object of desire to become, as it were, a muse that catalyzes creativity.

This work is also significant in another sense. With its appearance, the genealogy of beautiful fighting girl anime is nearly complete. I have identified thirteen different subgenres to this point, but no entirely new one has emerged since *Gunbuster.* For reference, I provide a table in this chapter classifying the works I've mentioned in this chapter into subgenres. You can see at a glance that most of the works that have appeared

since the 1990s are mixed; they tend to be constructed as quotations and parodies of or homages to works in previous lineages. Their ability to grasp and anticipate this state of affairs probably accounts for the fact that the people connected with Gainax are still on the cutting-edge of the otaku business.

The other principal works of the latter half of the 1980s include the splash of crimson works *Akira* (1988), the feature-length anime written and directed by Ōtomo Katsuhiro that pioneered the Japanimation boom in the United States, and *Patlabor* (*Kidō keisatsu Patoreibaa*, 1989), written by Yūki Masami and directed as a feature-length anime by Oshii Mamoru, but these are not particularly important in the genealogy of the beautiful fighting girl. Miyazaki Hayao's feature-length anime *Kiki's Delivery Service* (*Majo no Takkyūbin*, 1989), while not a beautiful fighting girl work, is still important. This anime is about learning rather than the use of magic because it is about the coming of age of the heroine Kiki. Depictions of both learning and coming of age tend to be excluded from the standard beautiful fighting girl works in the magical girl subgenre. This is because, although the traditional magical girl repeatedly matures and regresses with her transformations, she never truly comes of age. In this sense, *Kiki* can be categorized as a nonconforming member of the subgenre.

The 1990s

The 1990s will probably be remembered as the age of anime revival. If *Sailor Moon*, a work that was successful domestically—not to mention internationally—is evoked to represent the first half of the decade, *Evangelion* represents the second half. Many other good works also came out, and the anime industry appeared to recapture the dynamism of the first half of the 1980s. Whether or not we see a connection between this revival and the decline of the bubble economy and the accompanying recession, it is still the case that anime were released practically to the point of overproduction, including so many beautiful fighting girl works that it would be impossible to list them all.

First, the release of the complete laser disc (LD) box set of *Urusei yatsura* (1990) was a milestone in otaku history. Although it was far from inexpensive, this set of more than fifty discs containing all 218 episodes of the television series sold well and established the product category of the complete LD box set. It's said that otaku constitute the majority of LD users, and this certainly confirms the otaku preference for the format. It's

not unusual for beautiful fighting girls to be connected to the evolution of a media market; I note this here because it is one of the more symbolic instances.

This is not the only time that the diversification of media was tied to further advances in the mixing of media. The appearance of a series like *Tenchi muyō* (1992), which conquered every type of media, was also part of this trend: it was made into a novel, a game, a radio drama, and so on. The 1994 releases of the Sega Saturn and the PlayStation in particular were epoch-making events for anime in terms of media-mix strategy. From this time on, anime characters were widely used in games. Of course, one reason for this was the improvement in the functionality of gaming devices; advances in the ability of CD-ROMs to process voice data were particularly influential. The ease with which actors' voices could be included in gaming software led to an expansion of the genre, which was accompanied by a surge in the popularity of voice actors. Popular works such as *Evangelion*, *Nadesico*, *Slayers*, and *Sorcerer Hunters (Bakuretsu hantaa)* were quickly made into games. Furthermore, as in the cases of works such as *Sakura Wars (Sakura taisen*, 1996) and the OVA *Battle Athletes (Batoru asuriitasu daiundōkai*, 1996), the reverse, in which popular games were made into anime, was no longer uncommon.

Another important point that must be noted in terms of media mixing is the development of a new genre, the anime made into a musical. Starting with Sailor Moon, this "musicalization" trend encompassed works such as *Little Red Riding Hood Cha Cha (Akazukin Chacha)* and *Nurse Angel Lilika SOS (Ririka SOS)*, and even led to a musical "event" involving the voice actors for *Sakura Wars*.

The cult-level popularity of *Akira* in the United States had already signaled a shift in the reception of anime abroad, and the 1990s marked the emergence of major works that were true hits there. For example, the popularity of the television drama *Power Rangers* surged in 1994. This drama, shown in Japan as *Kyōryū sentai jūrenjaa* (Dinosaur squadron beast ranger) and remade with American actors, was a splash of crimson work that included two female soldiers in its force. It was extremely unusual for an American drama to feature heroines who were teenaged, female, and members of a minority. *Ghost in the Shell (Kōkaku kidōtai*, 1995), the feature-length anime written by Shirō Masumune and directed by Oshii Mamoru, attained the rank of number one in video sales in *Billboard* magazine in the United States in 1996, further cementing its reputation in Japan.

Miyazaki Hayao's 1997 film *Princess Mononoke*, which established a new box-office record in Japan, opened throughout the United States in October 1999. Given the rating of PG-13 because of a section with depictions of cruelty, it didn't attain hit status, but it was praised by many film critics. *Pokemon the Movie: Mew Two Strikes Back (Poketto monsutaa: Myutsū no gyakushū)*, an anime that appeared in theaters at the same time as *Princess Mononoke*, attained the rank of number one at the box office in the United States, making it the most popular Japanese film ever released there.

As mentioned above, no new beautiful fighting girl lineage emerged in the 1990s; the focus was rather on expanded forms of existing subgenres and hybrids; in other words, crossovers and remixes. One of these was the television anime *Nadia: The Secret of Blue Water (Fushigi no umi no Nadia,* 1990), a Gainax production based on a script by Anno Hideaki. In this adventure tale, a young girl named Nadia and a boy named John set out together on a journey of self-discovery and become embroiled in disputes with a secret society that has designs on Nadia's jewel, the Blue Water. Although it borrowed some elements from Miyazaki Hayao's *Castle in the Sky (Tenkū no shiro Rapyuta)*, it ended up as a work with a considerably different flavor. Nadia, while not necessarily a beautiful fighting girl, is an important heroine to consider when thinking about the position of the girl in anime. Whether she belongs to the magical girl category or the girl medium *(miko)* category, the young girl in anime is always in the position of catalyzing some kind of emergent change. While using the emptiness that underlies Nadia's existence to pull the story along, the premise of the girl's search for her origins also contributes to the process by which she becomes filled with a kind of paradoxical reality. This kind of structure can probably also be identified in many other beautiful fighting girl works.

I suggest that the drama *Bishōjo Mask Poitrine* (1990), a tokusatsu comedy scripted by Urasawa Yoshio with its own share of ardent fans, is representative of the transforming girl subgenre. The subgenre also includes another Tōei live-action series, *Yūgen jikkō san shimai shushutorian* (What's said is done, three sister Shushutorians, 1993). In the former, second-year high school student Murakami Yūko is requested by God to use a spell to transform herself to preserve the peace of the neighborhood and fight the bad guys. This work, popular both with otaku and with mainstream audiences, starred the actress Hanashima Yūko as the irresistible Poitrine-san; she also appeared frequently on the variety shows of other networks and in

magazine photographs. As I mentioned in my discussion of *Ultra Seven*'s Anne, an actress who becomes popular as a heroine in a tokusatsu may not be able to resume her acting career afterward. Hanashima Yūko, who played Poitrine, was forgotten when the program ended. Isn't it partly to avoid this that many famous actresses omit the fact that they've acted in a tokusatsu from their résumés, even if they aren't conscious of the reason they're doing it?

In the grit and determination subgenre, martial arts works became the mainstream after *YAWARA*. For example, the manga *Natsuki Crisis* (*Natsuki kuraishisu*, 1990) was about Gōju-ryū karate, and the anime *Metal Fighters Miku* (*Metarufaitaa MIKU*, 1994) took as its theme a girl professional wrestler at a time in the near future. However, the biggest expansion of the subgenre by far probably took the form of beautiful fighting girls in martial arts games. The fighting heroine Chun Li appears in the very popular *Streetfighter II* (*Sutoriitofaitaa II*, 1991). Also, the fighting girls Pai Chan and Sarah Bryant appear in the game *Virtua Fighter* (*Baachafaitaa*, 1992). There are endless additional examples of beautiful girls who practice martial arts. This can also probably be seen as a unique representational form facilitated by the development of media.

In March 1992 one of the most important works in the history of the beautiful fighting girl began broadcasting. It was the *Sailor Moon* series. First we should touch on the processes of production and publication of this work. Tōei and Kōdansha cooperated on simultaneous release of the anime series and the manga serialization in the monthly magazine *Nakayoshi*. Huge numbers of transformation-related merchandise and other novelties were marketed and distributed. Thus *Sailor Moon* was conceived and created as a work in the hybrid subgenre with an explicitly planned media-mix strategy. Supported by a broad class of fans ranging from children to otaku, broadcasts of the series *Sailor Moon R*, *Sailor Moon S*, and *Sailor Stars* continued for five years, until March 1997. Exported to Europe, the United States, and other countries in Asia, it achieved great popularity internationally. The two works that transcended the confines of anime to become a kind of social phenomenon, *Sailor Moon* and *Evangelion*, discussed below, have no equals.

Here is a basic introduction to the story of *Sailor Moon*. Eighth-grader Tsukino Usagi is informed by Runa, a black cat that she has rescued by chance, that she is a chosen warrior. The brooch and spell she receives from Runa transform her into the beautiful girl warrior Sailor Moon, who has the power to kill ghosts. It is revealed that four of Usagi's classmates

are fighters as well, and the five unite to fight ghosts. When they are in a pinch, a mysterious youth, Tuxedo Mask (his real form is that of Chiba Mamoru, Usagi's boyfriend), appears to help them in their fight.

The *Sailor Moon* series has a considerably complex structure even for a story about past lives. Later in the story, it is revealed that the characters were involved with each other in their previous lives in an ancient era, where the moon and Earth were opposing forces. In addition to this complex premise, the writer makes her authorship quite apparent throughout. For example, place-names from Azabu Jūban, the home of the original writer, Takeuchi Naoko, are cited in descriptions of the neighborhood around the junior high school attended by the Sailor warriors. Takeuchi, who collects minerals as a hobby, uses the names of ores such as Zoicite and Kunzite for the enemy characters. But of course the marks of individual artistry went beyond those inscribed by the original writer. The popularity of Sailor Moon was ensured when it was made into an anime and much more talent was invested in it such as Tadano Kazuko, who adapted the original designs to the anime format and embellished the characters with *moe* elements as she drew them; Ikuhara Kunihiko, whose unique direction expanded the scope of the story; and Mitsuishi Kotono, whose inspired performance of the voice of Tsukino Usagi will forever be identified with the character. The work was of course a major social phenomenon, and its multilayered artistry exerted a huge influence on subsequent works. For example, one theory holds that Anno Hideaki, the director of *Evangelion*, discussed below, was a fan of this work and was influenced by it both directly and indirectly. Not only was there overlap between the voice actors of the two works, but it has also been observed that the lonely blue-haired girl genius Mizuno Ami (Sailor Mercury) was the prototype for *Evangelion*'s Ayanami Rei. Further, the television anime *Wedding Peach* (*Aitenshi densetsu uedingu piichi*, 1995) is a direct descendant of *Sailor Moon*. With the exception of a few points, this story, of three junior high school girls who fight evil, is identical to that of *Sailor Moon;* although a highly accomplished work, it was not particularly popular.

The television anime *Rayearth* (*Majikku Naito Reiaasu*, 1994), whose original script was by the five-woman (at that time) writers' group CLAMP, was also a work with a quite complex structure. Hikari, Umi, and Fu, three junior high school students who find themselves in the world of Cephiro, receive orders as magic knights to save Princess Emeraude, who has been

imprisoned by the High Priest Zagato. To defeat the enemy, they must set out on a journey to find the giant robot Mashin and bring it back to life. As in the case of *Sailor Moon*, the complexity of this work results from its layered structure of intertwined narratives, and in that respect it is like an RPG (role-playing game). Rayearth belongs to the "summoned to another world" subgenre that developed in the 1990s.

This genre, in which utterly ordinary girls become mixed up in an alien world by chance and are forced into battle willy-nilly, is actually a classical form of fantasy. Its cohorts in the beautiful fighting girl genealogy include *Leda: Fantastic Adventures of Yoko* (1985) and the television animes *Fushigi yūgi: The Mysterious Play* (1995) and *Escaflowne* (1996).

The year 1997 was as important for anime as 1984. It saw the release of *Princess Mononoke*, a culmination of the best work of Miyazaki Hayao. The story is set in the Japanese middle ages. Atsutaka, the last remaining descendant of the Emishi, embarks on a trip to the West to remove the curse placed on him by the Tatarigami. During his travels Atsutaka meets Lady Eboshi, the leader of the Tataraba, and San, the princess Mononoke, a misanthrope who has been raised by the wolf god Moro no Kimi. Embedded within the work on multiple levels are ideas that have long preoccupied Miyazaki, such as the opposition between civilization and nature, here embodied by these two characters, which cannot be reduced to a question of good versus evil. In terms of both theme and story structure, *Princess Mononoke* is fundamentally a further development of *Nausicaä*. Like Nausicaä, San is a heroine of the medium *(miko)* subgenre, and the confrontation between San and Lady Eboshi corresponds exactly to that between Nausicaä and Kushana. It is also worth noting that the voice of the boar god Okkoto was performed by Morishige Hisaya, who was the voice of the hero of *Panda and the Magic Serpent,* Japan's first full-length color animation discussed at the beginning of this chapter. It is a casting choice that cannot possibly be coincidental. This quiet homage to Morishige speaks volumes about Miyazaki's inability to repudiate the traumatic nature of his experience as a young boy watching *Panda and the Magic Serpent*. In any case, although this complexly structured and themed work was harshly denounced by some critics in Japan, it broke records at the box office. As I mentioned earlier, *Princess Mononoke* opened in the United States in October 1999, and the critics loved it. Does this contrast between unpopularity in Japan and praise abroad suggest that Miyazaki is approaching the status of Kurosawa Akira? In any case,

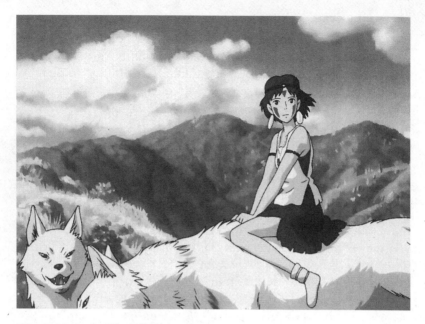

Princess Mononoke (Miyazaki Hayao, 1999)

the acclaim it received in the United States forces a reevaluation of its abysmal reception at home in Japan.

The feature-length anime *The End of Evangelion (Shinseiki Evangerion/Air/Magokoro o kimi ni)* was also released in Japan in 1997. It is set in 2015 in Hakone, where the Third New City of Tokyo has been constructed as part of the slow recovery from the Second Impact, which destroyed the world in the year 2000. Fourteen-year-old Ikari Shinji is ordered by his father, Ikari Gendō, to join the special unit Nerv and board the All-purpose Humanoid Fighting Machine, Evangelion. The mission is to save the city of Tokyo from attack by the Angel, an enemy of indeterminate form. However, while the true form of the weapon Eva, which can be operated only by a fourteen-year-old girl or boy, is shrouded in mystery, it is revealed that one of its pilots, Ayanami Rei, is a clone. Furthermore, what Nerv's goal—the "Human Instrumentality Project"—is and how it is to be accomplished is not clear until the end. Even while spawning enigma after enigma, the first half became popular by sticking to the format of a thrilling robot anime. However, as the inner struggles of the hero Ikari Shinji come to the fore in the latter half of the series, the narrative begins to falter as well. Most viewers interpreted this simply as the result

of an overidentification of the creator, Anno Hideaki, with the struggles of his hero.

The feature-length version of *Eva* derived from the necessity to bring closure to the failed television series. The third impact occurs, liquefying one character after another, who die as their souls are absorbed into a giant Ayanami Rei. But Ikari alone rejects this fusion. However, although he has avoided death by exchanging it for the risk of loneliness, he is rejected as "disgusting" by Asuka, a girl character who has also survived.

A great deal has already been written about *Evangelion*, and I myself have contributed to the discussion by theorizing that it overlaps with what psychiatry refers to as "borderline" personality disorders, so I will not repeat any interpretations here. In terms of beautiful fighting girl history, we should note that it broadened the ranks of anime fans and also brought back former fans. *Evangelion* is also remarkable for having created the artificial girl Ayanami Rei. Rei's existence is the culmination of the Pygmalionism that began with *Nanako SOS*, and her emptiness is perfectly exemplified in her identity as a clone. In this sense, Ayanami was an archetype; variations of her recurred in a number of important subsequent works. One example is Hoshino Ruri, the twelve-year-old heroine of the television anime *Nadesico* (1996), who achieved immense popularity. Ruri, the strategic officer who operates the battleship's supercomputer, is the only member of the crew who is passionate about her work. Although she is appalled by the blasé attitude of her comrades, who are more focused on fun than fighting battles, the cool, expressionless Ruri gradually mellows. A feature-length version of this was also released (1998), and in 1999 Ruri was selected as the most popular anime heroine by the magazine *Animage*. Another variation is the girl princess Anthy, who is given as the "prize" to the winner of the ultimate battle in *Utena* (*Shōjo kakumei Utena*, 1997), the controversial work in the Takarazuka subgenre directed by Ikuhara Kunihiko. Like Ayanami, Iwakura Rein, the nonfighting heroine in the television anime *Serial Experiments Lain* (1998), ends by choosing her own annihilation.

It was also symptomatic that during the latter half of the 1990s there was a noticeable increase in anime that foregrounded the emptiness of the fighting girl rather than her joy. Although beautiful fighting girls before this time were also the bearers of a certain emptiness, it was never quite as blatant. I return to ask what this emptiness means in the next chapter.

Other principal works of the latter half of the 1990s include the television anime *Akihabara Cyber Team* (*Akihabara dennōgumi*, 1998) and

Serial Experiments Lain

Cardcaptors (*Kaado kyaputaa Sakura,* 1998). Both were generic hybrids, and neither gave rise to a new form of representation sufficient to have an impact. They did, however, make good use of the unique qualities of the beautiful fighting girl genre with highly original settings and a critical stance toward the genre as a whole translated into convincing narratives.

To reiterate, the 1990s saw a remarkable increase in the number of beautiful fighting girl works; far more were produced than we can possibly enumerate, even if we confine our focus to anime. Although no new subgenres emerged, a variety of new tales were spun out of existing ones, and their premises became more complex. Their ability to crossover and coexist in such a multiplicity of media types—television anime, LD, DVD, feature-length releases, games, radio programs, and so forth—cannot be attributed to anything other than their reliance on the border-crossing heroine known as the beautiful fighting girl. It is highly unlikely that people will tire of the basic premise of the beautiful fighting girl itself or that it will go out of fashion in the near future. The beautiful fighting girl will not end up as an exhausted stereotype but will continue to inspire countless narratives. What does it mean that it has functioned that way for nearly thirty years without the least sign of decline? The answer, I believe, has to do with the power of "drawn sexuality." But I save the details of that for the last chapter.

The Beautiful Fighting Girl outside Japan

The fighting heroines from outside Japan that I have mentioned so far in this chapter are better described as "fighting women" than beautiful fighting girls. The film *Barbarella* is just one in a long history of experiments combining fighting with sexuality. These would include all of the many catfight and female prisoner films, not to mention the Bond girls in the 007 series. However, these are nearly all live-action works, and although the heroines may be young, they are adult women and certainly not girls. No matter how attractive they are, they are all Amazonian descendants of *Wonder Woman* (1941). I could list other heroines belonging to this lineage, such as Catwoman, Supergirl, She-Hulk, and Lady Death, but I have to omit them because they are beyond the scope of this book.

What is remarkable about these fighting women, first and foremost, is their common origin in feminist politics. It is comparatively easy to understand the significance of their existence because it is a direct reflection of improvements in the social status of women. They are the products, shall we say, of a kind of political correctness, and while they may exude some sexual attraction, it remains too weak to transcend the framework of fiction.

Very recently, however, there has been a sudden increase in the West in works that seem intent on representing the "sexuality of the fighting girl" and hence the power of drawn sexuality. Of course, there still are not many examples of what I am talking about. However, works like *Battle Chaser*, discussed below, which has a nine-year-old fighting girl as its heroine and drawings heavily influenced by Japanese anime, are becoming very popular, and it seems likely that this tendency will only accelerate from now on. I discuss some of the representative works in this lineage below (unless otherwise specified, they are American works). I have also included some in the Amazonian subgenre because they are important works from several points of view.

The French director Luc Besson, who is also very popular in Japan, has experimented with the combination of young girls and guns in two of his works, *Nikita* (*La Femme Nikita*, 1990) and *Léon* (*Léon the Professional*, 1994). The former depicts the girl delinquent Nikita, a first-rate sniper trained in a spy organization, struggling over her inability to tell her lover what she does. In the United States this was later remade into the movie *Assassin* and went on to become a popular television series, *Nikita*. *Léon*

Lineage	1960s	1970s	1980s	1990s
Splash of Crimson	Cyborg 009 (manga, 1964) Rainbow Battleteam Robin (TV anime, 1966) Ultra 7 (TV drama, 1967)	Battle of the Planets (TV anime, 1972) Star Blazers (TV anime, 1974) Time Bokan (TV anime, 1975) Secret Squadron Five Rangers (live-action TV drama, 1975) Gundam (TV anime, 1979) Future Boy Conan (TV anime, 1978) Galaxy Express 999 (feature-length anime, 1979)	Space Runaway Ideon (TV anime, 1980) Macross (TV anime, 1982) Akira (manga, 1982) Harmagedon (feature-length anime, 1983) Uchū Keiji Shaider (live-action TV series, 1984)	Squadron, giant robot, and so forth in very large numbers
Magical Girl	Witch Girl Sally (TV anime, 1966) Secret Akko-chan (TV anime, 1969)		Gigi and the Fountain of Youth (TV anime, 1982) Creamy Mami (TV anime, 1983) Esper Mami (TV anime, 1987) Kiki's Delivery Service (feature-length anime, 1989)	Little Red Riding Hood Cha Cha (TV anime, 1994) Nurse Angel Lilika SOS (TV anime, 1995) Pretty Sammy (TV anime, 1996) Magic User's Club (OVA, 1996) Cardcaptors (TV anime, 1998)
Transforming Girl	Pa-man (TV anime, 1967)	Marvelous Melmo (TV anime, 1971) We Love You, We Love You, Magic Teacher (TV drama, 1971) Cutey Honey (TV anime, 1973) Kekko Kamen (manga, 1974)		Bishojo Mask Poitrine (TV drama, 1990) What's Said Is Done, Three Sister Shushutorians (TV drama, 1993)
Team	009/1 (manga, 1967)		Cat's Eye (manga, 1981) Southern Cross (TV drama, 1984) Dirty Pair (TV drama, 1985) Megazone 23 (OVA, 1985) Project A-ko (OVA, 1986) You're Under Arrest! (manga, 1986) Gall Force (OVA, 1986) OVA Bubblegum Crisis (OVA, 1987) Silent Möbius (manga, 1988)	Gunsmith Cats (manga, 1991)
Grit and Determination	V Is the Sign! (manga, 1968) Attack No. 1 (manga, 1968)	Aim for the Ace (TV anime, 1973) Song of the Baseball Enthusiast (TV anime, 1973)	YAWARA (manga, 1986)	Natsuki Crisis (manga, 1990) Streetfighters II (game, 1991) Virtua Fighters 2 (game, 1995) Battle Athletes (OVA, 1996) Princess Nine (TV drama, 1998)
Takarazuka (included in the Sartorial Perversion Lineage)	Princess Knight (TV anime, 1967)	Star of the Seine (TV anime, 1975) The Rose of Versailles (TV anime, 1979)		Utena (TV anime, 1997)

Genealogy of the beautiful fighting girl

Lineage	1960s	1970s	1980s	1990s
Sartorial Perversion	Shameless School (manga, 1968)		Sailor Suit and Machine Gun (movie, 1981) Kuru Kuru Kururin (manga, 1982) Stop! Hibari-kun (manga, 1983) Delinquent Girl Detective (TV drama, 1985) The Asukas of Flowers (manga, 1985) V Madonna War (movie, 1985) Ranma ½ (movie, 1989)	Fly! Isami (TV anime, 1995) Birdy the Mighty (OVA, 1996)
Hunter	Epa-parera (manga, 1967) Lupin III (manga, 1967)	Eko eko azaraku (manga, 1975) Alien (manga, 1979)	Dream Hunter Rem (OVA, 1985) Appleseed (manga, 1985) BASTARD!! (manga, 1985) Vampire Miyu (OVA, 1988)	BASARA (manga, 1990) Zeiram (OV, 1991) Mamono Hunter Yoko (OVA, 1991) Ghost Sweeper Mikami (TV anime, 1993) Slayers (TV anime, 1995) Ghost in the Shell (feature-length anime, 1995) Tomb Raider (game, 1997) Aika (OVA, 1997) Hyper Police (TV anime, 1997)
Alien Girl Next Door		Urusei yatsura (manga, 1978)	3X3 EYES (manga, 1987)	Video Girl (manga, 1990) Tenchi muyō (OVA, 1992) Seiba Marionettes (TV anime, 1996) Save Me, Guardian Shaolin (TV anime, 1998)
Pygmalion			Dr. Slump (manga, 1980) Nanako SOS (TV anime, 1983)	GUNNM (manga, 1991) All-Purpose Cultural Cat Girl (OVA, 1992) Robot Force Iron Maria (manga, 1993) Azumi (manga, 1994) Serial Experiments Lain (TV anime, 1998)
Medium	Little Norse Prince (feature-length anime, 1968)		A Child's Dream (manga, 1980) Nausicaä of the Valley of the Wind (feature-length anime, 1984)	Samurai Spirits (game, 1993) Joan (manga, 1995) Princess Mononoke (feature-length anime, 1997) Joan of Arc (movie, 1999)
Other World			Leda: Fantastic Adventures of Yoko (OVA, 1985)	Rayearth (TV anime, 1994) Fushigi yūgi: The Mysterious Play (TV anime, 1995) Escaflowne (TV anime, 1996)
Hybrid			Gunbuster (OVA, 1988)	Sailor Moon (TV anime, 1992) Wedding Peach (TV anime, 1995) New Century Evangelion (TV anime, 1995) Sakura Wars (game, 1996) Nadesico (TV anime, 1996)

is a love story about a lonely murderer and the girl he picks up; the girl gets a gun to avenge the massacre of her relatives.

A wild girl from outer space is at the center of Besson's *Le cinquième élément* (*Fifth Element,* 1997). Synthesized from DNA, she is psychologically empty and very similar to a beautiful fighting girl. Clearly, the journey to his *Jeanne d'Arc* (*The Messenger: The Story of Joan of Arc,* 1999) has been pervaded with the theme of the beautiful fighting girl. Perhaps in the not-too-distant future this director will try his hand at making a live-action work from a Japanese anime.

Tank Girl (directed by Rachel Talalay), released in 1995 by United Artists, is a film based on a popular comic serialized by the British cartoonists Jamie Hewlett and Alan Martin in *Deadline* magazine beginning in 1988. Set in a postapocalyptic desert world, the film depicts the conflict between an organization that has monopolized control of water and Tank Girl, whose lover was killed by the organization; Jet Girl; and a group of soldiers enhanced with kangaroo DNA who protect them.

Aeon Flux is the heroine of the spy action anime of the same name created by the Korean-born Peter Chung. A sexy heroine clad in a black uniform and toting a machine gun, she mercilessly shoots anyone she deems an enemy. Originally aired on MTV in 1991, it was made into a very popular series. Now it is available as a video, and there are also comic and video game versions. *Aeon Flux* caused a stir among anime fans for its use of the fast action specific to Japanese limited animation.[14] In addition to these technical aspects, Japanese influence can be seen elsewhere— for example, in its media-mix distribution strategy.

Buffy the Vampire Slayer, a live-action drama that aired on the U.S. network WB in 1997, is a remake of the 1992 film of the same name produced by the husband-and-wife team Katsusuke and Fran Rubel Kuzui. The film was not much of a hit, but the television series was very popular and was still being broadcast in 2000. A mysterious man suddenly appears one day before Buffy, an ordinary high school student, and tells her that she has been selected as a vampire slayer. After receiving training as a slayer, she sets out to save Earth by exterminating vampires. The crux of the story, in which a perfectly ordinary high school girl is suddenly swept up in the strife of another world and forced into battle willy-nilly, combines the "summoned to another world" and "hunter" subgenres. The heroine is a Valley Girl, whose cuteness is emphasized over her strength.

The live-action drama *Xena: Warrior Princess* was a hit broadcast by MCA beginning in 1995. It is the story of the woman warrior Xena, who

formerly rampaged around Greece with a band of hooligans but, penitent now, exterminates monsters from the frontier with her follower Gabrielle. This was a unique work in a number of respects, including the fact that its heroine was a lesbian.

The *Shi* series, a manga set during the period of Warring States in Japan written by William Tucci and published by Crusade Entertainment in 1995, is the story of the heroine Ishikawa Ana, who has been banished from the Enryakuji warrior monk band and fights with a rival warrior organization to avenge the deaths of her father and elder brother. In addition to its Japanese setting, the design appears to have been strongly influenced by Japanese anime in other ways as well. In *Kabuki*, a manga by David Mack published by Image Comics in 1997, Noh is a secret organization that engages in secret maneuvers to maintain the power structure of Japan. The manga depicts the battles of the heroine Ukiko, who is known in the organization by her code name, Kabuki. In an interview, the author said that using a hero of a different gender and culture from his own was a strategic way to pursue a universal theme. However, a glance at any of these works shows that the Japanese setting is being used to project the theme of polymorphous perversion. In these cases an orientalist notion of "Japanese culture" is just being used to bolster the atmosphere of fantasy.

In *Witchblade* by Marc Sylvestri, published in 1997 by Top Cow Productions, the New York City homicide detective Sara Pezzini is in the midst of an investigation when she is chosen to possess the Witchblade, a mysterious glove that has been passed down since ancient times; she uses its tremendous power to fight crime. This sexy woman warrior, who fights while experiencing conflict in her personal life, is extremely popular; even now Sara always reaches the top ten when fans vote for their favorite comic book heroines.

In 1997 an American company called Eidos made news when it began selling *Tomb Raider,* a 3-D adventure game set amid ancient ruins with Lara Croft as heroine. Until that time, Japanese game heroines had always been voted first in fan rankings; Lara became the first made-in-USA game heroine to be voted in first place. Her extraordinary popularity goes beyond that: among other things, she appears in magazines, a movie version is planned, and a pornographic version of the game software circulates as freeware among fans.[15] The representation of sexuality in this work is low key, but Lara will likely be remembered as the first virtual heroine to capture the passion of Western fans.

To my knowledge, *Battle Chaser*, published by Cliffhanger Comics in 1998, is the first beautiful fighting girl work to appear in the West. This work by Joe Madureira, a former writer for the X-Men series, features a fighting girl only nine years old. The story takes place in a Dungeons and Dragons–type fantasy world, where the five protagonists, who have met by chance, join forces to fight evil. The center of the group is Gully, a nine-year-old girl who wields a magic glove (like the item in *Witch-blade*) inherited from her father. The five-member team—in addition to her there is Monica, another woman warrior; a swordsman; a wizard; and a war golem—fights off attacks by the enemy. You can see at a glance that Japanese anime strongly influences the design. The eyes are larger and the facial expressions easier to make out than in the usual American comic. The drawing of the hair in particular is completely different from that seen in American comics until this time and clearly emulates that of Japanese anime design. Rather than drawn as one solid mass, the hair is shown as an aggregated bundle of stiff yet supple fibers. This is clearly identifiable as a technique developed by the manga artist Fujishima Kōsuke (known in the West as Kousuke Fujishima). Furthermore, the diagonal lines drawn above the cheekbones—probably to signify blushing—are anime-style lines you don't find in earlier American comics. Plenty of attention has been paid to the heroine's sexuality, of course, and the combination of the beautiful girl and the mecha is interpreted in the style unique to American comics, all of which makes for a very attractive work. The work is extremely popular, and many unofficial Web sites about it have been created. Perhaps to develop RPG-type stories, fans have published many narratives using the character (called fanfic for short), a practice that is fundamentally similar to Japanese SS culture (see chapter 1).

Cliffhanger Comics has published other beautiful fighting girl works and has a fairly good reputation in the genre. The 1998 work *Danger Girl*, by Andy Hartnell and J. Scott Campbell, is the story of three mysterious secret agents who fight evil, and the influence of Japanese manga is perceptible in the drawing style, if somewhat subtly so.

As is clear from what I have said up to this point, the number of beautiful fighting girl–like works appearing outside Japan increased sharply in the latter half of the 1990s. To reiterate, the appearance of a major work like *Battle Chaser* is highly significant as a sign of this trend. In the future we are sure to see an even greater increase in the number of works of this type.

While direct influence from Japan is certainly part of the picture, there is surely also something inevitable about this tendency. Is there not, in other words, some generalizable relation between the development of the media environment and the problem of sexuality? If such a relation does exist, the beautiful fighting girl will acquire a universality that goes beyond its value as a uniquely Japanese icon. In the next chapter I at least try to define them from such a perspective.

6 THE EMERGENCE OF THE PHALLIC GIRLS

The Unique Space of Their Emergence

In this chapter we finally focus on how these beautiful fighting girls came into existence. To understand where they came from, we also have to ask about the particularities of the environment in which they were nurtured, namely, the media environment of manga and anime.

At the same time we must not forget the community of otaku who, as I have argued, did the most to raise and nurture these girls. A unique media environment was formed by the demand of an equally unique community of otaku. It was this demand that solidified the existence of the beautiful fighting girls. We must begin by examining the particularities of this media environment.

There are a few basic matters that need to be clarified. First, psychoanalysis regards the space of the imagination as having a high affinity for "perversion." Of course, there are various ways in which this can be argued.[1] But here I go with the straightforward interpretation that insofar as the Imaginary is governed by the principle of narcissism it will naturally be marked by polymorphous perversity.

Let us also remember that popular fiction, be it film, television, or manga and anime, is sustained by relatively simple principles of desire. Namely, sex and violence, otherwise known as romance and adventure. The following two quotes should be sufficient evidence of this. As Jean-Luc Godard declared, with a bit of irony, "All you need to make a movie is a girl and a gun." Or, as Pauline Kael, a film critic I trust implicitly, put it in a phrase she used for the title of a book, "Kiss Kiss Bang Bang": that says it all about the movies.

I am reiterating these basic ideas for a reason. It is to fend off naive interpretations such as the idea that the representation known as beautiful fighting girls, being a compact version of "sex and violence," makes an excellent fit for a nation known for its love of miniaturization. That this sort of interpretation might seem plausible only makes it more of a problem. Our methods of interpretation need not be popular just because their object is popular culture. But what we have established so far are only the preconditions for interpretation.

So what is so special about the space of manga and anime? I define it using the keywords *atemporality, high context,* and *multiple personality space.*

The Atemporality of Manga and Anime

Every form of visual media functions according to its own temporality. In the case of popular culture most of these temporalities are a matter of movement.[2]

All forms of visual expression are marked by a form of movement particular to their medium. Manga, anime, and film each have their own "grammar" of movement. Lining up photographs of real people like frames in a manga, for example, would not produce the same effects as a manga. On the contrary, it would lack reality *(riariti)*, and the only effect it could produce would be of kitsch. This is because the kind of movement specific to the photographic medium clashes with the manga form.

These techniques for expressing movement include everything from the macro-level of montage in film to the micro-level of speed lines in manga. Used effectively, they produce the effect of realistic movement. Reality *(riariti)* in anime is produced not by naturalistic backgrounds or by imitating cinematic techniques but only by realizing the kind of movement that is unique to anime. Under these conditions even a character drawn with a single line can seem just as real or even more real than a person in a photograph or a film.[3] Now let us consider the question of temporality in manga and anime while paying attention to how they express movement.

A comparison of the work of Ishinomori Shōtarō and Nagai Gō is useful in thinking about temporality in manga. Ishinomori and Nagai use very different methods for representing time. Simply put, one uses "cinematic time" and the other "*gekiga* time."[4]

As Katō Mikirō has also argued, Ishinomori's work brought the representation of time in manga to an extremely sophisticated level.[5] His

techniques were then adopted as a kind of grammar unique to manga and eventually rendered even more sophisticated in the hands of artists like Ōtomo Katsuhiro. One can certainly see the influence of film in these techniques (Ishinomori himself was also a great fan of Western films). Even more than someone like Tezuka Osamu, Ishinomori intended his manga to be like films. In contrast to this, Nagai's techniques are more specific to manga, almost as if he were taking a position against cinema. Because this point is very closely related to the emergence of the beautiful fighting girls, let us look into it in greater detail.

In Ishinomori's work, time "flows," as it were, at a mostly consistent speed. It is his well-known techniques for describing intervals in dialogue—for example, the kind of time produced by the contrast between the dialogue within speech bubbles and the handwritten dialogue outside the speech bubbles—that maintain the objectivity or intersubjectivity of time in Ishinomori's works. It is a more chronological, measured time that flows straight and even, without slowing or faltering.

In Nagai's work, on the other hand, time no longer flows. It contracts and expands along with the reader's subjective viewpoint. Action-packed, high-impact moments are drawn with large frames and take up many pages. This way of representing time, hardly used by Ishinomori at all, has become the trademark of Japanese manga in general. Ishinomori's *Masked Rider (Kamen raidaa)* and other works in the squadron genre have been more often adapted as live-action dramas than as anime. This is in stark contrast to Nagai's works, which have almost always been adapted as anime. There are no doubt reasons internal to the industry for this, but that does not explain everything. It seems clear that Nagai's work itself has a greater affinity for being adapted as anime. And one of the things that anime have adopted from manga is the kind of atemporality represented in Nagai's work.

In an earlier essay I was critical of this sort of atemporality in the work of Miyazaki Hayao.[6] Here, I would like to return to that earlier essay to reconsider the atemporality of manga and anime.

As Miyazaki himself points out, anime starts out as the stepchild of manga. Anime often borrow techniques directly from manga. The best known example of this is the use of so-called *manpu* (©Takekuma Kentarō), but the atemporality of anime is also derived from manga. Miyazaki compares anime's atemporality to a traditional Japanese form of storytelling known as *kōdan* storytelling, in which time and space are grossly distorted and exaggerated according to the passion and expressivity

of the characters. The *kōdan* "Kan'ei sanbajutsu" (Horse riding in the Kan'ei era), for example, is a long and extremely detailed description of how Magaki Heikurō climbs up a stone staircase on a horse. This kind of unlimited extension of a single privileged moment is typical of the atemporality of *kōdan* storytelling, and Miyazaki is extremely critical of it.

One sees this kind of temporality most often in *gekiga* comics like those of Kajiwara Ikki. The most extreme example is perhaps Nakajima Norihiro's *Astro kyūdan (Asutoro kyūdan)*, the climax of which is a single baseball match between the Astros and the Victories, the description of which took three years in serialization and more than two thousand pages. *Astro kyūdan* was a groundbreaking work, but it was neither minor nor avant-garde. It was published in *Shōnen jampu (Jump)*, a leading manga magazine, and, with the exception of a few raised eyebrows here and there, readers had no trouble accepting it.

The media space of manga and anime clearly tends toward atemporality. Manga about sports inevitably favor these descriptive techniques. The time between the moment the ball leaves the pitcher's hand to the time it is swallowed up in the catcher's mitt, the moment when a long-distance runner speeds up just before the finish line, the time of a round of boxing: all of these extremely short periods of time are extended and rendered in elaborate detail. The impact of a particular scene is heightened in direct proportion to the time spent describing it and the density of the narrative. Such techniques have been used most effectively in manga and anime. There is nothing in films or even novels capable of rendering this sense of atemporality quite as naturally. This point may have to do with the particularity of "Japanese space" that I discuss later.

Of course, the *imaginaire*, the realm of the imagination and fantasy, is atemporal to begin with. Dead people, for example, do not age in this realm. This is very different, however, from Sigmund Freud's notion of the atemporality of the unconscious. The unconscious is atemporal by its very nature, while the Imaginary can accurately be said only to strive for atemporality. In the imagination there is often a striving toward unlimited experience, which leads to a frantic gathering together of privileged moments.

In an essay on schizophrenia, the psychiatrist Nakai Hisao writes about the distinction between chronological and kairological time.[7] Chronological time, named after Chronos, the Greek god of time and the father of Zeus, refers to physical time that we can measure on the clock. *Kairos*, on the other hand, is the Greek word for "opportune moment" and refers to time as human beings actually experience it. When we feel as if a boring

lecture will go on forever or the time spent with a lover is over in a milli-second, it is because we are experiencing the time of kairos. Nakai writes that at a certain point in the progress of schizophrenia, patients experience "the collapse of kairological time and the maintenance of chronological time." If this is possible, then there is no reason to think that the opposite might not also happen. Chronological time might recede, and the individual might leap headfirst into kairological time. In borderline cases and hysterics, for example, kairological time is clearly dominant. The time experienced by these individuals is often marked by the "here and now" of narcissism.

There are several other ways in which anime and manga strive for atemporality, or the suppression of chronological time. Characters like Sazae-san and Doraemon never grow old, and their stories unfold cyclically, always in the same setting. The technique of the tournament form that anime borrowed from manga magazines like *Shōnen jampu* is another example of an atemporal form, like an infinite musical scale. The way the ranks of the enemy grow infinitely stronger is nothing if not a technique for introducing cyclical atemporality even as it disguises the passage of time. In anime there is also the issue of the voice actor. What does it mean that the voice actor seems ageless and immortal? Often we have no idea how old they are in reality, and they may play the same boy roles for years on end. They must be immortal as well: When Yamada Yasuo, who did the voice of Lupin, died, the role was taken over by a virtual vocal clone of Yamada's named Kurita Kan'ichi.

In this sense we can say that the time of manga and anime is kairological. The credit for inventing this technique goes, not surprisingly, to Tezuka Osamu. It was Tezuka's introduction of kairological time that made manga after Tezuka so utterly different from manga before Tezuka. One can already see that kairological time has taken over in those instances where he uses only the division of the frames rather than words or narration to express a character's emotional turmoil.

We can thus identify a particular grammar of kairological time in Japanese popular culture that extends from *kōdan* storytelling all the way through to manga and anime. The extraordinary popularity of manga and anime in Japan would be inconceivable without this technique.

For example, even cutting-edge American comics are quite slow-paced compared with Japanese manga. This slowness is what limits American comics and keeps them from ever being able to surpass the popularity of film. So why are American comics so "slow?"

Is it because the drawings are so detailed and intricate? It is true that a comic like *Heavy Metal* has extremely detailed, almost lifelike drawings, which makes it difficult to skim them. But even in Japan there are some manga artists, like Araki Hirohiko and Hara Tetsuo, whose heavy illustrations overpower everything else—yet their works are much more fast-paced than American comics. Why is this?

American comics are fundamentally loyal to the techniques of cinema. In other words, they use chronological time in every respect. The flow of time from frame to frame is always even, and emotional prolongation and exaggeration is minimized. The characters' subjective viewpoints are rendered through their monologues, and they do not demand readerly identification any more than necessary. In Japanese manga, on the other hand, particularly since kairological time was introduced by Tezuka, there has been a proliferation of techniques for rendering brief moments with high density and a very light touch. As these techniques were developed and further refined, they forced readers to identify with the characters even as they made it possible for them to read at a very fast pace. There is nothing else like this in the history of representational culture. It is very different from the way short time periods are represented in long novels such as the four days of the *Brothers Karamazov* or the single day of Joyce's *Ulysses*. The high temporal density of these literary works derives from their indexical and polyphonic narrative structures. What they lack, moreover, is speed. The paradoxical combination of high-density and high-speed forms of expression is the unique quality of the media space of manga and anime.

The atemporality of manga derives from the screen effect whereby something looks as if it were stopped because it is moving so fast. Atemporality is not the only effect made possible by this copious description of instantaneous moments. I have pointed out that it also makes speed-reading possible. What does the copious description of instantaneous moments have to do with speed-reading? Here it would be useful to explain one of the most conspicuous codes that characterizes manga and anime.

Synchronic Space in Unison

Manga has its own very particular set of codes. As is well known, manga have multiple means for communicating these codes, both visual and verbal, as well as various supplemental onomatopoetic and mimetic

expressions. Its methods of visual expression are far from simple. The background may be drawn in great detail, but the characters must be drawn using symbolic abbreviations. This is necessary to maintain visual continuity for the same characters from frame to frame. The characters' emotions must also be expressed symbolically. This is the function of so-called *manpu*. Movement is expressed symbolically using various kinds of "speed lines." I use the word "symbolic" here to indicate that these expressions directly transmit meanings as simple codes, leaving almost no room for multiple interpretations.

A frame from a manga chosen at random illustrates what I mean in greater detail. It is easy to see that multiple code systems coexist within even a single frame. We may begin by reading the text, but the shape of the bubbles that envelop the text are also expressive of emotions and situations. The manga as a whole consists of a very long list of codes, including the facial expressions of the characters, *manpu*, onomatopoetic and mimetic expressions, and speed and concentration lines. In manga it is almost impossible for a given mark on the paper *not* to carry any meaning. The brush or pencil strokes and the panel layout, as well as the empty spaces and the abbreviations, all contribute in some way or another to the meaning.[8] When we stop and think about it, it is quite surprising that we have read such huge quantities of manga without ever being conscious of all of these codes. How is it that a system of codes of this complexity has come to be shared as a common grammar so unconsciously—and accurately? Answering that question alone would make for a fascinating history of representational culture. But for now let us leave that aside and move on.

Some readers may be wondering whether there is really anything unique here about manga and anime. Don't film and theater have their own complex systems of codes? What is unique about manga and anime is not the layering of codes on top of one another, or even the number of codes in use. What is important is that in manga and anime these codes do not create a polyphonic effect. Instead, they work in unison.

What do I mean by this? Even though multiple layers of codes operate in a manga or an anime, they express the same meaning, or the same emotion. Multiple code systems are synchronized to convey the meaning of a single situation. The more precise and rhythmic this synchronization is, the more rapidly we end up reading them. Speed-reading is an effect of this unison of codes, but at the same time the codes are brought into greater synchronicity by being read quickly.

One more crucial factor is that each of these codes that we have been discussing is highly incomplete on its own. No single manga code can convey meaning by itself. The text or the images alone do not relay sufficient meaning to be read in isolation. This means that all of the code systems must supplement each other. It is only this mutual supplementation that makes possible the synchronization and the unisonic effect of the whole.

For this reason the space of manga functions as a representational space that is both excessively overdetermined in meaning and highly redundant. A related phenomenon is the rapid spread of those unsightly so-called telops that have become so irritatingly common on television programs in recent years.[9] The words of the performers on variety shows are repeated for emphasis using subtitles, to which are added (in all likelihood synthesized) recordings of the laughter of the crew. Here also, you have multiple codes working in unison to ensure that the viewer has no way to react but to laugh. Some have pointed to this as an example of television becoming like manga. But I am more interested in considering what it is about our culture that makes us so fond of these redundant and exaggerated forms of expression.

According to Frederik Schodt, who has also written about Japanese manga, the Japanese preference for combining visual with verbal expression has its roots in the *kibyōshi* picture books of the Edo period.[10] Schodt's thesis will of course require careful study before we can be certain. But at the present moment it does seem to be the case that Japan is the only country in which the fundamental grammar of popular culture can be described as the copious expression of multiple codes in unison. It is not that there are no examples of this in other countries, but nowhere else has it attained the widespread popularity and sophistication that it has in Japan.

This distinctive medium, which becomes meaningless when the codes are separated out and excessively meaningful when they are synchronized, brings to mind something else as well. It is very similar to how the Japanese language itself uses phonetic *kana* along with Chinese characters. As the anime director Takahata Isao has argued, anime and the Japanese language stand in a very intimate relation to one another.[11] Takahata's point is that anime *is* the Japanese language. Of course, there have been claims like this before, such as the one that suggests that manga resemble Japanese calligraphy. Misconceptions about *kanji*, particularly the idea that they are ideographic, and fascination with the refined look

of the characters led even Jacques Lacan into thoughtlessly remarking that "the Japanese cannot be psychoanalyzed."[12] If we accept the distinction between the Symbolic and the Imaginary, we have to recognize that this is wrong. If there is something unique about *kanji*, it is not that they are closer to symbols than to letters. It is entirely possible to be attached to the visual appearance of writing, to treat it like a fetish, whether it be *kanji* or alphabetic letters. For the same reason we should avoid facile conflations of the imaginary function of anime and manga with the symbolic one of the Japanese writing system.

My sense is that the uniqueness of the two-pronged *kanji/kana* writing system employed in Japanese has less to do with its visual qualities than with the fact that reading it is a highly context-dependent process. And it is this fact that helps regulate the emergence of symbolic effects into the Imaginary. What we can say at this point for sure is that neither a Chinese character nor a phonetic reading on its own is sufficient to denote meaning. And it goes without saying that it is only with the addition, in synchronic unison, of *katakana* and roman letters that the full meaning can be gleaned. It is probably not a coincidence that the code systems of anime and manga work in a similar way.

The ease with which we enter into the world of a manga and the extraordinary speed at which we are able to consume them suggest that we may "read" them in the same way that we read Japanese writing. If this is indeed the case, we might make a further hypothesis about the Japanese writing system. We cannot claim that Japanese writing somehow blurs the boundaries between the Imaginary and the Symbolic. We can argue, however, that it provides us with a sophisticated mechanism for processing imaginary objects using symbolic operational forms.

This hypothesis helps explain a number of strange phenomena. The first of these is that drawing ability is not the most important factor in assessing Japanese manga artists and anime directors. In fact we are strangely forgiving of their technical skills in drawing. The ability to draw certainly doesn't hurt, but it is merely an added value. There are any number of Japanese artists who are considered "greats" but whose drawing ability is inexpert when judged by the standards of the West. Even Ōtomo Katsuhiro, for example, is not valued in the West for his ability to draw. Instead, his international reputation rests on his ability to tell a good story. This tendency to downplay drawing ability is also reflected in the fact that almost all critical writing on manga and anime to date focuses exclusively on narrative and character analysis.

It seems likely that we Japanese inhabit a cultural sphere that has experienced a rather distinctive development of technologies for the symbolic processing of imaginary things. This hypothesis has implications that are not limited to the theory of manga and anime. But because those implications would take us far beyond the scope of this book, we leave them for later and return to the main argument, bearing this hypothesis in mind.

The Space of Multiple Personalities

It should be possible to further expand on and generalize from these notions of the multilayered codes in manga and anime and the way they function in unison. It should be possible, for example, to think of a character in a manga as a kind of code. In my understanding, manga works have a structure that resembles a patient with multiple personalities. The better the work, the more occasions it provides for the multiplication of these personalities. To put it differently, the more perfect the manga, the more completely it succeeds in integrating the totality of its characters into a single mutually supplementing system of partly personified characters.

In clinical practice it is well known that the separate personalities of patients with multiple personality disorder are highly incomplete in themselves. It is not uncommon for these individual personalities to be simple types whose entire nature can be expressed with a single phrase. In this sense it might be more appropriate to refer to them not as "personalities" but as individual "specs" (functions). This sort of incompleteness applies to many manga works as well.

It should be clear that what I am opposing to this space of multiple personalities is Mikhail Bakhtin's notion of polyphony. Here is Bakhtin on the space of polyphony:

> A plurality of independent and unmerged voices and consciousnesses, a genuine polyphony of fully valid voices is in fact the chief characteristic of Dostoevsky's novels. . . . a plurality of consciousnesses, with equal rights and each with its own world, combine but are not merged in the unity of the event. . . . not only objects of authorial discourse but also subjects of their own directly signifying discourse. . . . The consciousness of a character is given as someone else's consciousness, another consciousness, yet at the same time it is not turned into an object, is not closed, does not become

a simple object of the author's consciousness. In this sense the image of a character in Dostoevsky is not the usual objectified image of a hero in the traditional novel. . . . He created a fundamentally new novelistic genre.[13]

The space of manga and anime has virtually nothing to do with these characteristics. In fact that space is more like an even more extreme version of what Bakhtin describes as having come *before* Dostoevsky. In other words, manga and anime give us "a multitude of characters and fates in a single objective world, illuminated by a single authorial consciousness," in which "a character's discourse [can] be exhausted by the usual pragmatic functions of characterization and plot development" and made to "serve as a vehicle for the author's own ideological position."[14]

It is a fact that is often misunderstood, but like many other subcultural productions, the degree of freedom of expression in the manga genre is extremely low. Compared with the novel, the formal characteristics and the range of narratives and narrative perspectives in manga are much more tightly circumscribed. What manga have instead is a much greater diversity of styles than the novel. This is also typical of most subcultural forms. To put it in semiotic terms, manga are impoverished on the syntagmatic axis (i.e., the horizontal structure) but extremely rich on the paradigmatic axis (i.e., the vertical branch).

For this reason it is not possible for manga to convey narratives above a certain level of complexity. The personalities of characters in manga have to be simple enough to be understood at a glance. If complex personalities cannot be described, complex narratives are not possible. In manga, therefore, the individual personalities of characters are inevitably types. If many manga contain only characters that belong to identifiable types, this is because the characters have to be arranged according to a code in which each one of them carries a single meaning. But this is no reason to complain about the lack of complexity and depth in manga characterization. In manga, a single personality is often divided among multiple characters. In other words, an entire manga work in its entirety is the coordinated expression of a single personality—of, for example, the personality of the author.

If it seems like I am belittling manga and anime by making this argument, this is not my intention. But just to be sure, let me make my defense of them explicit. The characteristics of manga that I have described above are weaknesses in terms of their capacity for literary expression. But do we not live in a time when the authority of the literary has been

considerably weakened and the exponents of so-called high culture are being banished to an ever-shrinking territory?

If the weaknesses of subcultural forms like manga fall under the category of what I have just described as the syntagmatic, their strength lies in their paradigmatic diversity. One example would be popular music, where a diversity of sounds and arrangements are applied to simple structures, making for virtually infinite repetition and renewal. These days, techniques like sampling and remixing are not limited to music. We can all remember quite clearly how refreshing and powerful we found the anime series *Neon Genesis Evangelion (Shin seiki Evangerion)*, which was produced almost entirely using these technical refinements. Subcultural forms will surely continue to seduce and bewitch us with their uncompromising superficiality. They may not be able to portray "complex personalities," but they certainly do produce "fascinating types." The beautiful fighting girl, of course, is none other than one of those types. That she can only survive in a subcultural habitat is due to the reasons given above.

High Context

Expression takes many forms. In this book I have interpreted the word *media* in a broad sense and treated each form of expression that I have discussed as an independent medium. What, then, is the reason for the existence of multiple media like manga, anime, and film? Are these simply multiple forms for mediating the same reality? Not at all. Multiple media exist in order to support multiple fictions. We clearly perceive the form of a particular expression at the same time as we take in its content. The various media function as a kind of context, or a transparent and continuous totality that attaches meaning to content. In this instance the media themselves attain their own unique contextuality. For example, we are not in the least confused if a heroine who breaks down in tears in a television drama suddenly appears smiling in a commercial during the break. This is because it is very easy for us to shift instantaneously between the context of the drama and the commercial.

In an earlier work I referred to this idea of the unique contextuality of each medium as the "representational context," in order to use it in a more limited sense.[15] This is because it is possible to use the media form itself as a form of representation. As I explained in chapter 1, my use of the term *context* is based chiefly on a combination of the ideas of G. Bateson and E. T. Hall, which I have also explained in greater detail

elsewhere.[16] For our purposes here, it is possible to understand the contexts contributing to expression as existing in hierarchical strata. In the case of manga, the first context level is that of the narrative that gives meaning to the characters' actions. Above that is the genre of the narrative—the expressive context that determines whether it is to be taken seriously or as a gag. The representational context is one level above this. Or, if we order them from top down, the process by which we understand the content of a manga can be understood as a hierarchical series of stages beginning with the work's representational context (manga), proceeding to its expressive context (genre), on to the narrative context, and finally to the comprehension of the content. Of course, in actual fact we have to admit that this sort of hierarchy is ultimately not valid. It goes without saying that content and context exist in a relationship based on simultaneous and mutual corroboration. Therefore I should emphasize that the notion of representational context serves only for convenience of description and is not in any sense an isolatable object.

It is possible, for example, to think of visual media in the order of their dependence on representational contextuality. Contextuality in this case refers to the degree to which the form of expression itself determines the context expressed. In order of descending contextuality, then, we have anime, manga, television, film, and photographs. The statement "I saw a photograph," for example, conveys no meaning on its own. But the statement "I saw an anime" evokes a relatively concrete image in the listener's mind. This is because the anime form restricts the range of content much more than does the photograph. In other words, anime has the highest level of contextuality and photography has the lowest. Here I follow Hall in calling this the "high context" nature of anime. In general, we can say that more popular forms of expression tend to be higher context (as in the difference between classical and popular music). In visual media, the less information conveyed on the screen, the higher the context (this being the difference between television and film). Thus "cool" media (with low levels of detail) tend toward high context.

Let us think more concretely about the high-context nature of anime and manga. We have already established that form and content are intricately connected in both. In the case of these expressive forms, we can easily make guesses about the content and authorship even of works that we know nothing about. Even a single frame of the work will be enough to tell us the genre, the orientation of the content, and sometimes even the identity of the author. Moreover, the instantaneous switching between the

"gag" and "serious" modes that would be unthinkable in film but forms part of the grammar of anime (its so-called *yakusoku* [conventions]) can be explained only on the basis of this high-context nature.

I think of high context as the sensibility that emerges when there is no sense of distance between the producer and the consumer of a given media form. Once we immerse ourselves in this high-context space, the meaning of all stimuli is grasped instantaneously. Inevitably, emotional codes are more easily transmitted here than verbal ones. This high-density transmissibility enables extremely high levels of concentration and absorption.

Intersubjective Mediation, or Media Theory

Based on what I have said above, we can identify the difference between film and anime or manga first in terms of contextuality.

Is this the place for us to move to a discussion of media theory? Is the desire for the beautiful fighting girls a sign of an internal transformation, an "implosion" and extension brought on by our contemporary media environment?[17] In some senses this may be true, but in others it is certainly not.

The development of the media environment has in fact partly transformed the structure of our society. The development of the mass media industry itself is one manifestation of this transformation. Its influence on the economy and on education has, of course, been enormous. But to what extent does this transformation penetrate our inner worlds?

In clinical terms there has not been the slightest structural transformation. The structure of our neurotic subjectivity remains intact, just as Freud discovered it a century ago. If asked to prove this, most analysts would say that it is not their role to offer general proofs of anything. This, too, has not changed in a hundred years. Analysts can speak about the truth. But, or perhaps therefore, they cannot prove what is true. To say that the structure of the subject is intact is to say that the structure of desire has been maintained. What needs to be emphasized here is that, in order for the structure of desire to be maintained, the object of desire must constantly change. If the object of our desire looks different than it did a hundred years ago, this is only a change in appearance that results from the continual maintenance that we as subjects have performed on the structure of that desire. Yes, the development of media has brought about an outward change, a superficial change in the objects of our desire.

From this we can derive at least two psychoanalytic hypotheses. If we use Lacan's divisions, the stability of the subject denotes primarily the stability of the relationality between the Symbolic and the Real. Moreover, the internal transformation that Marshall McLuhan referred to as "implosion" can be considered mainly as having emerged as a change on the level of form in the Imaginary. Herein lies one of the thorniest difficulties of media theory. If voice and writing are themselves already forms of media, what exactly have modern media been able to add to the equation? The transformation of the subject in the Imaginary can always make it seem as if nothing has happened. As long as this is the case, the appearance of media theory will remain in the always-awaited future, and its conclusions will only continue to be deferred.

But perhaps there is something to be gained nonetheless by taking a detour here and considering the mutual operations of the media environment and the Imaginary. The development of media is clearly most striking in the visual realm. Already we are able in principle to see any sort of image whatsoever. If we so desire, we can also keep large numbers of images in our possession on a computer hard drive. There is no little significance in the fact that, as is so apparent in the case of the ever-increasing functionality of the personal computer, it has become very easy for us not just to preserve but to reproduce, manipulate, and transmit visual information about all sorts of experiences. Our Imaginary has been dramatically expanded and accelerated by the media, or extended through "implosion."

The diversification of methods of mediation has had a number of effects. One of these is the potential impoverishment of content and form.[18] As was clear in the case of the beautiful fighting girls, the narratives in a diversified media environment are surprisingly similar to each other. As I pointed out in chapter 5, there are hundreds of examples of the beautiful fighting girl genre, but only thirteen story lines. From the 1990s on, no new story lines emerged, and new works were simply rearrangements of old ones. In this case at least, we can say that, while the diversification of media may contribute to the outward diversification of the works, we need to be aware of the possibility that it encourages the involution of the genre as a whole.

The more information is exchanged, the more redundancies there are and the more monotonous it becomes. For example, now that communication by personal computer has become the norm, people read and perhaps write enormous amounts of text every day. As a result, we see

developing a common "computer style" of writing that is excellent for transmitting information but extremely limited in its capacity for description and definition. The impoverishment of visual information is most evident in the spread of anime-style images.

So what is this about? Increasing the level of detail or rendering movement more subtly in anime would take exponentially more money and time. But of course these luxuries are not always possible. On the other hand, too much abbreviation reduces the images to mere signs and makes for a very dreary representation (like the Saturday morning cartoons in the United States, where the only facial movements are blinking eyes and opening and closing mouths). The solution to the problem in Japan was, I believe, the introduction of the "big eyes and small mouth" that has become the tradition in Japanese anime.

The only parts of a manga that cannot be drawn by assistants are the face, and particularly the eyes, of the main characters. The author's style appears in its most concentrated form in the facial expression and the eyes. The shortcut technique that resulted from this was to divide up the drawing of the background among assistants and make the characters like simple signs. This made possible the division of labor. Then, to avoid making the characters too much like mere signs, the facial expression, particularly the eyes, and the hands are drawn with great care. Among all of the human organs, these occupy the position closest to the grammatical subject. Drawing the eyes and hands with special care has the same value as inserting text. Or, to put it the other way around, as long as the eyes and hands are carefully drawn, the rest can be abbreviated. Then one can add more facial expressions and make them more complex with *manpu*. This procedure enables the streamlining of the production process while also effectively communicating a wide variety of subtle emotional codes, making it easy for the viewer to identify emotionally. This is the likely origin of the too-large eyes and tiny mouth that Westerners so often point out in Japanese manga and anime. The anime image is the result of a sophisticated technique that enables a maximum of communication with a minimum of lines.

One noticeable trend in recent years, which may have to do mostly with keeping costs down, is that even as the images are drawn with greater and greater sophistication of design and coloration, they tend to move much less. The appearance of movement is skillfully produced by blurring the image, using flashes of lights, and bank sequences,[19] but on closer inspection there is actually very little movement. The impact of "anime

images" results from drawings so refined that this sort of thing no longer appears unnatural. Moreover, because there is no need for the drawings to be particularly intricate, they can be easily digitized, which makes it possible to transfer them into a computer game without altering them. This style of drawing, which is devoid of texture and consists only of fine lines and surfaces, helps smooth the flow of the so-called media mix as the images are transplanted from comics to anime to film, games, figurines, and toys.

The space of manga and anime has introduced easily shareable code systems into our Imaginary. This shareability, in turn, introduces elements of polymorphous perversion into that space. As a result, in the 1980s we first became aware of a very important fact, namely, that even the objects of our sexuality were shareable through the mediation of manga and anime. This realization led to the explosive growth of sexualized images in this space. Of course, the wholesome notion that manga and anime are basically for children exists even now. But even this constraint was quickly converted into a useful technique. Depicting sex in a context that is for children almost inevitably produces undifferentiated, which is to say polymorphously perverse, effects.

To create an autonomous object of desire within the fictional space of manga and anime: was this not the ultimate dream of the otaku? They sought to create fiction not as a stand-in for the "real" sexual object, but fiction that had no need to be secured by reality. For this to work, not even the most elaborately constructed fictional worlds would suffice. In order for fiction to attain its own autonomous reality, it would have to be desired for its own sake. Only then would reality bow down to fiction.

"Fiction" versus "Reality"

Earlier I referred rather casually to the contrast between "fiction" and "reality." Of course, I do not accept this contrast naively. In fact, it is my belief that everyday reality is itself nothing more than a fiction (or fantasy) and that it is fundamentally impossible to draw a strict distinction between them. One reason that I raise the distinction nonetheless is in order to think once more about "Japan." The art critic Sawaragi Noi has argued that Japan functions as what he calls a "bad place" and that any act of expression that attempts to escape from that place can only end up by making it worse and getting caught in a vicious circle.[20] If such a place can be hypothesized, it is entirely possible that it could also subsume the

place of manga and anime that I have been discussing here. For now I call that space "Japanese space" and contrast it with another unique representational space, which I call "Western space."

As I pointed out earlier, in Japanese space the distinction between fiction and reality is not completely in effect. The distinction itself is in fact based on a Western idea. In his theory of ideals Plato begins with a three-part distinction between the ideal, reality, and art, and places art at the bottom of the hierarchy because it is only an imitation of reality. In Plato's system there is only a series of copies, with the copy of the ideal being reality and the copy of reality being art. Art must content itself with the lowly position of being a copy of a copy, an imitation of an imitation. Added to this is the influence of Judeo-Christian culture, which rejects idolatry. In "Western space," even today "reality" is made to conform strictly to this ranking. In this context the notion of the "reality of fiction" is already attenuated by being subjected to all sorts of constraints.

For example, in American popular culture the most privileged fictional form is film. To be made into a film is the ultimate proof of the success of any narrative, whether it originates as a novel or a play. Of course, there are any number of reasons for this, but one is surely the belief that live-action film is the most accurate imitation or reproduction of reality. The impact of live-action film is supported by the belief that what it portrays is a faithful reproduction of reality. In my opinion there is absolutely no difference between the fictionality of live-action film and animated ones; it is just that anime is considered more fictional because it is under the *constraint* of having to be drawn by someone. For this reason animated films have almost no chance of winning the Academy Award for Best Picture and will always remain a genre inferior to film.

Thinking about censorship practices makes this even clearer. Censors in Japanese space seem for the most part uninterested in the symbolic value of what they are censoring. As long as the genitals are not portrayed explicitly, they will allow even the most depraved images to be shown. In Western space, however, images are censored according to their symbolic value. The censors are not interested in the trivial question of whether or not the genitals are visible, but reserve their strictest scrutiny for obscenity and perverse content. A recent example is the cover for Marilyn Manson's CD *Mechanical Animals*. In the composite photograph, Manson appears nude as he glares at the viewer, but with the smooth groin and small breasts of a young girl. This level of perversion does not cause the least problem in Japan. But in the United States

it created quite a scandal, with several large music stores refusing to carry the album. One could list any number of similar examples of this difference in the way Japanese and Americans judge an image obscene. Of course, even in Japan this sort of taboo on images still lingers when it comes to the Imperial family, but even that is losing the force it once had. In fact, that taboo has become so weak that it would shock even Okuzaki Kenzō.[21] We are now living in an age when it is possible to publish a manga depicting a bomb thrown at Princess Masako during a parade, and the romance between Princess Kiko and Prince Akishino has been made into an anime. In other words, we still do not have the slightest idea what it is that defines depravity.

One conclusion that we can draw from this comparison is that visual expression in Western space is symbolically castrated, while in Japanese space there is only imaginary castration, at most. For example, in Western space any image that symbolizes the penis is censored, while in Japanese space as long as you do not portray the penis itself anything goes. In this ironic sense I would suggest that the Japanese media enjoy the greatest freedom of expression. The problem arises with this freedom itself.

In Japanese space, fiction itself is recognized as having its own autonomous reality. As I mentioned earlier, in Western space reality is always in the superior position, and the fictional space is not allowed to encroach on it. Various prohibitions are introduced to establish and maintain this superiority. It is not permitted, for example, to produce images depicting sexual perversion. This is because fiction must not be more real *(riaru)* than reality. Fiction must be carefully castrated so that it does not become too appealing. This is what I mean by symbolic castration.

It is often remarked that the heroines of Western comics and anime are for the most part not very cute. They often include beautiful women and naked bodies, but rarely do they directly represent characters as sexually attractive. This cannot be explained simply as a result of a discrepancy in technical skill or differing notions of beauty. In the case of an actual Hollywood actress, Japanese and American fans are likely to speak in similar ways about her sexual attractiveness. But the situation is very different when it comes to heroines who appear as drawn images. Betty Boop, for example, may be drawn in a sexy outfit (with a garter belt!), but she is more like a parody of a sexy actress. Her fans are not immediately captivated by Betty's sexual charms.

To continue with our discussion of Western space, we might remember that 1957 saw the creation of the so-called Comics Code Authority

that formulated self-regulatory codes for comics in the United States and effectively spelled the end of the golden age of American comics.[22] At the time juvenile delinquency had become a hot-button issue, and comics were singled out as a contributing factor. Among comic fans the formation of the CCA is referred to as the "Total Disaster." The list of restrictions is as absurdly detailed as the rules at a Japanese high school. A few items that stand out on the list are

"Divorce shall not be treated humorously nor represented as desirable."

"If crime is depicted it shall be as a sordid and unpleasant activity."

"In every instance good shall triumph over evil and the criminal punished -[sic] for his misdeeds."

"Policemen, judges, government officials and respected institutions shall never be presented in such a way as to create disrespect for established authority."

Under the category of "Marriage and Sex" the code states that "Nudity in any form is prohibited," "Females shall be drawn realistically without exaggeration of any physical qualities," "Illicit sex relations are neither to be hinted at nor portrayed," "Seduction and rape shall never be shown or suggested," and "Sex perversion or any inference to same is strictly forbidden." Japanese manga as harmless as *Sazae-san* and *Doraemon* might run afoul of these rules (and a bath scene with elementary school girls is out of the question!). If regulations this strict were in force in Japan, virtually every manga magazine in print would have to be shut down.[23]

It is thus quite possible to analyze the differences between Japan and the United States from the perspective of regulations. But what I want to stress here is that these rules show all the symptoms of an excessive defense reaction. No matter how popular comics had become by the 1950s, they could hardly compete with film. Nevertheless, they were much more severely regulated, to the point of destroying an entire genre of expression. Would it be too much to see in this an echo of what we might call the West's iconographic taboo? The highly detailed and concrete restrictions on the depictions of sexuality are particularly remarkable. In these restrictions we can clearly see operating the obsessive idea that *images themselves must not be sexually attractive.*

Pornography must be considered as part of this discussion of the visual expression of sexuality. Pornography, needless to say, prizes images that are realistic and highly practical. In the decline of *roman poruno* and the

rise of adult video, for example, one can see the pursuit of convenience and practicality. Pornographic images trend toward being more suitable for private consumption, reproduction and distribution gets easier, and pornographic expression gets more and more explicit. But in the Japanese space this leads to another contradiction: namely, the existence of "porno comics." I want to stress once again that I am speaking of pornography in general here, not of "erotic expression." It is perhaps only in Japan that pornography has taken the form of comic books and attained a certain popularity in doing so. Of course, there are porno comics that are meant to be used as masturbation aids in the West as well, but on a scale that does not even begin to compare with that of Japan.

It seems absurd that such an enormous market would emerge for pornographic comics in a country where "hair nudes" are everywhere and people are somewhat bored even of adult videos.[24] As I pointed out earlier, anime-style drawing has been hugely influential in this genre as well. In terms of their correspondence to everyday reality, there is no less realistic style of drawing. Despite this, however, these kinds of representations have been widely preferred as a medium for pornography. This would be entirely unimaginable in Europe or the United States, and the contrast points to a significant cultural difference.

Of course, there is a historical background to this as well. According to Timon Screech of the University of London's School of Oriental and African Studies, the so-called *shunga* that were produced in such huge quantities in the Edo period were used by the masses as masturbation aids.[25]

If that is in fact the case, we should also be able to find the roots of manga and anime in the Edo period, in a culture in which sexual desire was both stimulated and satisfied by drawn images. The issue here, needless to say, has nothing to do with anything like the symbolic expression of eros. The problem that we have arrived at instead is that of *the immediacy of the drawn image.*

As I have already pointed out, there are many fans of anime and manga in the West. But they are virtually unanimous in their hatred for so-called tentacle porn. They believe that sexuality does not belong in animation. What do Japanese otaku think about this? If they were shown this sort of pornographic work they would either give a wry smile or launch into a lengthy discussion of the history of adult anime using works like *Cream Lemon (Kuriimu remon)* and *Legend of the Overfiend (Urotsukidōji)* as examples. I cannot help but see in this difference another huge contrast between Japanese and Western otaku.

Leaving aside the question of whether it is possible to read in this the traces of taboos and repression, for now let us reiterate the minimal facts of which we can be certain. In the Western space of popular culture, it is exceedingly rare to find drawn iconic images of cute little girls and erotic nudes. In that space there is an unconscious censorship of drawn images, and their reality is kept within certain limits. The type of caricatures so conspicuous in Disney's animations can even be considered as a technique of exaggeration for the purpose of repression. Constant and meticulous efforts are made in this space to prevent drawn images from attaining their own autonomous reality. In other words, drawn images are always kept in the position of being substitutes for objects that exist in reality.

In Japanese space, on the other hand, it is permissible for all sorts of fictions to have their own autonomous reality *(riariti)*. In other words, real *(riaru)* fictions do not necessarily require *the security of reality (gen-jitsu)*. There is absolutely no need in this space for fiction to imitate reality. Fiction is able to clear a space around itself for its own reality *(riariti kūkan)*. The appeal of drawn images of little girls, for example, is a crucial element in the production of this reality *(riariti)*. Here, fiction must establish a logic of sexuality all its own. This is because, in Japanese space, sexuality is the most important factor upholding reality *(riariti)*. Of course, this is not true only of anime. Why else, for example, did the artistic traditions of the past put so much emphasis on the depiction of women? Why do *rakugo* raconteurs spend so much time extolling the pleasures of womanizing?[26] And why do manga instruction courses always begin with how to draw a boy-girl couple? All of these things, which are particular to Japan, suggest that in this space it is sexuality that upholds the reality of fiction *(kyokō no riariti)*.

So let us accept the autonomy of fiction and put forward the thesis that this autonomy is a necessary precondition for the beautiful fighting girl to emerge. If this is the case, we cannot in any sense see in them the reflection of "everyday reality." It would not be permissible, for example, to infer from the popularity of beautiful fighting girls that girls are being empowered in the real world. It is the stubborn habit of seeing fiction as an imitation of reality, which is hard even for the Japanese to resist, that is at the root of this misunderstanding. The misunderstanding may be logically consistent, but that same logical consistency is also precisely what renders it invalid.

Getting back to our discussion of the image in Japanese space, I repeat that representations in this space do not undergo symbolic castration.

There are some gestures toward imaginary castration with regard to sexual codes, but these are barely functional, and in the end they actually come closer to initiating a drive toward the disavowal of castration. The disavowal of castration is of course the initial condition for sexual perversion, which is why this space exhibits such an affinity for perverted objects. All sorts of images come to occupy various positions within this ecosystem of autonomous reality, and the space begins to overflow with meanings rendered through sexual and other codes. In this place, so highly charged with meaning because of this sheer verbosity of codes, context is privileged over any single disarticulated code. Meaning is transmitted instantaneously here, but its provenance can never be traced back to a single code.

This sort of high-context representational space can sometimes lose some of its reality effect if it is circulated too widely and understood too easily. How might it resist this attenuation of reality? One way is, of course, through sexuality. As I have argued several times already, *sex* is a necessary component for a narrative to seem real. The various struggles and manipulations surrounding sexuality (i.e., "romance") are what introduce a core of reality into a narrative.

The widespread transgression of sexual limits in Japanese representational culture can also be interpreted in light of the high-context nature of Japanese space. High-context expressive space is, by nature, incapable of making full use of the effects of structural and formal reality. Instead it is the intensities that emerge at moments of shifting and switching from one context to another that are used to create reality effects. In the highest context spaces of anime and manga, most important are those gestures capable of transcending the context of heterosexual desire. The various characteristics of the beautiful fighting girls, which include hermaphroditism, transformation (i.e., accelerated maturation), and the strange mixture of proactivity (i.e., fighting ability) and passivity (i.e., cuteness), all help facilitate the emergence of this *transcendental reality*. That all manner of perversions should be evoked in their presence is only natural.

The Phallic Girl as a Form of Hysteria

Let me take a moment to recapitulate my argument. The forms of expression known as manga and anime that have emerged within the framework of Japanese representational culture with its fundamentally high-context nature have refined the qualities of atemporality, simultaneity,

and multiple personality to such an extent as to produce a representational space in which communication and transmission of information have become extremely efficient. To maintain its autonomous reality, it is to some extent inevitable that this kind of imaginary space incorporates sexual expression. By "autonomous" I mean an autonomous economy of desire that has its own existence within the representational space and is no longer simply a projection of the desire of the viewer. The more heterosexual the viewer's desire is to begin with, the more the imaginary "expressed sexuality" must transcend it and deviate from it. It is from this perspective that we can largely explain the gap between the polymorphous perversity of manga and anime and the relative wholesomeness of its readers' desires.

The icon of the beautiful fighting girl is an extraordinary invention capable of encapsulating polymorphous perversity in a stable form. She radiates the potential for an omnidirectional sexuality latent with pedophilia, homosexuality, fetishism, sadism, masochism, and other perversions, yet she behaves as if she were completely unaware of it all. She will probably continue to be seen as the companion to the boy hero character and protected as a feminist icon. Anyone boorish enough to point to her perversity can only bring on himself or herself the scorn typically heaped on psychologists and psychiatrists these days. The reception of the beautiful fighting girls, they say, perfectly symbolizes the conditions of today's society, particularly that of women. This is true in part, and books written from this perspective are certainly given a warm reception.[27] But I cannot bring myself to find much interest in this kind of analysis. At this point any analysis naive enough to see a direct reflection of reality *(genjitsu)* in a fictional construct is itself a typical example of confusing fiction and fact. As long as we remain at this level, we will never be able to decipher the dissociative sexuality of the otaku. As I emphasized in chapter 1, in this book I have always assumed the possibility of the existence of multiple "realities as fiction" *(kyokō toshite no genjitsu),* one of which is our everyday reality *(genjitsu).* Our everyday life and the various realities we encounter in fiction are here all considered components of reality *(genjitsu).* I want to stress once again that this is neither idealism nor a semantics of potential worlds. When we posit the Real as the impossible realm of "things," its very impossibility stimulates the Symbolic and the Imaginary, and it emerges as an imaginary reality *(sōzōteki genjitsu) that is plural on the level of meaning.* So-called multiple personality disorder is the most extreme expression of this "plural reality" (i.e., it consists of

alternating personalities). In this context it is a singular latent reality, namely, a traumatic reality that causes one's imaginary reality to splinter into multiple versions. What I call the "plurality of (imaginary) reality" *(sōzōteki genjitsu no fukusūsei)* has its origin and latent source in the positing of the Real. Without that it is nothing more than a variant of the idea that fantasy is all that exists.[28]

The so-called phallic mother is one of the key concepts of psychoanalysis. It literally means a mother with a penis and is sometimes also used to describe a woman who behaves authoritatively. The phallic mother symbolizes a kind of omnipotence and perfection. The tough fighting women in Western media, for example, can all be termed phallic mothers. It is in comparison with these Amazons that I use the term "phallic girls" to refer to the beautiful fighting girls.

Kotani Mari has made the very suggestive observation that most phallic mothers are marked with some sort of wound (such as having been raped).[29] Kotani's comment made me realize that the phallic girls have not experienced any trauma. Consider Nausicaä. Are we more likely to empathize with her or with Kushana, queen of Tolmekia? With Kushana, of course. Kushana is precisely a phallic mother in the Western sense. She has already experienced a great deal of trauma from her brothers' betrayal and other things. The ultimate proof of this is the wound on her body inflicted by the Ohmu. Kushana has been raped by the Ohmu, and we find it perfectly natural that she fights for this reason. If we are captivated by Kushana, our desire is directed first toward her trauma. We apply to this situation the same structure of desire that captivates us about hysteria when we witness it in our daily lives.

What about Nausicaä? There are many mysterious aspects to her behavior. Why does she love the Ohmu so much as to offer her own life to save one of their children? There is something quite moving about this, but it may be nothing more than perverse self-sacrifice that moves us. To the extent that Nausicaä's actions are not supported by personal motives they appear empty. Why is this?

There is no "trauma" in Nausicaä. Of course, early in the narrative, when her father, the king, is killed by Tolmekian soldiers, Nausicaä lashes out and kills several of them instantly. The slaughter sequence finally comes to an end with Yupa's bodily intervention. Could we not interpret this murder of her father as a kind of rape or trauma for Nausicaä? Such an interpretation appears possible. But think for a moment. What is this scene in which Nausicaä kills and wounds her enemies supposed to tell us? It is

telling us that she is already a very skillful fighter, perhaps even that she has honed these skills in a number of battles. If that is the case, it would mean that Nausicaä was a phallic girl even before this traumatic event occurred.

In the latter part of the narrative Nausicaä fights to protect the Ohmu. At this time she bears no trace of trauma. Nausicaä is not a character who will ever be raped. To say that she can never be raped is also to say that she is a being without a concrete existence. We do not read in Nausicaä the typical narrative, which is to say the neurotic narrative, of the repetition of and recovery from trauma. Why is this?

Compared with the phallic mother who fights as a result of the trauma of rape, the phallic girl lacks sufficient motive to fight. As I discussed in detail in chapter 5, manga and anime in which phallic girls appear can be divided into thirteen different subgenres. As will be immediately apparent when looking over that list, these subgenres almost never center on narratives of trauma or revenge. Of course, it is true that in manga and anime each episode must be able to stand alone, which makes it difficult to accommodate narratives of trauma, recovery, and revenge. But this is not the only explanation. The phallic girl is a thoroughly vacant being. One day she finds herself in another world and, for no apparent reason, is given the ability to fight. Her fighting ability is either (as in the case of Nausicaä) an unexplained, self-evident precondition, or it is given to her suddenly, from without, and for no reason. In either case I think few would disagree that she is in a position very much like that of a medium (miko); that is, she functions to mediate the other world. The destructive force that she wields is not one that she manipulates subjectively but rather a manifestation of a kind of repulsive force that operates between different worlds. As a kind of medium, it is only natural that she should be hollow inside. Women who are able to mediate desire and energy by being empty in this way would be referred to by some psychodynamic psychiatrists, myself included, as hysterical.[30]

If the phallic mother is a woman with a penis, the hysterical phallic girl is a girl who is identified with the penis. The penis here, however, is a hollow, empty one that will never function again. The most telling example of this is Ayanami Rei, the heroine of the anime *Neon Genesis Evangelion*, which I have mentioned a number of times. Her emptiness is symbolic of the emptiness common to all fighting girls. Her existence has no solid basis, she knows no trauma, and she lacks motivation. Her emptiness allows her to make a permanent home in a fictional world. In

the completely fictional world of manga and anime, the very baseless-ness of her existence generates a paradoxical reality. In other words, by being placed in a completely empty position she acquires the functions of a truly ideal phallus and drives the narrative forward on that basis. Our desire, moreover, is awakened by her emptiness.

Let me say a little more about the hysterical status of the phallic girl. First of all, what exactly is hysteria? It is a name for one of the structures of our desire (and hence of reality). By the time we recognize hysteria, we are already captivated by it, and it does not occur to us ever to doubt its existence.

Hysteria has always already been a part of psychoanalysis. Freud posi-tioned it as the origin of his method. And Lacan, who tried to be even more thoroughly Freudian than Freud, postulated a structure of hysteria that exists within all of us. This is most evident when, for example, we desire a woman.

When our desire is directed toward a woman in the name of "love," it is safe to say that we are always hystericizing the woman. When we are attracted to the outward appearance of a woman, we try to convince ourselves that what we are attracted to is some invisible essence of the woman in question. The first meaning of hystericization is this pro-cess, in which we set up a gap and an opposition, themselves baseless, between the visible exterior and the invisible essence. At the same time, the essence of the woman here is in fact equivalent to the "traumatic." What captivates us in the woman is in fact her external trauma. There are all sorts of traces of this in popular culture.[31] The "injured woman" is loved precisely for her trauma.

If it is possible for us to be attracted to an aggressive adult woman, we can define this as the process of hystericizing the "phallic mother." But needless to say, this definition does not mean *directly* that aggressive women become hysterical. To put it more rigorously, this is a descrip-tion of the change in the relationality between us and the woman who is our object, made with special attention to its symbolic elements. When we get an impression of aggressiveness from the female object, we see in her a phallic mother on the symbolic level. When we fall in love with her because we have sensed some sort of trauma in the depths of her aggressiveness, it is possible to say that we have hystericized the phallic mother on the symbolic level. Moreover, the realm in which these trans-formations take place is not limited to that of our own subjective view-point. Insofar as it is a change in relationality, it cannot help but involve

the woman as well, through processes of transference and projection in everyday reality. For this reason hystericization is often none other than the course taken by love.

Like the phallic mother, the phallic girl is also hystericized by the desiring gaze. Of course, we are well aware that she is a drawn entity that has no depth or essence beyond that. Why does this knowledge not get in the way of our desire? Most likely because she represents a *total lack of material existence*. What matters most about the entity known as the beautiful fighting girl is the fictionality that she possesses from the moment of her birth. Like the problem of the unicorn, the question here has nothing to do with whether girls who fight actually exist in the world.[32] We have already in this world accepted and loved the phallic girl as a being who is completely fictional to her core. Moreover, it is almost certain that it is her lack of a real existence that has made this desire possible.

It is at this point that we can finally understand the significance of Japanese space in the emergence of the phallic girl. Unlike Western space, which tries to anchor reality by preserving a sort of umbilical cord back to reality, Japanese space does not insist on this connection. Instead it actively attempts to separate and tear itself away bodily from everyday reality. We do not enjoy fiction because it is a form of virtual reality. We enjoy it because of its status as *another reality*, one that demands a rearrangement of the subject.

However, to maintain this space, this *other reality* that is apart from everyday reality, we often require the help of the magnetic field of sexuality. Of all of our various desires, sexual desire is the most resistant to fictionalization. Sexual desire is not destroyed by fictionalization and can therefore be easily transplanted into a fictional space. This is because human sexuality, which does not require a biological basis, has a fundamentally fiction-friendly nature. Fictional, or "drawn," money and power do not activate our desire. But when it comes to a drawing of a naked body, things are quite different. Even though we know it is drawn, we have a powerful, sometimes even corporeal, reaction to it. Our reaction is so predictable, in fact, that we really have no right to laugh at cats who pounce on toy mice. Sex is certainly not an instinct, but it is something so fundamental that it looks like one.

For the world to be real *(riaru)*, it must be sufficiently electrified by desire. A world not given depth by desire, no matter how exactingly it is drawn, will always be flat and impersonal, like a backdrop in the theater. But once that world takes on a sexual charge, it will attain a level of

reality *(riariti)* no matter how shoddily it is drawn. This is one thing that the popularity of pornographic comics teaches us.

The phallic girl is a point of connection to the desire that gives reality to fictional Japanese space. The desire directed toward her is the source of the power that maintains the reality of that world. In this sense she is similar to a lure or a decoy. Moreover, as a superficial entity that absorbs sexual desire she is also hysterical. This is only one of many commonalities between her and the hysteric.

The phallic girl is unaware of and uninterested in her own sexual attractiveness. Despite this lack of interest she cannot help but exhibit this attractiveness. The gap between this disinterest and the seductive exterior that contradicts it is the most definitive characteristic of hysteria. Disinterest, in the form of, for example, innocent and naive behavior, can be more seductive than anything. This is the same attitude of "good disinterest" that hysterical patients often exhibit. Nasio's observation that in the hysteric "the genital zone becomes an emptied out, disused place, while the non-genital body becomes aroused and erect like a powerful phallus" also aptly describes the phallic girl.[33] The issue is not whether she actually engages in sexual acts in the narrative. What is important here is that we, the readers or viewers, are not able to have sexual intercourse with her. Her privileged position is established on the basis of her being an absolutely unattainable object of desire. But even before her emergence, we should have been quite used to the erasure of the genitals and eroticization of the body in representations of women. The imaginary ethical restrictions (i.e., imaginary castration) that pervade our mass media had already brought about the widespread distribution of strange nude pictures from which the genitals alone had been erased. As we grew accustomed to these sorts of representations, were we not also learning techniques with which to hystericize women in our imaginations?

But we should get back on topic. Why does the phallic girl fight? Her fighting ability is the clearest manifestation of her identification with the penis. According to Nasio, paraphrasing Lacan, "the hysteric looks at the castrated other, becomes anxious, and, in the face of this anxiety, identifies with the imaginary object that the Other lacks [the phallus]."[34] Doesn't the phallic girl also often fight for the boy she loves (an impotent, weak, castrated being)? The hysteric phallicizes herself through the expression of somatic symptoms. In fact, it is possible to read the phallic girl's fighting as her "symptom." She is not "a being capable of fighting," but rather it is "fighting that brings her into being." She is not loved simply because

she is cute and lovable. She is loved for her ability to fight. Just as the "proof of existence" of the hysteric is written in the form of symptoms, the phallic girl's existence is inscribed in the symptom that is her fighting.

It is here that her hysterical nature begins to waver slightly. Was she not free of trauma? What sorts of symptoms are possible for a being who cannot even have the fantasy of trauma? The hysteric, moreover, was a person defined by his "persistent refusal to experience pleasure,"[35] yet, to quote Nasio again, "Freud was prepared to equate the hysterical fit with an orgasm."[36] So why does the phallic girl fight? In other words, why does she not fear and try to avoid fighting (i.e., orgasm)?

When we compare actual hysterics with the phallic girl, the greatest contrast is in the presence or absence of trauma, or the contrast between symptoms and fighting. Since the latter requires a bit of explanation, let me first provide a few more details about the symptoms of hysteria.

Lacan considers hysterical symptoms as inquiries into the mystery of femininity.[37] What does this mean? Questions about sexual difference are none other than questions about existence itself. These questions are directed toward the Symbolic, namely, the Other with a capital "O." Our existence and our desire are only possible in relation to this Symbolic. Hysterics also maintain their relation with the Symbolic through their symptoms, which is why their symptoms *are* their existence. This has the same significance as what I said earlier about hysterics phallicizing themselves through their symptoms. The phallus is the symbol of existence itself, and all existence refers back to the phallus as a mediator of the metaphoric chain. In other words, to assert one's existence in relation to the Symbolic one must secure for oneself a metaphoric phallus.

On the surface, hysterics exhibit an extremely wide variety of symptoms, but this variety parallels the variety in the manifestations of the superficial existence of femininity. Neither can be consolidated into any single form or law, and for this reason they appear as beings lacking an essence. Hysteria, however, can be described psychoanalytically because its various forms are all elaborated on the unshakeable basis of sexuality. But questions about femininity itself lead directly to questions about the origins of sexuality and the emergence of the Symbolic. As an infinite realm that extends outside the closed assembly of masculinity, it is considered essentially indescribable. Nothing can be done about this as long as the Symbolic remains a territory that privileges the phallus. Lacan expressed this indescribability with declarations like "Woman does not exist" and "Woman is a mystery to woman."

Questions about sexual difference posed by hysterics, be they male or female, are directed toward the mystery of femininity (this is why cases of male hysteria appear "feminine"), but at the same time they are entirely dependent on the symbolic value that is sexual difference. Looked at another way, their symptoms can be interpreted as gestures that rely on the Symbolic (i.e., the Other), even as they resist it. Resistance, needless to say, only leads to greater dependence. Furthermore, gestures of dependence are likely to be most extreme when they are traumatic in nature. Is this because trauma itself is real *(genjitsuteki)*? Of course not.

In the treatment of hysteria, the factuality of the traumatic experience that the patient relates is of very little import. Strictly speaking, trauma is regarded as a fantasy that is constructed retroactively on the basis of the hysterical symptoms. The reality of hysteria and its sublime nature are both located in this dimension of fantasy. This equation should help organize what I am trying to say:

Hysterical symptoms = inquiries about femininity = trauma (as fantasy) = the phallus = existence.

This equation is not at all meant to suggest that, because the trauma that causes it is a fantasy, hysteria is somehow a feigned illness. Hysterics tell their "lies" with their entire being, and the treatment of hysteria only works once the person treating them is able to share their sense of the reality of their symptoms. At the same time, however, it is necessary to proceed with extreme care when analyzing the traumatic experience that they relate, so as to bracket the question of their truth or falsehood. Their symptoms constitute serious and sincere inquiries, and those who treat them must work diligently to interpret what exactly is being asked. They must also be fully conscious of the seductions that lurk within these questions. The kind of attitudinal splitting that is required of the treatment provider can actually be described as a kind of hystericization of himself or herself. In almost the same sense, when we love a woman as a woman, which is also to say when we hystericize a woman, we place ourselves within the realms of hysteria as well. It is at these moments that we truly touch the reality of hysteria.

The fighting of the phallic girl exists on the opposite pole from these symptoms of hysteria. In a real woman, for example, a militant attitude might be a symptom behind which we can identify the traces of trauma. But in fighting within a work of fiction, motives and actions are unambiguously linked, and it is impossible to read any further depth into them.

The absence of trauma for the phallic girl means that her actions have no depth. Patients clinically diagnosed with hysteria have experienced trauma, but they do not fight as a result. Instead, they pour all their energy into their symptoms as a means of asking about their own sexual difference. The phallic girl, on the other hand, experiences no trauma but chooses to fight anyway. In this regard she is like a case of inverted hysteria.

The hystericization that we perform on women when we fall in love with them is made possible by nothing other than the actuality of the woman as she exists before our eyes. It is the very existence of this actuality that makes it possible for us really to *(riaru ni)* understand the paradox of Lacan's pronouncement that "Woman does not exist." When we start to represent this actual individual as a woman and try moreover to perceive the sublime (and often traumatic) essence of woman in the background, are we not using twice the effort to try to prove the "inexistence" of woman? Nasio writes, "Hysteria produces knowledge, but the answers are deferred indefinitely." Was it not precisely this "knowledge" that never leads to answers that constituted the proof of the "inexistence of woman?"[38] The hysteric's inquiry about what it means to be a woman is in this sense a question on which she wagers her existence. Paradoxically, the reality of her existence is guaranteed by the impossibility of answering this question. This is because one cannot claim of an insolvable mystery that the mystery does not exist.

The phallic girl's fighting, then, is the inverted mirror reflection of hysterical symptoms in a fictional space, specifically, a visually mediated one. In contrast to actual hysterics, who heighten their phallic value by covering it over with symptoms, the phallic girl openly embodies the phallus and acquires symbolic value through her complete nonexistence. If, as I have argued, Japanese space founds an autonomous space of fiction separated from everyday reality, the beautiful fighting girls who emerge in this space do so already, needless to say, as "beings in a state of lack." They have broken with all actuality and substance. In fact, the desire of the otaku is oriented toward highlighting and exposing their inexistence even further by extending their fictionality through various strategies of parody and pastiche. Why does this not diminish their reality? Is it because, as Slavoj Žižek has also said, knowing the mechanism of a fantasy makes it possible to immerse oneself in it even further?[39] Perhaps. But that is not the only reason.

The banishing of trauma from the phallic girl is an indispensible configuration that makes it possible to purify the fictionality of her existence, or,

in other words, the precondition of her inexistence. Why is this? Because the everyday real *(nichijōteki riaru)* would seep into a setting in which she was a victim of trauma. The pure fictional space would immediately be polluted by the osmotic pressure of everyday reality *(nichijōteki genjitsu)* and leave us with a half-baked allegory lacking in reality *(riariti)*. But no pure *(real [riaru])* fantasy could emerge there. The phallic girl's battles must not have the slightest thing to do with revenge. Rather, they must be "drawn *jouissance.*" Of course, *jouissance* in psychoanalysis does not necessarily mean pleasure or enjoyment in the usual sense. It is better understood as pleasure in the context of the Real, the effects of which are brought to us as reality. When we perceive reality in an object, we are touching the traces of *jouissance*. Or, to put it differently, not until it is put in an unreachable place does *jouissance* activate *real* desire.

Going back to Lacan, we note that he saw the phallus as the signifier of *jouissance.*[40] When the phallic girl is fighting she identifies with the phallus and enjoys the battle in the sense of *jouissance*. This *jouissance* is then further purified within the fictional space. By what circuits, then, do we find ourselves captivated by her? As we have seen already, she is an inverted hysteric. When we are captivated by hysterics in reality, we begin with the bodily image as an eroticized entity (sexuality) and then direct our desire toward the trauma that we perceive deep within her reality *(riariti)*. In the case of the phallic girl, we are first captivated by her fighting, namely, the image of her *jouissance* (reality *riariti*), and when this is conflated with the erotic attraction of her drawn image (sexuality), *moe* emerges. Thus both hysterics in reality *(genjitsu no)* and phallic girls in works of fiction are the same in the sense that both are subjected to a hystericization in which "sexuality" and "reality" *(riariti)* are inextricably linked. In this way both lead us into the realm of hysteria by mediating heterosexual desire.

Return to Darger

Throughout the writing of this book Henry Darger has always been on my mind. Surely what Darger wanted most was to figure out how to work the magic that would give his works their own autonomous reality. He spent enormous amounts of time in the attempt and used every technology at his disposal. His greatest source of fascination and encouragement in this creative effort came from the phallic girls that he himself had drawn. If hysteria can be said to captivate us with its symptoms, what captivated

Darger were hysterical girls whose hysteria had been inverted within the fantasy space that he pioneered. The clearest sign of this "inversion" is the penises that Darger drew on the little girls. In a fictional world exempt from the restrictions of reality *(genjitsu)*, which is to say in a mediated space, it is the negative of hysteria more than drawn hysteria itself that can most easily become the object of real desire. The credit for the invention of the phallic girl belongs, after all, to Darger alone.

As a neurotic, Darger suffered from eternal adolescence. He limited his social relations and did everything he could to isolate himself. Of course, he did have a job, and to that extent he participated in society. But I cannot help thinking that he chose to work because he knew that this was the best way to shut himself off completely from society. Had he not worked, he would have had to rely on social welfare or join the ranks of the homeless. Both of these options would have forced him into troublesome interpersonal negotiations. By abandoning all social ambitions and engaging in the minimum necessary and least conspicuous occupation, he was able to render his existence as transparent as possible. This "employment as camouflage" enabled Darger to completely seal off his own sacred space. As a result, his adolescence was preserved for sixty years.

Some doubts still remain. Is it really possible for someone who is not mentally ill to live this way? My own clinical experience tells me that it is entirely possible. While they might not be as extreme as Darger, there are now more and more young men and women who shut themselves in at home for long periods of time.[41] The first symptom to appear for many of them is the refusal to go to school, and when this becomes chronic they can end up becoming adults without being able to leave the house. For some this condition lasts into their thirties and forties. The fact that this situation can persist over the long term without being accompanied by a psychiatric disorder is still not widely known. I believe that we can infer something about how Darger felt from the example of these Japanese shut-ins, known as *hikikomori*. Of course, not all young shut-ins have the creativity of a Darger. In this sense Darger was a conspicuous exception. So what qualities enabled Darger's creativity?

I believe it was Darger's eidetic memory. As I explained earlier, eidetic memory is present in many children, but tends to recede with age. We do not know why this happens, but I believe one factor has to do with how we are disciplined and socialized. Darger entered into his bachelor's existence without receiving much of an education and remained almost completely cut off from society thereafter. Given this education

and lifestyle, it is not unreasonable to think that Darger's eidetic memory might have been preserved undiminished.

As is well known, eidetic images are different from normal ones. It is said that one can gaze at them at leisure and examine them in detail as if one were looking at an actual landscape unfolding before one's eyes. Therefore they are less like imaginary images than actual figures, with the kind of materiality that Bergson attributed to what he called the *image*.[42] In this sense, the eidetic image can be said to exist outside the representation, as something more than an image. Let us assume that such eidetic images formed the nucleus of Darger's creativity.

The issue here is Darger's narcissism. What is most striking about Darger's paintings is that they seem to have been the product of an almost perfect self-love. The purity of this expressive act with no intended recipient is what accounts for their ability to move us. Would it be too much to suggest that here we are in direct contact with what Michael Balint described as the mysterious realm "where there is no object relationship and no transference," the psychic territory of the "area of creation?"[43]

But where was his self-love directed? From his descriptions of himself in his biography as an "old lame man,"[44] we know that his self-image was not particularly exaggerated or idealized. In other words, his self-love was not directed toward his own image of himself. Was its object not rather the images that came to life inside him, provided by his eidetic memory? When Darger's narcissism operated reflexively on them, these extrarepresentational eidetic images functioned as the catalyst for boundless fantasizing. His imaginary kingdom was the recipient of a continuous libidinal cathexis that made it a virtually homeostatic ecosystem of fantasy.[45] Giving the little girls penises in the place of trauma and weaving a narrative of an endless war while resisting the encroachment of maturation provided this ecosystem with the drive to generate itself further. This generation would have been supplemented even more by his manipulations of various media. This perspective will put us on a surprising trajectory.

Of course, this model may be too simple to describe the creative process of a work of art. But it was necessary for me to articulate it. Now we can move the discussion to a more general level. Let us hypothesize that what happened in Darger's little apartment is being repeated on a far larger scale in Japan today. It is here that my discovery of the problematic of the phallic girl in the encounter with Darger takes on its full significance. We must recognize Darger's position as the lone, privileged harbinger of something much larger. Darger provides a prognostic model

for the kind of creativity that can result from the interaction of the modern media environment and the adolescent psyche, a model that we are now repeating. Its psychoanalytic value is all the more pure because we repeat it without realizing it.

It has now become possible to do without the eidetic memory that we have imagined for Darger. We have already acquired an extremely sophisticated media environment in which our visual perception and our memory in particular have been vastly expanded. In this environment it has become possible in principle to instantly access, reproduce, and transmit any kind of visual image. Or at least we have no problem believing in such a possibility. When the adolescent psyche is linked to and interacts with this space, we should not be surprised if the result is to summon the icon of the phallic girl. In Darger's, or even our own, uncastrated imaginations, she is sure to flourish even more. As a creature with no connection whatsoever to "everyday reality," she thrives in any and all possible media spaces.

Media and Sexuality

The notion of "raw reality" has now lost all of its usefulness. The opposition between reality and fiction has nothing to contribute to our definitions of the actual. Whether or not the opposition is a true one, discussions premised on its self-evidence tend to be crushingly boring. The process leading to this likely has to do with the impossibility of pure fiction and the impossibility of a pure medium. This kind of awareness advances irreversibly, so that no amount of effort will allow us to return to our earlier state of naïveté. Our shared fantasies have been reduced to a single one: that we are all living our lives consuming vast quantities of information. I wrote in-depth about this fantasy in my previous book, *Bunmyakubyō* (The disease of context), so I will not repeat myself here.

For us who live this fantasy of an informationalized everyday, there is nothing at all surprising about the existence of something like a fiction more real than reality *(genjitsu ijō ni riaru na kyokō)*. The same is true of the autonomy of fiction. When our desire comes into contact with these spaces, it comes naturally to us to boot up the beautiful fighting girls. I am trying to read into this process an unintended inversion of desire. Why is it that we are so captivated by these phallic girls who will never exist in actuality? Are they not a strategy for resisting the informationalization of society, in other words, the flattening fictionalization of the entire world?

If anything, we are more sensitive than we have ever been to the way fiction works. We know very well that our awareness is always limited, that it is nothing more than an image constructed according to the logic of our nervous system and the organization of our psyche. We also believe that all awareness can be turned into information. With this understanding we can conclude many times over that everything is fiction and nothing more. But we must be careful, because this is only the sign of an equally naive nihilism. Lacanian theory, for example, is still a powerful framework, but one of its side effects has been the creation of a naive idealism and a naive metaphysics. This kind of epistemological revolution does little more than introduce a false complexity into the circuitry of self-reference.

It is *sex* that keeps resisting to the end the fictionalization and relativization brought on by the fantasies of an informationalized society. Sexuality has never been portrayed as a complete fiction, and it is unlikely that it ever will be. In Darger's work and in Japanese space, I see the figure of the phallic girl appearing to open up a pathway to reality for people whose exposure to the media space has caused them to seclude themselves in the information fantasy. No matter what kind of character she is made out to be and what kind of specs are used to describe her, the moment we desire her, reality *(genjitsu)* intrudes. This is not the "everyday reality" that I have discussed with such care so far. The reality *(genjitsu)* that I am talking about here refers to the real *(genjitsuteki)* operations that underpin on a fundamental level the logic of that everyday reality *(genjitsu)*. Through the circuits of our desire we are touching the "reality" *(genjitsu)* of the "mystery of the woman who does not exist." In this context, the media space of anime, for example, serves as a kind of turnout where we can wait while we verify the "reality" *(genjitsu)* of sexuality. In this spot we fully experience the economy of desire, and then we return to everyday reality *(genjitsu)*. Understanding that the difference between fiction and reality *(genjitsu)* is only imaginary is possible only after one has set foot on the impossible territory of the Real that underlies it. We are able to understand this only through the real *(genjitsuteki)* functioning that is our own sexuality.

We see reality in the existence of the phallic girls. This is because no one who is ignorant of the reality of sex is capable of loving them. Knowledge of the reality of sex, needless to say, has almost nothing to do with the amount of sex one has experienced. It has to do with the reality that, however irrational it may be, we can be nothing other than sexual beings. But

people often try to forget this fact. The information fantasy contributes to the illusion that the development of the media will cause our minds to begin functioning solely according to the principles of the Imaginary. A typical example of this can be found in the theories of Sherry Turkle.[46] She predicts that the Symbolic will disappear and psychoanalysis will collapse as the mind becomes manipulable through a visual interface like a Macintosh desktop. But this sort of prediction is plausible only when we close our eyes to the "reality of sex."

In order not to fall under the sway of this sort of illusion, I fully affirm the otaku's way of living. I would never try to lecture them about "getting back to reality." They know reality better than anyone. Of course, cases of pathology and depravity occur in any community: this is as true of the community of maniacs as it is of the otaku, and of psychoanalysts, for that matter. What deserves our criticism is not otaku sexuality but the deception of those who love anime but reject sexuality. If there is a certain sincerity and ethics in a dissociated life lived with self-awareness, it is because hypocrisy and deception dwell in the falsely coherent life.

How are we to develop strategies for living in fantasy communities that have been excessively informationalized? No matter how maladaptive it may appear, loving the phallic girl is in fact an adaptive strategy. How does a psychic organization structured by logos resist the informationalization brought on by the media? How do we survive the neurotic life under the logic of a community that has been transformed and weakened to such an extent as to give rise to the mistaken belief that the Symbolic has ceased to function? One answer to this question is, by using one's sexuality. It may be only temporary, but loving the phallic girl is a choice we have made toward greater self-awareness of our own sexuality.

AFTERWORD TO THE FIRST EDITION (2000)

In the fall of 1993 I received an invitation from the Setagaya Art Museum to an exhibition with the theme "outsider art." To this day I do not understand why I, a mere doctor in private practice, would be invited to this show, which was called "Parallel Visions." Perhaps it was because I happen to be a psychiatrist and a member of the Japanese Association of Pathography. According to my diary, I went to the exhibit on October 17, and I remember that it was a very clear Sunday.

I had been looking forward to seeing the Prinzhorn Collection, which had long been famous among pathographers. But I was blindsided by an encounter with the works of an artist that I had not anticipated at all—it was as if I had been hit by a truck. The paintings of Henry Darger, an artist previously unknown to me, came before me suddenly, from a place other than that of "art," and struck me unawares. I have seen Darger's originals only one other time, about three years later, at a solo exhibition at the Ginza Art Space in January 1997. Nevertheless, I have continued to experience irrational feelings of longing for Darger. These feelings—which were like, yet unlike, a lovesick yearning or a longing for home—for an artist who had not even had one proper catalog of his works published, grew stronger and stronger. Did my natural aversion to the orthodox and attraction to the marginal pull me in his direction? That was definitely part of it, but there was something else as well. It would not be an exaggeration to say that I began writing this book in an attempt to discover what that was.

As I mention repeatedly throughout the book, I first understood what was special about the beautiful fighting girl icon when someone pointed out the resemblance between Darger's Vivian girls and Sailor Moon. I

then came up with the idea for this book in September 1994. I wrote a small piece called "Henry Darger's Phallic Girls" when I was invited to contribute a critique of a topic of my choice to the inaugural issue of the now-defunct *La Luna*, a magazine about psychiatry for the general reader.[1] After that I wrote a slightly longer article, "Phallic Girls Transgress Borders," for Seidosha's *Imago* magazine, also now defunct.[2] In that piece, which is included in my 1998 Seidosha book, *The Disease of Context: Lacan, Bateson, Maturana*, I came to a conclusion that is the exact opposite of this book's, sounding a warning about the infantilization of the media space.[3] I wince when I read certain parts of it now, but I tell myself it was a long time ago.

It has always been my style to use writing as a way to think things through, and the prolonged period over which this project came together only exacerbated this tendency. In the beginning, I anticipated that I would adopt a slightly critical tone toward otaku, but in the end I found myself writing in their defense. This was because, in the course of meeting with otaku and collecting materials about them for this book, I discovered that I had had many misperceptions about them. Gaining an understanding of the nature of otaku desire and their ability to switch between fantasy mode and everyday life mode was a real revelation for me. I doubt that I would have been able to write this book had I been wedded to a critical stance toward otaku.

My biggest misperception was my firm, yet baseless, conviction that even if I could not claim to be an otaku myself, I would be able to empathize with them. I had never really watched an anime series closely, but with the knowledge I could obtain from books and the Internet, I was certain that I would be able to talk about anime as well as any otaku. That was, of course, an illusion. I didn't have the ability to empathize with the most important parts of the otaku experience. To this day, for example, I cannot grasp the feeling of *moe*. Nor can I entirely suppress a sense of discomfort toward anime images and the voices that accompany them. Of course, inasmuch as my intention is to gain perspective on the otaku community from the outside, this lack of empathy can be useful in maintaining distance. But I needed many friends to supply the qualities I lacked. I'm grateful to the young friends including Hanasaki Takashi and others who shared their valuable experiences with me, including details of their sex lives, and who gave me so much encouragement.

Let me provide a little more of the backstory. The planning of this book took place in fits and starts. It began when, immediately after I published

the piece in *Imago*, an editor suggested that I expand it into a book. I was very enthusiastic about this proposal, but at the time I had my private practice, as well as two other books in the planning stages. The progress I made was as dismal as you would expect from an inexperienced writer with three parallel book projects, and the writing fell further and further behind schedule. As my delays stretched out farther and farther, I heard less and less frequently from the editor, who probably concluded that the project had no future. Thinking about it now, however, it was probably fortunate that it was shelved for a time.

Sugiura Naoyuki, an editor at Ōta Publishing, expressed interest in the idea that I had somewhat reluctantly abandoned. Sugiura had worked very closely with me on my first book, *The Disease of Context*, and he was an editor whom I trusted a great deal. With his encouragement, I finally got back to work on the manuscript, which was about halfway complete. But Sugiura had to leave his position for personal reasons in the midst of the editorial process. He arranged for Ōta's Naitō Yūji to take over—the second time the baton had been passed. Naitō checked the manuscript with care while also managing his onerous duties as editor of *Hihyō kūkan* (Critical space). It was painstaking work for him, as anime and manga appeared to be outside his bailiwick. He got on my case when I tended to get careless, corrected my mistakes, and always argued back when he wasn't convinced by my interpretations. Without his involvement, the book would have been one-sided and smug. My deepest gratitude goes to Naitō for his tireless work as midwife to this long, difficult labor.

There were additional advantages to this book's lengthy gestation. One was that I was able to make the acquaintance of the artist Murakami Takashi, who designed the entire book package. He continues to produce fascinating artworks with the strategic goal of translating otaku culture into the context of contemporary art. Although I learned about it quite recently and wasn't able to incorporate it into the book, the representational space that I refer to in this book as "Japanese space" is none other than what Murakami calls the "superflat." Happily, the importance of context is one of the tenets we share; as mentioned, the title of my first book was *Diseases of Context*. For these reasons, I had no hesitation whatsoever about leaving the book's cover design completely to Murakami. I was already thinking that while I wanted this book to be a serious piece of cultural theory, I also wanted it to have a certain girlish sexiness about it. But since my writing style does not exactly overflow with sex appeal,

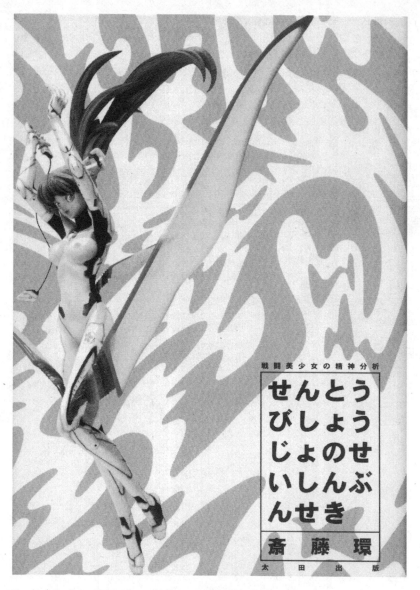

戦闘美少女の精神分析

せんとう
びしょう
じょのせ
いしんぶ
んせき

斎藤　環

太田出版

Cover of the first edition, *Sentō bishōjo no seishin bunseki*

I have entrusted the sexiness of the book to Murakami. This resulted in a cover that was itself a work of art. This book was also a milestone in that it was the first to have its artistic format designed entirely by Murakami. The content may not live up to the design, but as a Murakami fan I think I can live with that. I thank him for his kindness.

February 8, 2000
Gyotoku, Ichikawa City

AFTERWORD TO THE PAPERBACK EDITION
(2006)

I am truly fortunate that this book reverberated in ways utterly unimagined by its author. Those reverberations and subsequent developments are covered in detail in *Mojo genron F kai* under the editorship of Hiroki Azuma,[1] so I won't repeat them here. But I will say that I am glad that the next generation has taken over the debate on the question of otaku sexuality that I first brought up here. I also want to express my gratitude to Mr. Azuma for writing a substantial postscript to this edition of *A Psychoanalysis of the Beautiful Fighting Girl*.

Thinking about it now, I realize that the first edition of this book came out just in time. Since 2000 the "*moe* bubble" has expanded rapidly, and otaku culture has expanded so drastically in terms of both quality and quantity that it is no longer something that any one individual critic could tackle. Particularly because I have very little knowledge of girl games, I am certain that I would be unable to write a follow-up work that adequately addresses the dizzying changes and new trends of recent years. So in that sense as well this book slipped in just under the wire.

In addition to *Mōjō genron F kai*, there are a number of other books that I would strongly recommend to readers of this one:

Hiroki Azuma, *Otaku: Japan's Database Animals* (*Dōbutsuka suru posutomodan: Otaku kara mita Nihon shakai*, Kōdansha, 2001), trans. Jonathan E. Abel and Shion Kono (Minneapolis: University of Minnesota Press, 2009). I recommend this if you are looking for a recent book on the fundamentals of otaku theory.

Nobi Nobita, *Otona wa wakatte kurenai: Nobi Nobita hihyō shūsei* [Adults don't understand us: collected criticism of Nobi Nobita] (Nihon Hyōronsha, 2003). The best criticism on *yaoi* I know of. Includes a dialogue with me.

John M. MacGregor, *Henry Darger: In the Realms of the Unreal* (New York: Delano Greenridge Editions, 2002). Translated into Japanese by Koide Yukiko as *Henrii Daagaa: Higenjitsu no ōkoku de* (Sakuhinsha, 2000). The translation was the first substantial collection of Darger's illustrations published in Japan. This is the most complete and detailed treatment of Darger I know.

Kokusai Kōryū Kikin (Japan Foundation), *Otaku: Jinkaku = Kūkan = Toshi: Venechia Biennaare Dai 9 Kai Kokusai Kenchikuten-Nihonkan Shutten* [Otaku: persona, space, city: the ninth International Architecture Exhibition in the Japanese Pavilion of the Venice Biennale] (Gentōsha, 2004).

Morikawa Kaichirō, *Shuto no tanjō: Moeru toshi Akihabara* [The birth of the hobby capital: Akihabara, city of "Moe"] (Gentōsha, 2003). The first work by Morikawa, who was the commissioner of the Japanese Pavilion at the Venice Biennale.

Azuma Kiyohiko, *Azumanga Daiō* (1)–(4) (Mediaworks, 2000–2002). I lack the otaku gene, and this was the first manga that opened my eyes to the phenomenon of *moe*. Also wonderful as a manga plain and simple.

Kio Shimoku, *Genshiken* [The society for the study of modern visual culture] 1–7 (Kōdansha, 2002–2006), trans. David Ury (New York: Del Rey). An extremely authentic depiction of the world of today's otaku.

Finally, Naitō Yūji, who handled the editing of this book, died of cancer on May 19, 2002. He was only thirty-eight years old. I dedicate this book to him, with renewed gratitude.

The Elder Sister of Otaku: Japan's Database Animals

HIROKI AZUMA

In the past few years dramatic changes have occurred with regard to otaku and anime. Miyazaki Hayao received an Academy Award, Murakami Takashi has conquered the art world, the Venice Biennale had an exhibition on otaku, *moe* became a buzzword, the "light novel boom" began, and news about the so-called content industry came to roil the pages of the financial newspapers daily. Last fall *Yuriika* published consecutive special issues on anime criticism and manga criticism. Now when I say I am doing research on otaku and anime, nobody bats an eye.

But things were entirely different in April 2000, when Saitō Tamaki published the hardcover edition of *Beautiful Fighting Girl*. Akihabara was merely a place where electronics were sold, and there was no talk of soft power. Most of what was written about anime and games was either reportage by journalists in the industry, fan-oriented supplementary materials, or attempts at close readings: there was virtually no attempt to address these topics in a consistently scholarly manner. Girl games and light novels were not widely known, and the Internet did not function, as it does now, as a venue for alternative criticism. (Personal Web pages began appearing in the 1990s, but blogs and social networking were not ubiquitous, as they are today.) Five years had already passed since 1995, and nothing had created the same kind of stir as *Evangelion* did that year. The general population's awareness of otaku was fading. At that time otaku were very rarely considered from a sociological standpoint, and in that context it was a major event for a first-rate psychiatrist to publish a book that treated the imagination and sexuality of otaku both seriously and sympathetically.

I am going to dwell a bit on this because young people today probably have difficulty visualizing such a time. In Japan today, a new kind

of critique based on an interdisciplinary approach using both sociology and subcultural analysis is attracting attention. This new discourse differs from both the postmodernism of the 1980s and the emphasis on "the real" of the 1990s, and it has no counterpart in Europe or North America. Specifically, this new discourse was formed by works including my *Otaku: Japan's Database Animals* (2001; English translation, 2009), Morikawa Kaichirō's *Shuto no tanjō* (Birth of the hobby capital, 2003), Kitada Akihiro's *Warau Nihon no nashonarizumu* (Japan's laughing nationalism, 2005), Itō Gō's *Tezuka izu deddo* (Tezuka is dead, 2005), and Inaba Shin'ichirō's *Modan no kūrudaun* (The modern cools off, 2006). Most readers who pick up this book probably are doing so as a follow-up to this new kind of criticism. That is not wrong, but it is backward. In reality, this book prepared the way for that discourse to emerge.

To be pioneering also entails being a bit scattered. This book is loaded with noise and contradictions. For example, it includes a universalizing statement about the emergence of the beautiful fighting girl (as "the inverted mirror reflection of hysterical symptoms in a fictional space, specifically, a visually mediated one"), while also positioning them as a uniquely Japanese cultural phenomenon. These two stances, which do not mesh, create a dissonance in *Beautiful Fighting Girl*. The book's contents, which include everything from an analysis of Henry Darger's work to discussions of Lacanian psychoanalytic theory and even the confessions of individual otaku, are too scattered and tend to dilute the thesis. Yet these shortcomings are not a result of theoretical immaturity. Rather, they should be thought of as a function of the author's zeal and the labor pains from birthing a new paradigm. Even now, six years after its original publication, it still contains many hints and ideas that remain unrealized. I encourage readers to uncover their potential with their own efforts.

As it happens, I am one of the people who was profoundly influenced by the publication of *Beautiful Fighting Girl*. I first met the author in 1999. We are nearly a decade apart in age, but I felt an immediate closeness to him because of our mutual interest in contemporary thought and otaku. I was also lucky enough to actually work with him. At the time, neither of us had yet written a book on the subject of otaku. If that had remained the case, I probably would have been satisfied using the language of critical theory to talk about anime and games, remaining stuck in some middle zone as a theorist crazy about otaku (or an otaku crazy about theory).

But the publication of *Beautiful Fighting Girl* gave me the opportunity to reexamine my position because I disagreed with everything it said (with the exception of some of the finer points of its argument). For the first time, I felt compelled to articulate why I was thinking about otaku and why it was necessary to do so. As a result, I wrote *Otaku: Japan's Database Animals*.

Saitō's work cast a long shadow on my own book, shaping it even in places where there was no obvious connection. For example, I steered as clear as possible of analyzing individual works, emphasized the mode of consumption over the images themselves, and attempted to use a sociological approach to solve the riddle of the otaku, all of which were explicit reversals of Saitō's approach. *Otaku: Japan's Database Animals* thus came into being as a kind of younger brother to *Beautiful Fighting Girl*.

Why did I disagree so strongly with Saitō's book at that time? It had to do with my doubts about the usefulness of analyzing otaku based on their sexuality and my related skepticism about the usefulness of a psychoanalytic methodology in this context. Saitō believes that the analysis of otaku should begin with the question of sexuality, and I don't. That is where we differ.

I don't have room to go into the details of that here, but Saitō and I have exchanged opinions on this elsewhere, so the reader can easily access our debate. I refer the interested reader to http://www.hajou.org, where you will find an exchange of online letters among Takekuma Kentarō, Itō Gō, and Nagayama Kaoru along with Saitō and myself. In addition to providing information about my differences with Saitō, this lively discussion, which is as good as anything you would find in a published book, also provides many different points of view useful in gaining an understanding of this book. It was later published in the collection *Mōjō genron F kai*, with added commentary by Kotani Mari.

As our debate indicates, Saitō and I differ on a variety of points, including the basic understanding of otaku, the value of specific works, and even our understanding of psychoanalysis. Since the publication of *Beautiful Fighting Girl*, Saitō has continued to publish actively about manga and anime in works such as *Hakase no kimyō na shishunki* (A doctor's strange adolescence, 2003), *Kairi no poppu sukiru* (Popular dissociation skills, 2004), and *Fureemu tsuki* (Possessed by frames, 2004). The essays in these collections indicate that his approach is moving closer to film and manga criticism, while my own interests have shifted differently,

toward the structural relationships between narratives and computer games. In the bigger picture, since our first meeting in 1999, Saitō and I have been united in the struggle to articulate a more robust and diverse analytic paradigm through which to study the world of the otaku.

Had it not been for the appearance of its "elder sister," *Beautiful Fighting Girl, Otaku: Japan's Database Animals* could never have been written. In that respect, and despite any differences we may have on individual points, I think of Saitō as a friend and ally who opened the way for a new field of critique in the twenty-first century. I hope he will forgive my presumption in thinking he feels the same way about me. I look forward to a new generation of critics emerging from among those of you who pick up this book to continue the conversation that we have begun.

"Commentary" written for inclusion in the paperback edition (2006) of Beautiful Fighting Girl.

NOTES

Translator's Introduction

1 "Girl Power! Shojo Manga!" was in fact the title of a traveling exhibition on post-war Japanese girls' comics put together by Masami Toku in 2005. The choice of title suggests the centrality of the "fighting girl" trope to the genre. See Masami Toku, "Shojo Manga! Girls' Comics! A Mirror of Girls' Dreams," *Mechademia* 2 (2007). The emphasis on empowerment is also common among American feminist academics writing on the related phenomenon of "tough girls" in popular culture in the United States (such as Wonder Woman or, more recently, Buffy the Vampire Slayer). See Sherrie A. Inness, *Tough Girls: Women Warriors and Wonder Women in Popular Culture, Feminist Cultural Studies, the Media, and Political Culture* (Philadelphia: University of Pennsylvania Press, 1999); and Elyce Rae Helford, *Fantasy Girls: Gender in the New Universe of Science Fiction and Fantasy Television* (Lanham, Md.: Rowman and Littlefield, 2000).

2 Susan Jolliffe Napier, *Anime from Akira to Howl's Moving Castle: Experiencing Contemporary Japanese Animation*, updated ed. (New York: Palgrave Macmillan, 2005), 33.

3 See, for example, Kimiko Akita, "Cuteness: The Sexual Commodification of Women in the Japanese Media," in *Women and the Media: Diverse Perspectives*, ed. Theresa Carilli and Jane Campbell (Lanham, Md.: University Press of America, 2005), 44–57.

4 Anne Allison, "Fierce Flesh: Sexy Schoolgirls in the Action Fantasy of *Sailor Moon*," in *Millennial Monsters: Japanese Toys and the Global Imagination* (Durham, N.C.: Duke University Press, 2006), 137. Allison's reading of *Sailor Moon*, although not psychoanalytic and focused mostly on her girl fans, ends up in interesting proximity to Saitō's thesis: "*Sailor Moon* is a harbinger of a consumer demand/product based on transformation, fragmentation, and polymorphous perversity" (161).

5 Masami, "Shojo Manga! Girls' Comics!"

6 The "primal scene," of course, as Sigmund Freud uses the concept, is understood as a retroactive construction of analysis that may or may not have actually occurred but around which meaning and memories have accumulated. Thus while Saitō's

theory is certainly vulnerable to the criticism that it cannot be true because he has no way to know what was going on in Miyazaki's head as a boy, Saitō would no doubt respond, in Freudian fashion, that the fantasy is valid psychoanalytically as long as it has explanatory power. The question of the reality of the primal scene has interesting connections to the "reality" of the otaku's fantasies, discussed below. On this question in Freud, see "From the History of an Infantile Neurosis (1918 [1914])," in *"An Infantile Neurosis" and Other Works*, ed. and trans. James Strachey, vol. 17 of *The Standard Edition of the Complete Psychological Works of Sigmund Freud* (London: Hogarth, 1995), 57–60.

7 Miyazaki himself has been famously cool toward the otaku community, but Saitō hints that this may be a case of like disliking like.

8 No doubt for some readers one of the more problematic of Saitō's claims will be his schematic division between what he calls "Japanese space" and "Western space," where the former is characterized by (among other things) a tolerance for erotic drawn images and the latter by a puritanical aversion to them. While the distinction he draws is fascinating and of significant theoretical interest, mapping it onto "Japan" as a whole and an undifferentiated, transhistorical "West" reduces the argument to yet another theory of Japanese particularism.

9 See Saitō Tamaki, "Otaku Sexuality," in *Robot Ghosts and Wired Dreams: Japanese Science Fiction from Origins to Anime*, ed. Christopher Bolton, Istvan Csicsery-Ronay Jr., and Takayuki Tatsumi (Minneapolis: University of Minnesota Press, 2007). This piece also includes a useful introductory note by Kotani Mari on *yaoi*. On the tension between "yaoi" culture and "real" gay males during the 1990s, see Keith Vincent, "A Japanese Electra and Her Queer Progeny," *Mechademia* 2 (2007): 64–82. On the beautiful boy in *yaoi* as a source of identification for lesbians, see James Welker, "Beautiful, Borrowed, and Bent: 'Boys' Love' as Girls' Love in Shōjo Manga," *Signs: Journal of Women in Culture and Society* 31, no. 3 (2006): 841–70. And for an English translation of a fascinating metafictional exploration in manga form of the female otaku (also known as "fujoshi"), see Natsumi Konjoh, *Fujoshi Rumi* [Female otaku Rumi], vol. 1 (New York: Media Blasters, 2008).

10 Morikawa Kaichirō points out that the close connection between information technology and otaku culture is apparent from the fact that Akihabara, the computer and electronics district of Tokyo, transformed in the 1990s into a mecca for otaku-related products such as girl games, figurines, and anime DVDs. See his *Shuto no tanjō: Moeru toshi Akihabara* [Birth of the hobby capital: The budding city of Akihabara] (Gentōsha Bunko, 2003).

11 See Melek Ortabasi, "National History as Otaku Fantasy: Satoshi Kon's *Millennium Actress*," in *Japanese Visual Culture: Explorations in the World of Manga and Anime*, ed. Mark W. MacWilliams (Armonk, N.Y.: Sharpe, 2008), especially 277–83.

12 Such as the Daicon IV opening video (1983), which was shown on a continuous loop at "Little Boy," Murakami Takashi's exhibition of otaku culture (2005), and the feature-length *Royal Space Force: The Wings of Honneamise* (*Ōritsu uchūgun Oneamisu no tsubasa*, 1987).

13 Okada Toshio, *Otakugaku nyūmon* [Introduction to otaku studies] (Ōta Shuppan, 1996), 14.

14 Ibid., 356–57.

15 See Ōtsuka Eiji, *Monogatari shōhi-ron: "Bikkuriman" no shinwagaku* [Theory of narrative consumption: Studies in the "Bikkuriman" myth] (Chikuma Bunko, 1989); and Ōtsuka, *"Otaku" no seishinshi: 1980 nendai ron* [A psychological history of the otaku: 1980s theory] (Kōdansha Gendai Shinsho, 2004); see also Morikawa, *Shuto no tanjō.*

16 Thomas Lamarre, "An Introduction to Otaku Movement," in *Japan after Japan: Social and Cultural Life from the Recessionary 1990s to the Present,* ed. Tomiko Yoda and Harry Harootunian (Durham, N.C.: Duke University Press, 2006).

17 Okada, *Otakugaku nyūmon,* 349.

18 [The "Lolita complex," or *rorikon* (also spelled lolicon), is a pop-cultural term used to describe men who are sexually attracted to young girls or, more typically, to images of young girls. It is also used to describe the images themselves as well as the genres in which they are featured. It is a reference to the fictional prepubescent girl named Lolita who so obsessed the protagonist of Vladimir Nabokov's novel *Lolita.* While it can be and is used pejoratively in Japanese, it is not unheard-of for men to use it to describe themselves, and it does not trigger the same horrified reaction that a term like *pedophile* does in the United States or Europe. This is probably because it is generally understood to be a sexual fantasy that exists and can be satisfied in the realm of fiction.—Trans.]

19 One of Okada's more intriguing arguments is that otaku culture is perfectly suited to a postmodern culture in which the distinction between children and adults no longer holds. Unfortunately, however, his argument quickly devolves into Japanese cultural exceptionalism when he goes on to claim that Japanese culture is unique for its tradition of treating children like adults, as in the kabuki and Noh tradition of putting very young children on stage. While the child in "the West" was at best an imperfect adult and at worse a source of chaos and perversion, the Japanese, he claims, have always seen in the child nothing less than "the fundamental image of humanity *[kongenteki na ningenzō]*" (Okada, *Otakugaku nyūmon,* 350).

20 See the interview in *Little Boy: The Arts of Japan's Exploding Subculture,* ed. Takashi Murakami (New York: Japan Society/New Haven, Conn.: Yale University Press, 2005), 176.

21 Saitō, "Otaku Sexuality," 227. I have slightly adapted Christopher Bolton's English translation: Bolton translates "reality and fiction" *(genjitsu to kyokō)* in the second sentence with the Lacanian terms "the real" and "the imaginary." In this translation we have reserved the Lacanian terms for those instances where Saitō uses the suffix *–kai.* Hence "genjitsu" we have rendered as "reality" and "genjitsu-kai" as "the Real."

22 Bruce Fink, "Perversion," in *Perversion and the Social Relation,* ed. Molly Anne Rothenberg, Dennis Foster, and Slavoj Žižek (Durham, N.C.: Duke University Press, 2003), 40.

23 As I discuss later, this is not the same as saying that the otaku cannot *distinguish* between real and imaginary objects of desire. Recently, however, some critics in Japan have started to argue that sex is better had in the head anyway and that the attempt to make it real not only leads to inevitable disappointment but means

buying into a debased and commodified ideology of romantic love. Honda Tōru calls it "romantic capitalism" and advocates instead what he calls "intracerebral love." See his *Moeru otoko* [*Moe* man] (Chikuma Shinsho, 2005) and *Nōnai ren'ai no susume* [An encouragement of intracerebral love] (Kadokawa Gakugei Shuppan, 2007).

24 As Lacanian otaku Slavoj Žižek put it in an interview dating from about the same time that Saitō was writing, "I think what is so horrible about virtual sex is not: My god before we had a real partner whom we touched, embraced, squeezed, and now you just masturbate in front of the screen or you don't even masturbate, you just enjoy knowing that maybe the other enjoys it through the screen or whatever. The point is we become aware of how there never was real sex" ("Hysteria and Cyberspace: Interview with Slavoj Žižek," *Telepolis*, July 10, 1998, http://www.heise.de/tp/r4/artikel/2/2492/1.html [accessed May 21, 2010]).

25 A good example of the revulsion inspired by otaku culture in the United States can be found in the reader responses to an article in the *New York Times* that discussed the phenomenon (in Japan) of "two-dimensional love" in which some otaku choose imaginary, drawn partners over "real" girlfriends. As one respondent wrote, "I can't remember reading about anything as revolting as the subject matter of Lisa Katayama's 'Phenomenon.' Please tell me that I'm not the only one who thinks that a 37-year-old man (Nisan) obsessed by a caricature of a childlike girl dressed in a bikini is sick and twisted" (Denise Orengo, letter to the editor, *New York Times Magazine*, August 7, 2009). And another, from the Web site, "This is a sad and pathetic statement on our devolving culture and society. People need a good slap in the face and need to come back to reality instead of relying on materialism to be happy" (Eric, Seattle, Washington, July 24, 2009). For the original article, which unlike many articles in the *Times* belonging to the genre of "Aren't the Japanese Weird?" was a well-researched and sympathetic piece that resisted the temptation to pathologize, see Lisa Katayama, "Love in 2-D," *New York Times*, July 26, 2009.

26 Of course, given that the Imaginary is all that we can experience or perceive to begin with, it has always in a sense "overwhelmed" the Symbolic. It is the unprecedented expansion of the Imaginary caused by media saturation that creates the sense of crisis.

27 Lamarre calls the *Densha otoko* narrative a "reactionary panic formation" against the threat of otaku sexuality ("Platonic Sex: Perversion and Shōjo Anime [Part Two]," *animation: an interdisciplinary journal* 2, no. 1 [2007]: 13). More recently and provocatively, Christophe Thouny has argued that while the "grand narrative" of *Densha otoko* "stages a desire to escape from the closed world of the otaku to become part of a heteronormative consumerist social structure," its original online version also "stage[s] the collective production of the narrative itself" among the community of 2-channelers to produce a kind of ecstatic disavowal and delay of closure ("Waiting for the Messiah: The Becoming-Myth of Evangelion and Densha otoko," *Mechademia* 4 [2009]: 122).

28 Eve Kosofsky Sedgwick, *Epistemology of the Closet* (Berkeley: University of California Press, 1990), 25.

29 Thomas Lamarre, *The Anime Machine: A Media Theory of Animation* (Minneapolis: University of Minnesota Press, 2009), 256.

30 Particularly on target is Lamarre's discussion of the way Saitō's strict Lacanianism leads him into a simplistic account of the asymmetry of male and female desire.

31 Ibid.

32 I quote from Moon's unpublished manuscript, "Darger's Resources," which is forthcoming from Duke University Press. Thanks to Michael for letting me read it and for sharing his thoughts and enthusiasm about Saitō's work as well. Thanks also to Jonathan Goldberg and the members of Goldberg and Moon's spring 2010 graduate seminar on Eve Kosofsky Sedgwick at Emory University for taking the time to read and discuss the manuscript and this introduction with me and confirming my sense that there is much in Saitō's work for queer theorists to appreciate.

33 Judith Butler, *Gender Trouble* (New York: Routledge, 1990), 71.

34 Ibid.

35 See note 25.

36 *Dōbutsukasuru posuto modan: Otaku kara mita Nihon shakai* (Kodansha, 2001), translated by Jonathan E. Abel and Shion Kono as *Otaku: Japan's Database Animals* (Minneapolis: University of Minnesota Press, 2009).

37. "Posuto modan/otaku/sekushuariti," in *Mōjō genron F kai*, 131–96.

38 Ibid., 186–87.

39 Kotani and Saitō are also in accord with Sedgwick's view on the importance of letting people determine for themselves the nature of their own sexuality: "To alienate conclusively, *definitionally*, from anyone on any theoretical ground the authority to describe and name their own sexual desire is a terribly consequential seizure. In this century, in which sexuality has been made expressive of the essence of both identity and knowledge, it may represent the most intimate violence possible" (Sedgwick, *Epistemology*, 26).

40 It is worth noting that for a critic who is so fascinated by the otaku's deconstruction of grand narratives, Azuma himself is something of a compulsive narrator, be it in the form of constant periodizing of otaku generations or, as Lamarre has also suggested, of the development of media technologies. It could be argued that his celebration of the otaku's overcoming of the temporality of modernity is rooted in an equally powerful attachment to narrative teleology.

41 "Posuto modan/otaku/sekushuariti," 187.

Preface

1 [A major premise of this book is that the spread of new media has forced us to think in new ways about how we distinguish between reality and fiction. In Japanese, the word used for "reality" since at least the nineteenth century is the Sino-Japanese compound *genjitsu*. As is often the case in Japanese, however, the Sino-Japanese term exists alongside more recent imports from English that, rather than being simply synonyms, have taken on slightly variant meanings. Thus the words *riariti* and *riaru* (transliterations of the English words *reality* and *real*) tend

to be used in contexts where what is being described has more to do with a sensibility or an effect than an ontological state. In the sentence above, for example, when Saitō talks about the "reality" of the (fictional) fighting girls, he tends to use *riariti*, while he uses *genjitsu* to refer to material (and Lacanian) reality. In some ways *riariti* is closer to the concept of virtual reality, but since this latter term exists in perfectly serviceable translation in Japanese *(kasō genjitsu)* and Saitō has chosen specifically not to use that term, it would be inaccurate to translate it that way. Since in English there is no choice but to translate both *genjitsu* and *riariti* as "reality," we have included the Japanese terms in parentheses in cases where the distinction seemed relevant.—Trans.]

2 See introduction, note 18.

3 Isaiah Ben Dasan and Jan Denman were the fictional personae used by Yamamoto Shichihei and Saitō Jūichi, respectively. Yamamoto wrote and published the book *The Japanese and the Jews (Nihonjin to Yudayajin)* in 1971 posing as Ben Dasan, supposedly a Jew who was born and raised in Kōbe, and Saitō wrote a long-running column beginning in 1960 in the magazine *Shūkan shinchō*, posing as the Dutch journalist Jan Denman. Both writers exploited these fictional identities as outsiders to expound theories about aspects of postwar Japanese culture and the nature of the Japanese people in general, helping found the genre of "Nihonjinron," or "theories of Japaneseness."

1. The Psychopathology of the Otaku

1 [Japanese has many words that can mean "you," and "otaku" is a particularly formal and stiff one. For young people to use it when speaking to one another makes for an awkward, indeed "nerdy" impression.—Trans.]

2 [A slang term for a gloomy or depressed person, literally meaning "dark at the roots."—Trans.]

3 Taku Hachirō, the author of *Otaku Heaven (Ikasu! Otaku tengoku,* 1992), emerged as a spokesman for and defender of otaku culture in the wake of the Miyazaki incident.

4 Doi Takeo, *Amae no kōzō* (Kōbundō, 1971), translated by John Bester as *The Anatomy of Dependence* (Tokyo: Kodansha International, 1973).

5 Okada Toshio, *Otakugaku nyūmon* [An introduction to otaku studies] (Ōta Shuppan, 1996). Okada chooses to write *otaku* using the katakana syllabary rather than the more standard hiragana in order to strip away some of the negative associations that have built up around it. Okada's katakana version is quickly becoming standard. In this book, however, I have chosen to use the original hiragana version out of respect for its coiner Nakamori Akio. I do, however, use katakana in citations from Okada and when I am referring to otaku outside Japan. [This English translation places quotation marks around the term in citations from Okada and references to otaku outside Japan.—Trans.]

6 In *An Introduction to Otaku Studies*, Okada defines "iki no me" as "the ability to find one's own kind of beauty in a work and enjoy watching the growth of its

creator"; "takumi no me" as "the ability to analyze the work logically and grasp its structure like a scientist while also looking to steal its secrets like a craftsman"; and "tsū no me" as "the ability to get a glimpse into the creator's situation and the fine points of the work."

7 Ōtsuka Eiji, *Kasō genjitsu hihyō* [Critique of virtual reality] (Shin'yōsha, 1992).

8 Ōsawa Masachi, "Otaku ron" [On otaku], in *Denshi media ron* [A theory of electronic media] (Shin'yōsha, 1995), 242–93.

9 Here I follow Lacanian psychoanalysis in referring to anyone, including a so-called healthy person who "speaks language and suffers as a result" as a "neurotic." Also, people who are driven mad by their constant failure to speak the same language as we neurotics I call "mentally ill" *(seishin byōsha).*

10 A genre of role-playing games that features anime-style beautiful girl heroines with whom the player attempts to establish a love relationship. Typical examples include "Tokimeki Memorial" and "To Heart."

11 See Gregory F. Bateson, "The Logical Categories of Learning and Communication," in *Steps to an Ecology of Mind* (Chicago: University of Chicago Press, 2000); and Edward T. Hall, *Beyond Culture* (Garden City, N.Y.: Anchor Books, 1989).

12 Walter Benjamin, "The Work of Art in the Age of Mechanical Reproduction," in *Illuminations* (New York: Schocken Books, 1988).

13 ["Costume play": dressing up as one's favorite character in an anime or manga.—Trans.]

14 The distinction I am making here between the inside and the outside of the subject is a provisional one meant only to aid the reader's understanding. In strict psychoanalytic terms the distinction would be untenable.

15 When I use the word "reality" in this book without any further specification I am referring to this kind of imaginary or everyday reality. When I mean reality in the psychoanalytic sense—that material realm that is impossible for us to experience—I use Lacan's term "the Real," with a capital "R." That said, I have little occasion from here on to use the latter term. The focus in this book is on the relationship between the Imaginary and the Symbolic. Fighting girls are the product of neurotic desire and have nothing to do with psychosis, which of course makes it impossible to postulate the incursion of the Real when describing them. I am including this proviso because I realize that my earlier statement that "Reality is a form of fiction" might be misunderstood as a profession of belief in metaphysics or idealism.

16 See Azuma Hiroki, *Yūbinteki fuantachi* [Postal anxieties] (Asahi Shinbunsha, 1999). To be exact, one can rephrase Azuma's point to say that the "deterioration of song lyrics" is understood as a transformation or a shift in the imaginary application of language. The imaginary functions once entrusted to language—for example, the privileged functions of language such as the formation of coalitions among certain communities on the basis of "deep sympathy"—do in fact seem to be disappearing. And it is not just song lyrics; we see signs of the same phenomenon in the decline of those "trendy words" that could once symbolize a particular historical moment. But it is too simplistic to read this as the "loss of the Symbolic." I see

in it a shift in the position of media vis-à-vis the Imaginary, but I leave my discussion of that for another occasion.

17 There are "media" *(baikai)* everywhere, starting with television, film, manga, and the Internet. And of course there are also more individualized media like the telephone, letters, and e-mail. But these are not all. All relations with other people in daily life rely on some sort of media. This kind of media might be called "role consciousness." Thus every individual takes on multiple roles in multiple interpersonal situations. For example, when I interview a patient as a psychiatrist, that experience is mediated by "doctor-role consciousness." As a result, the treatment relation becomes fictionalized in a way. This provides a defense against the interview experience exercising too great an influence on the doctor's daily life.

18 Symptoms of dissociative illness cause people to complain of pain because of losing the sense of reality with regard to self and the external world, feeling that they are no longer themselves, or feeling that other people and landscapes are somehow unreal, as if seen through a membrane. These are seen often in cases of neurosis, depression, and schizophrenia. While in recent years it has been used to refer to cases in which patients feel as if another self is watching their body and movements from the outside, I use the term here in the former meaning.

19 A genre of parody engaged in primarily by female writers of fan magazines that involves putting beautiful male anime characters into homosexual relationships. As is well known, the term originated as a sort of abbreviation of the expression "yama nashi, ochi nashi, imi nashi," or "no climax, no punchline, and no conclusion," which characterize the genre. The first anime to be made into *yaoi* were *Captain Tsubasa (Kyaputen Tsubasa)*, *Saint Seiya (Seitōshi Seiya)*, *Ronin Warriors (Yoiroden samurai turupaa)*, and *Reideen: the Superior (Chōja Raidiin)*. See Watanabe Yumiko, "Shōta no kenkyū," in *Kokusai otaku daigaku* [International otaku university] (Kōbunsha, 1998).

20 If "Lolicon" refers to an obsession with little girls, "Shōtakon" is the love of young boys that appear in manga and anime. The name Shōta comes from Kaneda Shōtarō, the shorts-wearing boy protagonist of *Gigantor* (or *Ironman Number 28 [Tetsujin 28-gō]*). The official name is the "Shōtarō complex." Since the *yaoi* genre has stabilized there has been a growing Shōta boom, ensnaring not just female but male fans as well. See Watanabe Yumiko, "Shōta no kenkyū."

21 [Having a fetish for machines, robots, and technology.—Trans.]

22 Another likely explanation of the origins of the term *moe* is that it comes from a character named Sagisawa Moe, the heroine of the anime *Kyōryū wakusei (Dino Planet)*.

2. Letter from an Otaku

1 The term *figures* refers to various kinds of dolls representing characters, particularly plastic ones used for display purposes. Those with moveable joints are called "action figures." Recently, *figures* is used most often to refer to three-dimensional

models of popular anime characters. They became popular in the early eighties, when large numbers of fans began modifying plastic models of the main characters in *Gundam* and *Urusei yatsura*. The life-size figure of Ayanami Rei from *Evangelion* that I mention in the text sold out immediately despite being priced at ¥280,000. Recently another boom has taken off around prepainted figures sold in blister packs of characters from the comic book *Spawn* and the *Star Wars* and *Star Trek* films.

2 In recent years the beautiful girl characters in anime and computer games have splintered into different types to suit fans' tastes. The "maid" is one of these. Typical examples are the characters in games like "Little Bird in a Cage" ("Kara no naka no kotori") and "Pia Carrot" ("Pia Kyarotto").

3 "1/6" is the scale of the replica: 1/6 of "life size."

4 The Japanese company Takara was licensed by Mattel to market a version of the Barbie Doll in Japan but, when the license ran out in 1986, they renamed the doll Janey and continued selling it. Compared with the realistic face of the original Barbie, Janey has large eyes and a small nose and mouth, which has made her very popular in Japan.

5 Dolls like Mattel's Barbie, Takara's Janey, and Rika-chan that are made for little girls to play with by dressing them up in different outfits.

6 A very detailed version of a model made in small quantities for display purposes. Originally they were models of sailboats or classic cars, but recently they have diversified to include things like characters from anime and live-action special effects films. They have become very popular despite high prices resulting from their relative scarcity and the use of obsessive details that would be impossible to mass-produce. Garage kits are molded from the ground up with papier-mâché or putty (this is called *furu sukaratchi* [from the English "full scratch"] to differentiate it from partial modification of existing figures). Makers of original models are called "genkeishi"; appreciation of their artistry is an important aspect of garage kit connoisseurship.

7 [This link was no longer active as of August 2009.—Trans.]

3. Beautiful Fighting Girls outside Japan

1 American schools have both weekend days off, so many child-oriented cartoons are broadcast on Saturday morning. The idea, apparently, is to let parents park their children in front of the television to give them a respite from having to take care of them. Frankly, the quality of these shows is not what you could call high. This is apparently the origin of the pejorative phrase "Saturday-morning animator."

2 Saitō Minako, *Kōitten ron* [A single splash of crimson] (Chikuma Shobō, 2001).

3 Tentacle porn is the general term for adult-oriented anime containing scenes in which a female is violated by a monster with giant tentacles. Used chiefly by American anime fans, it has considerably pejorative connotations.

4 [The phrase means "very cute girls."—Trans.]

5 [A handheld digital pet.—Trans.]

4. The Strange Kingdom of Henry Darger

1 John M. MacGregor, "Thoughts on the Question: Why Darger?" *Outsider* 2, no. 2 (1998), http://www.art.org/theOutsiderMag/darger-whydarger.htm (accessed August 30, 2009).

2 John M. MacGregor, "I See a World within the World: I Dream but Am Awake," in *Parallel Visions: Modern Artists and Outsider Art*, ed. Maurice Tuchman and Carol S. Eliel (Los Angeles: Los Angeles County Museum of Art/Princeton, N.J.: Princeton University Press, 1992), 269.

3 Michael Bonesteel, *Henry Darger: Art and Selected Writings* (New York: Rizzoli International Publications, 2000), 13.

4 John M. MacGregor, *Henry Darger: In the Realms of the Unreal* (New York: Delano Greenridge Editions, 2002), 19.

5 Ibid., 92.

6 Bonesteel, *Henry Darger,* 74.

7 MacGregor, *Henry Darger: In the Realms of the Unreal,* 20

8 MacGregor, "I See a World," 260.

9 MacGregor, *Henry Darger: In the Realms of the Unreal,* 567.

10 Ibid., 570.

11 Bonesteel, *Henry Darger,* 240.

12 MacGregor, *Henry Darger: In the Realms of the Unreal,* 610.

13 MacGregor, "I See a World," 266.

14 MacGregor, *Henry Darger: In the Realms of the Unreal,* 486.

5. A Genealogy of the Beautiful Fighting Girl

1 The following references were used to compile the information in this chapter: *Anime LD zenshū* [Complete works of anime on laser disc], Metamoru Shuppan, 1997; *Bessatsu Takarajima 293: Kono anime ga sugoi!* [Takarajima special issue 293: This anime is awesome!], Takarajimasha, 1997; *Bessatsu Takarajima 316: Nippon'ichi no manga o sagase!* [Takarajima special issue 316: Find Japan's number 1 manga!], Takarajimasha, 1997; *Bessatsu Takarajima 330: anime no mikata ga kawaru hon* [Takarajima special issue 330: A book that will change your opinion of anime], Takarajimasha, 1997; *Bessatsu Takarajima 347: 1980-nen daihyakka* [Takarajima special issue 347: 1980 encyclopedia], Takarajimasha, 1997; *Bessatsu Takarajima 349: Kūsō bishōjo dokuhon* [Takarajima special issue 349: Imaginary beautiful fighting girls reader], Takarajimasha, 1997; *Bessatsu Takarajima 421: Kūsō bishōjo daihyakka* [Takarajima special issue 421: Encyclopedia of imaginary beautiful fighting girls], Takarajimasha, 1999; *Chōjin gahō* [Superhuman pictorial], Take Shobō, 1995; *Dōgaō 2-kan: sūpaa majokko taisen* [Anime kings, vol. 2: Showdown of the super magical girls], Kinema Junpō Sha, 1997; *Eiga hihō 8-go: sekushii dainamaito mōbakugeki* [Secret movie report no. 8: Bombardment of sexy dynamite], Yōsensha, 1997; *Kōkishin bukku 23-go: 80 nendai anime daizen* [Curiosity book no. 23: Big collection of 1980s anime], Sōgosha, 1987; *Nihon manga ga sekai de sugoi!* [Japanese manga are awesome worldwide!], Tachibana Shuppan, 1998;

Okada Toshio, *Otakugaku nyūmon* [Introduction to otaku studies], Ōta Shuppan, 1996; Okada Toshio, ed., *Kokusai otakugaku nyūmon* [Introduction to international otaku studies], Kōbunsha, 1998; *Poppu karuchaa kuritiku 2: shōjotachi no senreki* [Pop culture critique 2: History of fighting girl battles], Aoyumisha, 1998; *Roriita no jidai: "Takarajima 30"* [The age of Lolita: Takarajima 30] 2, no. 9, Takarajimasha, 1994; Saitō Tamaki, *Bunmyakubyō: Rakan/Beitoson/Maturaana* [Diseases of Context: Lacan, Bateson, Maturana], Seidosha, 1998; *Sūpaa hiroin gahō* [Superheroine pictorial], Take Shobō, 1998.

2 The abbreviations OAV and OVA are both used for original video animation, meaning works that are only released in video; I have consistently employed the latter in this book.

3 Miyazaki Hayao, "Animeeshon o tsukuru to iu koto" [Making animated films], in *Shuppatsuten* (Tokuma Shoten, 1996), translated as *Starting Point* (San Francisco: VIZ Media, forthcoming).

4 See introduction, note 18.

5 [Tokusatsu, an abbreviation of tokushu satsuei, refers to live-action dramas with an emphasis on special effects.—Trans.]

6 The Japanese adaptation of this work was published as *Nokosareta hitobito* [The People left behind] (Kadokawa Shoten, 1988).

7 The psychiatrist Yasunaga Hiroshi, who has expanded the personality tendencies of various types of epileptics into the realm of the normal personality, has called temperaments that possess the following symptoms "centrothymic temperaments." Yasunaga writes, "Bring to mind the image of a five-to-eight-year-old child who has 'developed normally.' The child is innocent and makes a simple differentiation between sadness and happiness," "has an intense curiosity about concrete objects," "becomes enthusiastic about something but soon becomes bored with it," "doesn't worry about tomorrow; 'tomorrow' isn't in the realm of consideration," and so forth (Yasunaga Hiroshi, " 'Chūshin kishitsu' to iu gainen ni tsuite" [On the concept of "centrothymic temperaments"], in *Hōhōron to rinshō gainen*, vol. 3 of *Yasunaga Hiroshi sakushū* [Methodological theory and clinical concepts] (Kongō Shuppan, 1992).

8 Pygmalion was the legendary king of the Greek island of Cyprus. It is said that he fell in love with the statue of a woman made of ivory, whom Aphrodite brought to life and made his wife. Here it is used to indicate the universe of narratives such as George Bernard Shaw's *Pygmalion,* the basis for the movie *My Fair Lady,* in which a man seeks to make an internally vacuous woman acquire a desirable personality by educating her.

9 [Ōtomo is well known for his use of a fine-tipped "mapping" pen to draw both background and characters with the same relatively fine lines.—Trans.]

10 Saitō Tamaki, Murakami Takashi, and Kayama Rika, "Mirai wa nijigen de dekite iru" [The future consists of two dimensions], roundtable discussion, *Hato yo!* 189 (January 2000).

11 [The animation plays on the name of the conference, which is homonymous with *daikon,* the word for a type of radish. The little girl is told to deliver a cup of water

to "Daicon" by two mysterious figures. After battling her way past one foe after another, including Godzilla, the Spaceship Yamato, and the USS Enterprise, she arrives to find a tired-looking daikon in the ground. When she waters it, it grows into an enormous spaceship in the shape of a daikon (with engines where the roots would be) representing the conference. As it blasts its engines and takes off, the audience is welcomed to the conference.—Trans.]

12 [The phrase means "no climax, no punchline, and no meaning," in reference to the genre's parodic and gratuitously pornographic nature. For more of Saitō's views on *yaoi*, see Saitō Tamaki, "Otaku Sexuality," in Bolton, Csicsery-Ronay Jr., and Tatsumi, *Robot Ghosts and Wired Dreams*, 222–49.—Trans.]

13 Araki Hirohiko and Saitō Tamaki, "Kakitsuzukeru yūki" [The courage to continue writing], dialogue, *Yuriika* 29, no. 4 (1997).

14 Broadly speaking, there are two types of animation using cels: the Disney type of full animation and the Japanese-made limited animation. As a rule, everything moves in full animation, not only the characters but everything else that can move— including the people in the background and the background itself. In limited animation, movement is confined to the characters that have to move, and static pictures are used for minor characters and the background. The limited animation method was developed out of the necessity to save on staff and other costs, but it is said that Japanese-made animation has made a virtue out of this necessity by developing a variety of unique expressive techniques.

15 Abe Hiroki, "Gaijin ni yoru, gaijin no tame no 'moe' kyara" [A "moe" character for non-Japanese by non-Japanese], *Bessatsu Takarajima 421: Kūsō bishōjo hyakka* [Encyclopedia of imaginary beautiful fighting girls] (Takarajimasha, 1999).

6. The Emergence of the Phallic Girls

1 As Matsuura Hisaaki points out, the preconditions of the image are that it be "real," "arbitrary," and "perverse" ("Denshiteki riarisumu" [Electronic realism], *Inter Communication* 10 [Summer 1994]). Matsuura argues that as long as the image forestalls the extinction of and stirs up desire, it will inevitably be perverse. But I am extremely skeptical of the claim that follows this (using the example, no less, of *Jurassic Park*), namely, that electronic realism is a concept that opposes this kind of perversion by virtue of its "immediacy." People are already growing tired of computer animation, and its expressive potential does not even come close to the "immediacy" of manga.

2 One thinks here of the distinction Gilles Deleuze makes between "l'image mouvement" and "l'image temps." (However, what I am dealing with here would likely be limited to the territory of "l'image mouvement.")

3 According to Yōrō Takeshi, the brain has two separate systems, one for processing visual information and one for processing auditory- and movement-related information (Yōrō Takeshi, *Yuinōron* [On the brain alone] [Seidosha, 1989]). These can be understood as two different systems for the perception of reality. Our perception of visual reality is atemporal, while perception of auditory- and movement-

related reality incorporates temporal elements. A good example is a screen on which dots are scattered at random. As long as the dots remain still we are unable to read anything into them. But what if a group of them moves for just a few seconds? We might understand even this simple movement as, for example, an imitation of a human gesture. From this animation, which requires very little information, we are able to sense a reality that greatly exceeds even a very detailed static image. In other words, when movement is expressed we have no choice but to take it in as meaning.

4 [*Gekiga* is a style of graphic novel developed in the 1950s and 1960s by artists like Tatsumi Yoshihiro. *Gekiga* do not shy away from serious adult themes and depict reality in a gritty, naturalistic style.—Trans.]

5 Katō Mikirō, *Ai to gūzen no shūjigaku* [Love and coincidental rhetoric] (Keisō Shobō, 1990).

6 Saitō Tamaki, " 'Undō' no rinri" [The ethics of movement], in *Bunmyakubyō* [The disease of context] (Seidosha, 1998).

7 Nakai Hisao, "Seishin bunretsubyō no kankai katei hi-gengoteki sekkin hō no tekiō kettei" [Adaptive decisions based on nonverbal modes of approach in the treatment process in schizophrenia], in *Nakai Hisao chosakushū dai ikkan: bunretsubyō* [Works of Nakai Hisao, volume 1: Schizophrenia] (Iwasaki Gakujutsu Shuppansha, 1984).

8 See *Bessatsu Takarajima E X: manga no yomikata* [Takarajima special issue E X: how to read manga] (Takarajimasha, 1995) for one example of a systematic attempt to classify and analyze these codes.

9 [An abbreviation of "television opaque projector," a device that can be used to superimpose text on the television screen. The term usually refers to the text itself, which is often animated and rendered in loud colors for emphasis.—Trans.]

10 Frederik Schodt, *Manga! Manga! The World of Japanese Comic Books* (Kodansha, 1983).

11 Tahata Isao, *Jūni seiki no animēshon* [Animation in the twelfth century] (Tokuma Shoten, 1999).

12 Jacques Lacan, "Avis au lecteur Japonais," in *Le séminaire de Jacques Lacan*, ed. J. A. Miller, vol. 11 (Paris: Editions du Seuil), 497–500.

13 Mikhail Bakhtin, *Problems of Dostoevsky's Poetics*, ed. and trans. Caryl Emerson (Minneapolis: University of Minnesota Press, 1984), 51–52.

14 [Bakhtin, *Problems of Dostoevsky's Poetics*, 51, 52. Saitō inserts the Japanese phonetic equivalent of the word "pragmatic" here, but the English word does not appear here in Emerson's translation.—Trans.]

15 Saitō Tamaki, " 'Undō' no rinri."

16 See Gregory F. Bateson, "The Logical Categories of Learning and Communication," in *Steps to an Ecology of Mind* (Chicago: University of Chicago Press, 2000); Edward T. Hall, *Beyond Culture* (Garden City, N.Y.: Anchor Books, 1989); and Saitō Tamaki, "Kontekusuto no ōtopoiēshissu" [The autopoesis of context], in *Bunmyakubyō*.

17 Marshall McLuhan, *Understanding Media: The Extensions of Man* (New York: McGraw-Hill, 1964).

18 Japanese architecture is diverse and mixed, but the society is regulated. American society is chaotic, but the design of its cities is thoroughly calculated and orderly.

19 Bank sequences, or *Bankukatto*, are sequences of animation that can be used repeatedly, such as when a heroine is transforming or assuming a decisive pose.

20 Sawaragi Noi, *Nihon, gendai, bijutsu* [Japan, modern, art] (Shinchōsha, 1998).

21 [Antiwar activist who was famously imprisoned for throwing a pachinko ball at Emperor Hirohito. He is the subject of a fascinating documentary by Hara Kazuo, *The Emperor's Naked Army Marches On (Yuki yukite shingun).*—Trans.]

22 Les Daniels, *Comix: A History of Comic Books in America* (New York: Outerbridge and Dienstfrey, 1971).

23 The child pornography law that was proposed in 1998 threatened to have a devastating impact—equal to that of the Comics Code—on freedom of expression in manga and anime. Many voices called for its revision at the time for this reason. The version that eventually passed during the 145th session of the Diet in 1999 exempted drawn images *(e)* from its restrictions, thus avoiding a "total disaster" in Japan.

24 Pornographic images showing pubic hair.

25 Timon Screech, *Sex and the Floating World: Erotic Images in Japan, 1700–1820* (Honolulu: University of Hawai'i Press, 1999).

26 A form of traditional Japanese comic storytelling.

27 Books like Saitō Minako's *Kōitten ron.*

28 [The term in Japanese is *yuigenron*, a notion associated with the work of the Freudian psychoanalyst and popularizer Kishida Shū (b. 1933–). See his *Monogusa no seishin bunseki* (Chūkō Bunko, 1982).—Trans.]

29 This comment was made during a public discussion at a Rofuto Purasu Wan: Tōku Raibu (Loft/Plus One: Talk Live) in Tokyo on April 12, 1998.

30 This term refers to psychoanalytic psychiatry. Strictly speaking, one cannot call oneself a psychoanalyst unless one has been through training analysis oneself. So in this sense I am not a psychoanalyst. But because I always use psychoanalytic principles in my clinical practice, I can say that my position is that of a psychodynamic psychiatrist.

31 For example, in the musical genre of *enka*, the trauma of the woman is an important element onto which the listener is able to project his or her own narcissism. A similar phenomenon can be seen in the rising emphasis on trauma in novels, particularly the mystery genre. Tendō Arata's *Eien no ko* [The Eternal child] (Gentōsha, 1999) is the most conspicuous example of this I can think of. The fascination of the novel's torture-victim heroine plays a very important part in the text.

32 See Saul Kripke, *Naming and Necessity* (Cambridge, Mass.: Harvard University Press, 1980).

33 Juan David Nasio, *Hysteria from Freud to Lacan: The Splendid Child of Psychoanalysis* (New York: The Other Press, 1998), 51.

34 Ibid., 107.

35 Ibid., 5.

36 Ibid., 119.

37 Jacques Lacan, "Ten'i ni kansuru shiken," *Ekuri I*, trans. Miyamoto Tadao et al. (Kōbundō, 1972).

38 Nasio, *Hysteria from Freud to Lacan.*

39 Slavoj Žižek, "*Cyberspace:* Or, the Unbearable Closure of Being." *Pretexts: Studies in Writing and Culture* 6, no. 1 (1997): 53–79.

40 Lacan, "Signification of the Phallus."

41 Saitō Tamaki, *Shakaiteki hikikomori* [Social shut-ins] (PHP Shinsho, 1998).

42 Henri Bergson, *Matter and Memory*, trans. Nancy Margaret Paul (London: Allen and Unwin, 1962).

43 Michael Balint, *The Basic Fault: Therapeutic Aspects of Regression* (London: Tavistock Publications, 1968), 29.

44 Bonesteel, *Henry Darger*, 240.

45 Homeostasis refers to a tendency toward regulating physiological processes to maintain stasis in the internal environment of an organism or a cell. It is conceivable that Darger's fantasy world was also regulated like this to fend off stimuli from the outside world and maintain internal stability. The fact that he cut off communication with society and remained a shut-in would have contributed to this homeostatic function.

46 Sherry Turkle, *Life on the Screen: Identity in the Age of the Internet* (New York: Simon and Schuster, 1995).

Afterword to the First Edition

1 "Henrii Daagaa no farikku gaaruzu," *Ra Runa* 1 (1995).

2 "Farikku gaaruzu ga ekkyō suru," *Imaago* 2 (February 1996).

3 *Bunmyakubyō: Rakan/Beitoson/Maturaana.*

Afterword to the Paperback Edition

1 [In the summer of 2000 Azuma Hiroki hosted a forum on his Web site (hirokiazuma.com) to discuss the issues raised by Saitō in *A Psychoanalysis of the Beautiful Fighting Girl,* which had appeared in the spring of that year. The discussion was titled "Sentō bishōjo no seishin bunseki o meguru mōjō shohyō" (Net-based reviews of *Beautiful Fighting Girl*) but became known simply as "Mōjō genron" (Debate on the net). The discussion was continued at a public forum on September 16, 2001, sponsored by Tinami and titled "Mōjō genron F: Posuto Evangerion no jidai," where the "F" stands for "Final," "Followup," and "Forward." Video footage of the symposium is available online at http://www/tinami.com/x/moujou. In 2003 Azuma published an edited volume that included the presentations at the conference along with a long discussion among Saitō, Azuma, and Kotani Mari and two additional essays by Itō Gō and Nagayama Kaoru. That volume is the one Saitō is referring to here: *Mōjō genron F kai: posutomodan, otaku, sekushuariti* (Seidosha, 2004).—Trans.]

INDEX

Adachi Mitsuru, 109
adolescents: American, 56; Henry J.
 Darger as, 168; Japanese, 51, 52, 56–
 57, 87, 101, 187n19; media use by, 9,
 30, 80–81, 170; mentality of, 68, 76, 81
Aeon Flux (anime), 130
Aim for the Ace! (television anime), 97
Akai Takami, 40
Akihabara Cyber Team (anime series),
 42, 125–26
Akihabara district (Tokyo), 181, 186n10
Akira (anime series), 109, 118, 119
Akiyama, George, 94–95
Alien films, 104
alien girl next door lineage, 12, 102,
 107, 123
Allison, Anne, x, 185n4
All-Purpose Cultural Cat Girl, 111
amae, 13. *See also* Japan/Japanese
Amazon women warriors, 47, 48, 85,
 127, 159
androgyny, 92, 100
Animage (magazine), 102; anime top ten,
 83–84
animalization, xxii, xxiv, 43
animation, 83, 118, 196n1, 196n3,
 196n14. *See also* Disney animation;
 OVA (original video animation) genre
anime, 85, 118, 119, 150, 152, 174; adult-
 oriented, 54, 104, 113–14, 193n3;
 atemporality of, 136–40, 157; codes

used in, 140–44, 148; in comics, 33,
132–33; in computer games, 119,
121, 151; creators of, xi, 143; decline
of, 114–15; gender in, 50–53, 120;
high-context, 146–48; Japanese, 50,
51, 56–57, 142–43; juvenilization
in, 48–49, 51, 61, 192n19, 192n20;
manga's impact on, 96, 98, 109–10,
111, 137; as masturbation aids, 30, 33,
35, 37–39; parodies of, 42–43, 93, 97,
98, 110, 118; revival of, 118–26; sci-
ence fiction, 103, 104, 106, 113; sexual
excitement from, xvii, 27–28, 30, 87,
116; sexuality in, 53–55, 56, 86, 87–88,
90, 95–96, 104, 110; social conditions
reflected in, 52–53; top ten, 83–84;
violence in, 51, 90; in the West, 45–61,
87, 119–20, 153, 155. *See also* beautiful
fighting girls; otaku; space: of anime
and manga; *and individual genres
and subgenres*
aniparo, 98. *See also* parodies
Anne (character). *See* Yuri Anne
 (character)
Anno Hideaki, 25, 108, 120, 122, 125
Araki Hirohiko, 115–16, 140
Arale-chan (character), 105–6
architecture: Japanese vs. U.S., 198n18
art/artists, 43, 143, 152. *See also* outsider
 art/artists
art brut. See outsider art/artists

SAITŌ TAMAKI is director of medical service at Sofukai Sasaki Hospital in Funabashi, Japan. A practicing psychiatrist in the Lacanian tradition, he is the author of numerous books in Japanese on adolescence and popular culture.

J. KEITH VINCENT is assistant professor of Japanese and comparative literature at Boston University. He is coeditor of *Perversion and Modern Japan: Psychoanalysis, Literature, Culture*. He has translated works by Natsume Sōseki and Okamoto Kanoko, among others, into English and works by Lee Edelman, Douglas Crimp, and Judith Butler into Japanese.

DAWN LAWSON is the East Asian studies librarian at New York University and a PhD student in the university's Department of East Asian Studies. She has translated works by Ōshima Nagisa, Hayashi Mariko, and Ueno Chizuko.

HIROKI AZUMA is codirector of the Academy of Humanities at the Tokyo Institute of Technology's Center for the Study of World Civilizations. His books include *Otaku: Japan's Database Animals* (Minnesota, 2009).